The Painted World
from Illumination to Abstraction

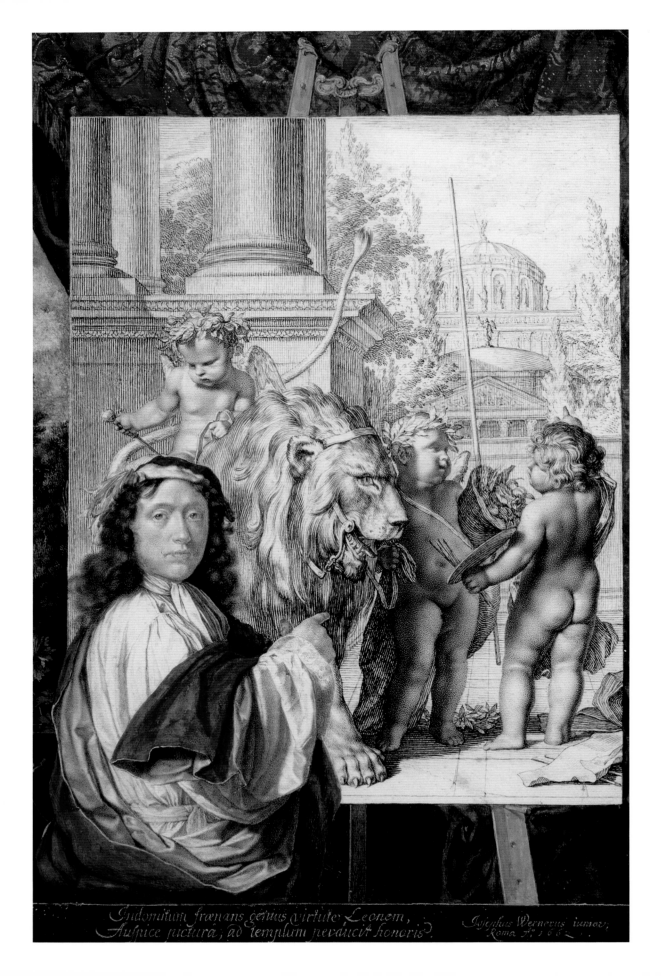

Indomitum fraenans genius virtute Leonem,
Auspice pictura; ad templum perducit honoris.

Josephus Wernerus iunior,
Roma A° 1662

The Painted World
from Illumination to Abstraction

Mark Evans

V&A Publications

Für Reini

First published by V&A Publications, 2005
V&A Publications
160 Brompton Road
London SW3 1HW

Distributed in North America by Harry N. Abrams, Inc., New York

ISBN 1 85177467 X

Library of Congress Control Number 2005923382

A catalogue record for this book is available from the British Library.

Designed by Bernard Higton
New photography by Paul Robins, V&A Photographic Studio

Note: in some cases, spellings in contemporary quotations have been modernized.

Printed in China

Front jacket illustration: Gustave Moreau, *Sappho*, c.1884. See p.98.

Back jacket: Plate decorated with *The Bellringer*, designed by Alexandra V. Shchekotikhina-Pototskaya, 1921. See p.122.

Half-title page: Ben Nicholson (1894-1982), *Gouache*, 1936. Gouache on paper, 30.5 x 42.2cm. Purchased, 1961. P.2-1961

Frontispiece: Joseph Werner (1637-1710), *Self-portrait before an easel*, 1662. Watercolour on vellum, 22 x 15.5cm. Purchased, 1931. P.168-1931
Shortly after completing this miniature self-portrait, in which the artist is seen working on an allegory of painting, Werner was summoned to Paris by Louis XIV. He later became the first director of the Berlin Academy.

V&A Publications
160 Brompton Road
London SW3 1HW
www.vam.ac.uk

Contents

Acknowledgements

This book could not have been written without the incomparable resources of the V&A, and the expertise of its staff. I am most grateful to Susan Lambert and John Meriton of the Word & Image Department for recommending this project to Carolyn Sargentson and Christopher Breward at the Research Department, under whose aegis it was carried out. My research was conducted with the hospitality of the National Art Library, to whose staff I owe special thanks. At the Paintings Section, my colleagues Katie Coombs, Catherine Flood, Charles Newton and Sonia Solicari have been a constant source of ideas and practical assistance, and have shouldered the extra duties resulting from my absences while writing this book. I am also grateful to Nicola Costaras, Alan Derbyshire, Pauline Webber and their colleagues in the Conservation Department for numerous insights into the physical properties and techniques of paintings.

For reading draft chapters and making helpful suggestions, I am grateful to Malcolm Baker, Stephen Calloway, Donal Cooper, Mark Haworth-Booth and Paul Williamson. For special help with the final chapter, I owe a particular debt to Gill Saunders. Elsewhere in the Word & Image Department, I gratefully acknowledge the assistance of Martin Barnes, Rosemary Miles, Liz Miller, Frances Rankine and Rowan Watson. Colleagues from other departments who generously helped me explore unfamiliar territory include Terry Bloxham, Frances Collard, Rosemary Crill, Judith Crouch, Rupert Faulkner, Alun Graves, Anna Jackson, Teresa Kirk, Sophie Lee, Reino Liefkes, Sarah Medlam, Susan North, John Clarke, Divia Patel, Susan Stronge, Jennifer Wearden and Hilary Young.

The Head of V&A Publications, Mary Butler, has enthusiastically supported this project from its inception. I am also grateful to my editor Monica Woods, to Richard Leon Rosenfeld, the copy-editor, to Bernard Higton, the designer, and to Ken Jackson and Paul Robins for the photography. I am profoundly appreciative of the generations of V&A curators, past and present, whose pooled knowledge has moulded my own ideas, but any errors remain my own. This book is dedicated to my wife, Reinhild Weiss, who has helped in more ways than I can list.

Preface

The Victoria and Albert Museum has nearly as many oil paintings as the National Gallery, as well as large and spectacular collections of watercolours, miniatures and master drawings. Initially assembled as a reservoir of exemplary material to improve the standards of art and design, these straddle traditional boundaries between the fine and applied arts, and illuminate the changing history of taste. A remarkable characteristic of the museum is its inclusiveness, spanning over a millennium, from the early Middle Ages to the present day. Its paintings range from monumental frescos to exquisite miniatures, and from highly finished salon paintings to albums of vibrant watercolours. This variety mirrors the encyclopaedic quality of the V&A.

The redisplay of much of the collections in 2001–5 made me reflect on the role of painting within the wider story of art and design. The history of art is often reduced to an account of a tiny elite of easel pictures, either old masters of superlative quality or avant-garde works of fundamental originality. Yet the majority of oil paintings, as well as watercolours, miniatures, modern works not perceived as 'cutting edge', and all non-European pictures, are barely admissible to this twin canon of old and modern masters. Also excluded, because they belong to the applied arts, is a wide range of pictorial works, from stained glass and enamels to painted ceramics, furniture and textiles. Furthermore, copies of any type are routinely discounted unless by a copyist of greater fame than the original artist.

The V&A abounds in such works, and it has been my aim to bring them to the centre of my narrative. I have also avoided anachronistic stylistic terms, such as 'Gothic', 'Renaissance' and 'Baroque' – which would have been meaningless at the time – and utilize contemporary opinion to express what has been succinctly termed 'the period eye'. My intention is to provide a more inclusive, summary history of painting, viewed through the lens of the V&A.

Assembled in the space between the collections of the British Museum, the National Gallery and, latterly, the Tate, the V&A's holdings of pictures sought strength in areas that were poorly represented at its sister institutions. At different times, the V&A prioritized watercolours and portrait miniatures, as well as British oil paintings and sketches between 1857 and 1897, and it was receptive to the Continental avant-garde around 1901. It has housed Raphael's celebrated Sistine cartoons, on loan from the Royal Collection, since the 1860s. (After 1909, the museum ceased to collect oil paintings, unless related to its wider responsibilities for the applied arts and design.) At the V&A, British and European pictures are accorded equal status to Indian and Far Eastern art, and to the entire panoply of the applied arts and architecture. This wide remit has helped to redefine artistic canons, and continues to provide a uniquely plural environment in which to enjoy and understand pictures. This is the principal objective of its collection of paintings, and this book.

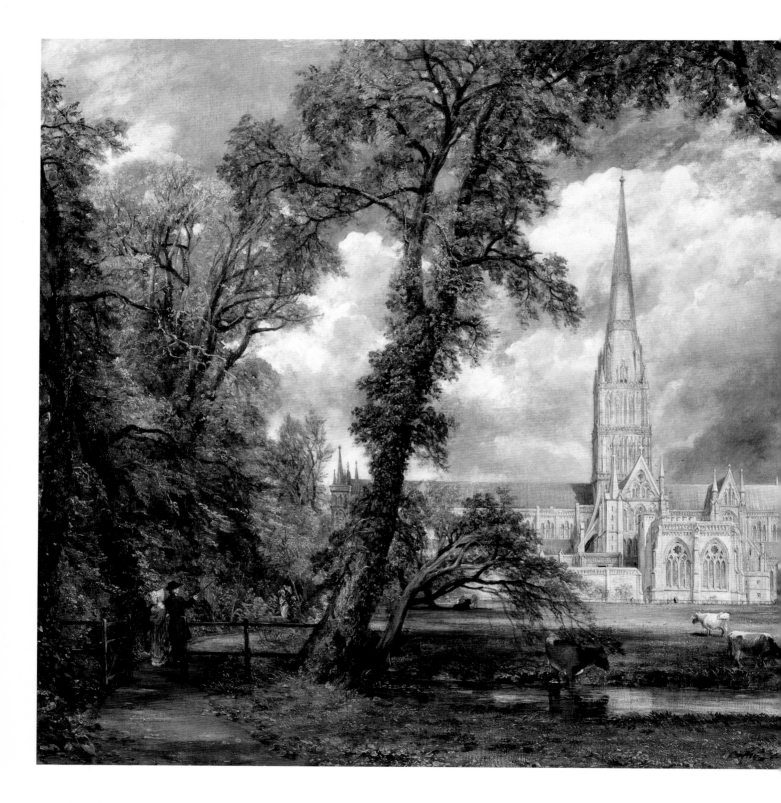

1 Collections of Pictures and Canons of Art

John Constable (1776-1837)
Salisbury Cathedral from the Bishop's Grounds, 1823
Oil on canvas, 87.6 x 111.8cm
Given by John Sheepshanks, 1857
FA.33
This image is canonical in two ways, first because of the acknowledged importance of the artist, and second because its subject is the definitive monument to the 'Early English' style of Gothic architecture, in a historic city on Salisbury plain, near the ancient sites of Old Sarum and Stonehenge. It exemplifies the values so important to the founders of 'The National Gallery of British Art' at the South Kensington Museum.

Collecting pictures, as we currently understand it, and the concept of a great work of art embodying a 'canon' or rule of correctness to be emulated, both emerged in the Renaissance. With the exception of late Roman mummy portraits, few classical paintings survive, and even less is known about the collecting of pictures in antiquity. However, the thirty-two lost Greek paintings described in the *Natural History* of Pliny the Elder (AD 23/4-79) came to embody a canon of artistic excellence, revered by later readers. Their descriptions also perpetuated the reputation of Apelles (late fourth century to early third century BC) as the greatest antique painter. Pliny himself perished in the eruption of Vesuvius which entombed and preserved what became the largest surviving group of Roman wall paintings, in the buried city of Pompeii. These paintings began to be excavated in 1748, and they were rapidly recognized and prized as an authoritative source by neoclassical artists and designers.

Following the dissolution of the classical world, early Christian and medieval religious images were venerated because of their relationship to a divine archetype. Celebrated icons include the sixth-century *Mandylion* (Vatican, Capella S. Matilda), believed to be 'a figure painted by God', and the Virgin and Child known as *The Salvation of the Roman People* (Rome, S. Maria Maggiore), thought to have been painted from life by the Evangelist St Luke.[1] Innumerable replicas of such pictures were made, whose spiritual efficacy depended upon the exactitude with which they reproduced the originals, thereby reflecting the divine essence.

A unique surviving representative of the collections of icons assembled by orthodox religious foundations is the hoard of about 3,000 panels in the monastery of St Catherine's, in Sinai. The monastery was founded by the Emperor Justinian in the sixth century at the location where Moses was believed to have encountered the burning bush. Now an international tourist destination, as well as an ancient centre of pilgrimage, its most famous treasures are on air-conditioned display, while its

icons of lesser art-historical interest continue to be embraced by the faithful, as they have been for over a millennium.

Unless attributed with miraculous origins or supernatural powers, paintings generally occupied a marginal role in the ecclesiastical treasuries of Western Europe. This was because of their intrinsically modest value when compared with objects made of gold and precious stones, or exotic rarities such as ostrich eggs and sticks of coral. By the fourteenth century, the commissioning of life-like secular portraits began, usually depicting ancestors, relations or other associates, but there is little evidence that the portraits were systematically assembled or displayed.[2] This began in earnest during the fifteenth century with the formation of numerous collections of ancient Roman coins that paved the way for the subsequent publication of illustrated compendia of medallic portraiture.[3]

Especially in Florence and Rome, humanist-inspired collectors enthusiastically acquired antique gems, bronzes, and recently excavated marble reliefs and statues. In 1471 Pope Sixtus IV donated several famous ancient bronzes, including the *Spinario* and the *Wolf*, 'to the Roman people' for display at the Palace of the Conservators on Capitol Hill.[4] In 1503 Julius II initiated the sculpture court at the Vatican Belvedere, which later became home to the *Apollo Belvedere* and the *Laocoon*.[5] These canonical collections of classical statuary were emulated by northern princes, notably King François I (from 1540) at the Palace of Fontainebleau, and Duke Albrecht V of Bavaria (from 1566) at the Munich Residenz.

A new departure occurred around 1521, when the Italian historian Paolo Giovio (1486-1552) began a collection of over 400 portraits of famous rulers, statesmen, generals and men of letters, of the past and present, which he placed on public display at his villa at Lake Como.[6] Giovio sought unsuccessfully to ensure the future of his *musaeum*, which nevertheless inspired collections of portraits and volumes of engravings throughout Europe.

Giovio was a friend and mentor of the painter Giorgio Vasari (1511-74), whose *Lives of the Painters, Sculptors and Architects* first appeared in 1550. Vasari's *Lives* presented detailed accounts of the principal Italian artists since Cimabue (1240/5-1301/2) within an overall history of the arts. His book transformed the literature of art history, providing a benchmark for subsequent authors for over three centuries, and it has been aptly stated that 'Giorgio Vasari invented Renaissance art'.[7] In so doing, he created an essentially Italianate canon of artistic achievement, which remains persuasive today. As court artist to the Medici dukes of Tuscany, Vasari also transformed Florence into a courtly milieu, designing the Uffizi to accommodate the ducal administration. In 1584 his successor Bernardo Buontalenti added an octagonal room to house the cream of the Medici collection of paintings, statuettes and *objets d'art*. Later grand dukes augmented this display with the *Venus de' Medici* and other famous classical marbles, to such an extent that, by the early eighteenth century, the Tribuna was one of the most famous rooms in the world, and a magnet for visitors to Italy.[8]

In 1604 the Dutch painter Karel Van Mander (1548-1606) published his *Book of Picturing*, which revised the structure of Vasari's *Lives* to include Netherlandish art over the previous two centuries. At that time, the Antwerp painter Peter Paul Rubens (1577-1640) was visiting Italy, a trip which transformed him into one of the most celebrated artists and connoisseurs in Europe. Rubens was a major collector of antiquities and paintings by Italian masters, such as Titian and Tintoretto, as well as by his contemporaries, including Jan Bruegel and Adriaen Brouwer.[9] He sold most of his collection to George Villiers, the Duke of Buckingham and a favourite of Charles I.

While still Prince of Wales, Charles purchased the Raphael Cartoons for weaving at the new tapestry factory in Mortlake, west of London. In 1623, accompanied by Buckingham, he also visited the Spanish court, an experience which magnified the

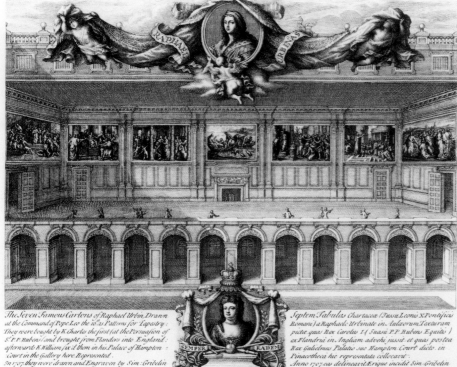

The Seven Famous Cartoons of Raphael Urbin, Drawn at the Command of Pope Leo the 10 as Patterns for Tapestry; They were bought by K:Charles the first (at the Persuasion of S.P.P. Rubens) and brought from Flanders into England; afterwards K:William fix'd them in his Palace of Hampton Court in the Gallery here Represented.
In 1707 they were drawn and Engraven by Sim:Gribelin and by him most humbly Dedicated to Her Late Majesty.

Septem Tabulas Chartaceæ (Jussu Leonis X Pontificis Romani) a Raphaele Urbinate in Aulæorum Texturam pictæ quas Rex Carolus I (Suasu P.P.Rubens Equitis) ex Flandriâ in Angliam advehi jussit et quas postea Rex Gulielmus Palatio suo Hampton Court dicto in Pinacotheca hic repræsentata collocavit.
Anno 1707 eas delineavit Ærique incidit Sim:Gribelin et Seren™ Annæ Reginæ humilissime Dedicavit.

S.G. inv. et sculp. & excudit 1720

Simon Gribelin (1661-1733)
The Seven Famous Cartoons of Raphael Urbin, 1707/20
Engraving on paper, 18.8 x 22.2cm
Bequeathed by Alexander Dyce, 1869
Dyce 2504
This engraving depicts the Raphael Cartoons as they appeared following their re-display in 1699, as though viewed through a cutaway in the wall of the remodelled King's Gallery at Hampton Court Palace. They were hung in an attractive formal arrangement, without regard to their narrative sequence. Above the view is an oval portrait of Raphael borne by putti, and below one of Queen Anne in a cartouche.

cultural aspirations of both men. The trickle of paintings which accompanied them back to England turned into a flood when the new king famously spent £18,000 on the pick of the Mantuan ducal pictures. Charles acquired over 1,500 paintings, many masterpieces by principal figures in Vasari's *Lives*, such as Mantegna, Raphael, Andrea del Sarto, Giulio Romano, Titian, Tintoretto and Correggio, as well as modern painters including Annibale Carracci, Caravaggio and Guido Reni.[10] Rubens compared the new royal collection favourably with those of Habsburg Spain.

After Charles's execution, most of his pictures were dispersed to collections throughout Europe. Philip IV of Spain acquired a dazzling group of major sixteenth-century Italian paintings, most of which were donated to the Monastery of the Escorial. There, in 1656, the Spanish court painter Diego Velázquez (1599-1660) created a new display in the principal rooms, comprising symmetrical arrangements of masterpieces by Raphael, del Sarto, Correggio, Titian, Veronese, Tintoretto, Palma Giovane and Luca Cambiaso, supplemented by

more recent works of Annibale Carracci, Reni, Guercino, Rubens, Ribera, Van Dyck and Seghers. This spectacular ensemble survived until the time of Napoleon, and was publicized in a series of guidebooks to the monastery, with English translations appearing in 1671 and 1760.[11] Similar displays at other courts, most notably those which Louis XIV inaugurated at the Louvre (prior to 1672), and at Versailles (from 1683), gave precedence to the Italian masters of the Renaissance, the late sixteenth-century Bolognese school, the Italianate Flemings (Rubens and Van Dyck) and such modern classical masters as Simon Vouet (1590-1649) and Charles Le Brun (1619-90).

In 1708 this canon was formally tabulated in the *Scale of Painters* by the French critic Roger de Piles (1635-1709).[12] This survey listed the 57 most famous Italian, Netherlandish, French, German and Spanish painters of the sixteenth and seventeenth centuries, awarding each one marks ranging from 0-20 for composition, drawing, colour and expression. The joint winners by a considerable margin were Raphael and Rubens with 65, followed by Carracci and Domenichino with 58, just ahead of Le Brun in third place with 56. The runners-up, with 55, were Rubens' best pupil Van Dyck and his little-remembered teacher Otto van Veen. Poussin was let down by a low score of six for colour and received 53, as did Correggio. The lowest mark, of 23, was awarded to Giovanni Francesco Penni, Raphael's principal assistant. Although now regarded as an extreme instance of the rigidity of academic logic, de Piles' *Scale of Painters* exemplified a value system which endured with little modification into the nineteenth century.

Meanwhile, the Raphael Cartoons remained in England, despite the depredations of the Commonwealth period, being pawned by Charles

II, and an attempt by Louis XIV to acquire them for the Gobelins Factory in Paris. They were eventually placed on display by William III in a specially designed gallery at Hampton Court Palace. In 1725 the cartoons were described by Jonathan Richardson (1665-1745) as:

> ... the best history pictures that are anywhere now in being ... which are generally allowed even by foreigners, and those of our own nation who are the most bigotted to Italy, or France, to be the best of that master, as he is incontestably the best of all those whose works remain in the world.[13]

Visiting artists repeatedly made prints and drawings after the cartoons, and they were reproduced as full-, half-, and quarter-size sets by Sir James Thornhill, the King's Serjeant Painter, for such clients as the Duke of Bedford and the Duke of Chandos. With the publication in 1759 of *The School of Raphael*, an edition of 102 copper-plate engravings of details after the cartoons, they attained full canonical status as some of the most famous and widely imitated works of art in existence.[14] By 1777 the cartoons were being celebrated as 'the pride of our island, as an invaluable national treasure, as a common blessing', and a campaign to make them publicly accessible led to their being exhibited at the British Institution from 1816-19, and their eventual loan to the South Kensington Museum, now the V&A.[15]

By the early eighteenth century, the British gentry and aristocracy included many of the wealthiest and best-informed art collectors in Europe. A prominent example was Sir Robert Walpole, 1st Earl of Orford (1676-1745), who became Prime Minister and Chancellor of the Exchequer. Although Walpole didn't have time to make the Grand Tour, his brother and sons did, and they helped augment the collection of pictures displayed in his Palladian country house, Houghton Hall in Norfolk.[16] This was especially rich in the work of seventeenth-century Italian and Italianate masters, from Luca Giordano, Pietro da Cortona, Andrea Sacchi, Carlo Maratti and Salvator Rosa, to Rubens, Van Dyck, Jordaens, Frans Snyders, and both Gaspard and Nicolas Poussin. It also included significant paintings by Rembrandt and his student Ferdinand Bol, as well as modern works by Jean Antoine Watteau, the English portraitists Sir Godfrey Kneller and William Hogarth, and the animal painter John Wootton. Walpole's collection was highly regarded, and some considered it part of the British patrimony, comparable in significance with the Raphael Cartoons. Consequently, its sale to Catherine the Great of Russia in 1777 was widely deplored, prompting the publication by John Boydell of a series of 162 prints of 'the Most Capital Paintings in the Collection', commonly known as *The Houghton Gallery*.

A detailed catalogue of Walpole's collection had appeared in 1747, compiled by his son Horace (1717-97), who is best remembered as a prominent antiquarian and a pioneer of the Gothic Revival. He compiled the earliest major compendium of source material for the visual arts in Britain, the *Anecdotes of Painting in England*, which was based on the notebooks of the engraver George Vertue (1709-56), and published between 1762 and 1771. Horace Walpole's own art collection included important English portrait miniatures and numerous portrait engravings. A scholar with influential connections, he was a natural choice as a trustee of the estate of the collector Sir Hans Sloane (1660-1753) which provided the nucleus of the British Museum, founded in 1753. Although the museum included major collections of prints and drawings from its inception, and it was proposed that the Houghton pictures should be purchased and housed in a gallery in its gardens, its representation of paintings remained trifling.

The Royal Academy was founded in London in 1768 with a membership of 40 Academicians and 20 Associates. Its objective was to raise the status of the visual arts by providing training, and by exhibiting works selected by its members. In 1780 the Academy moved into its prestigious new home at Somerset House, where it stayed until it moved to Trafalgar Square in 1836 before transferring to

Piccadilly in 1867. The annual series of *Discourses* delivered by its President, Sir Joshua Reynolds (1723-92), provide a unique, authoritative survey of established values on art.

He eschewed '*newly-hatched unfledged* opinions', and regarded 'Ideal Beauty' as 'the great leading principal, by which works of genius are conducted'.[17] Above all, Reynolds sought this quality in the formal clarity and elevated subjects of classical sculpture, and the works of Michelangelo, Raphael and the masters of the High Renaissance in Rome, which had powerfully influenced the Bolognese school and the French academic painters of the previous century. In comparison, Reynolds considered the sensuous, painterly values of the Venetian and Flemish schools inferior, and the profound naturalism of Dutch paintings indiscriminate. Reynolds sought to ennoble his own portraits by copying poses, groups of figures and motifs from this approved canon of acknowledged masters; a procedure which was noticed and criticized during his lifetime.[18]

Reynold's hierarchical outlook inevitably marginalized contemporary artists, as is apparent from his comparison of Thomas Gainsborough with Pompeo Batoni and Anton Raphael Mengs:

If ever this nation should produce genius sufficient to acquire to us the honourable distinction of an English school, the name of Gainsborough will be transmitted to posterity, in the history of the Art, among the very first of that rising name ... Pompeio Battoni, and Raffaelle Mengs, however great their names may at present sound in our ears, will very soon fall ... into what is little short of total oblivion ... I am well aware how much I lay myself open to the censure and ridicule of the academic professors of other nations, in preferring the humble attempts of Gainsborough to the works of those regular graduates in the great historical style. But we have the sanction of all mankind in preferring genius in a lower rank of art, to feebleness and insipidity in the highest.[19]

The British Museum – from the purchase of the Townley Marbles (in 1805) until the opening of its Round Reading Room (1857) – was much more preoccupied with acquiring antique sculptures, expanding its library, and the erection of a new building, designed by Sir Robert Smirke. The first major public picture collection in Britain was assembled by the French art dealer Noël Desenfans (1744-1807) and his friend, the Swiss painter Sir Peter Bourgeois (1756-1811), using the dowry of Desenfans' Welsh wife Margaret Morris (1731-1813). Partly acquired from the break-up of aristocratic collections during the French Revolution, these paintings had been intended for sale to the King of Poland, who lost his throne in 1795. As a result, they were given to Dulwich College instead, and housed in a gallery designed by Sir John Soane, which opened in 1814.

English artists barely figured in this spectacular display of largely seventeenth-century paintings, but Dutch painters were well represented at Dulwich, as in the private collections of Sir Thomas Baring, William Beckford and the Prince Regent. The British initially preferred the sparkling Claudian landcapes of Aelbert Cuyp (1620-91), and the polished scenes of everyday life by Gerrit Dou (1613-75) to the dark realism of Rembrandt. The growing British dominance in this area was marked by the appearance in 1829 of the first volume of John Smith's magisterial *Catalogue Raisonné of the Works of the Most Eminent Dutch, Flemish and French Painters*, which remained influential for over a century.

Ten years after the opening of Dulwich Picture Gallery, the House of Commons approved £57,000 to establish the nucleus of a national gallery. The paintings of the banker John Julius Angerstein (1735-1823) were purchased, and supplemented in 1826 by the gift of the collection of the painter and connoisseur Sir George Beaumont (1753-1827).[20] Despite suggestions that these pictures might be housed on the first floor of the newly built King's Library at the British Museum, they remained at Angerstein's house until 1838 when they were transferred to the building designed by William

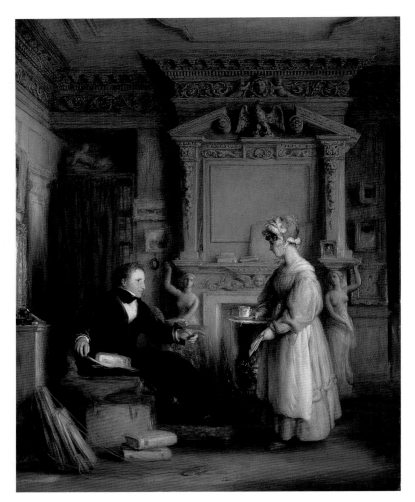

John Constable was a regular visitor to the Dulwich Gallery, and a close friend of Beaumont, at whose country house he made meticulous copies of Beaumont's paintings by Claude. Perhaps surprisingly, Constable had doubts concerning the proposed National Gallery, being anxious that its foundation might elevate a canon of approved masters above nature, which he passionately revered. The lectures on the history of landscape painting which he gave in 1833 and 1836, and which were summarized by his friend and biographer C. R. Leslie, shed considerable light on his outlook on past masters. He cautioned:

Manner is always seductive. It is more or less an imitation of what has been done already – therefore always plausible ... all painters ... should be perpetually on their guard against it. Nothing but a close and continual observance of nature can protect them from the danger of becoming mannerists.[21]

Constable then presented his own hero: '... at Rome Claude became the real student of Nature. He came there a confirmed mannered painter. But he soon found it necessary to become as a little child'.[22] The 'magnificent Rubens' excelled in 'freshness and dewy light ... rainbows upon a stormy sky, – bursts of sunshine, – moonlight, – meteors, – and impetuous torrents mingling their sound with wind and wave'.[23] A river scene by Ruysdael prompted the pithy maxim, 'We see nothing truly till we understand it'.[24] Constable considered that landscape painting subsequently entered a decline, reaching its nadir with François Boucher, whose work represented 'the climax of absurdity to which the art may be carried, when led away from nature by fashion ... His landscape ... is pastoral!; and such pastorality! The pastoral of the opera-house.'[25] He believed that landscape painting had 'revived in our own country, in all its purity, simplicity, and grandeur, in the works of Wilson, Gainsborough, Cozens, and Girtin.'[26]

For aspiring painters, Constable characterized two alternative professional options:

William Mulready (1786-1863)
Interior with a portrait of John Sheepshanks, 1832/4
Oil on panel,
50.4 x 39.7cm
Given by John Sheepshanks, 1857
FA.142
The artist's friend and patron John

Sheepshanks appears in the drawing room of his house at 172 New Bond Street, while his housekeeper brings in his letters and morning tea. He is surrounded by books and portfolios of prints and drawings. This painting was made shortly before Sheepshanks gave up collecting Old Master prints for contemporary British paintings.

Wilkins, in Trafalgar Square, which was initially shared with the Royal Academy. Although the collections of Angerstein and Beaumont were dominated by seventeenth-century Continental masters, they also included more recent British paintings by William Hogarth (1697-1764), Reynolds, his associates Richard Wilson (1713-82) and Sir Benjamin West (1738-1820), with just one solitary picture by a living artist, the popular Scottish genre painter David Wilkie (1785-1841).

In the one, the Artist, intent only on the study of departed excellence, or on what others have accomplished, becomes an imitator of their works, or he selects and combines their various beauties; in the other he seeks perfection at its PRIMITIVE SOURCE, NATURE. The one, forms a style upon the study of pictures, or the art alone; and produces, either "imitative", "scholastic", or that which has been termed "Eclectic Art". The other, by study ... pursued in a far more expansive field, soon finds for himself innumerable sources ... hitherto unexplored, fertile in beauty, and by attempting to display them for the first time, forms a style which is original.[27]

He presented these options almost as a 'Choice of Hercules', between vice and virtue, leaving his personal preference self-evident.[28] Although Constable's paintings are widely regarded today as being quintessentially English, the critical attention which they received during his lifetime was mixed. Some reviewers enthusiastically praised the naturalism of his work, while others violently attacked its lack of conventional finish. In 1837, shortly after Constable's death, his *The Cornfield* was presented to the National Gallery but, thereafter, his reputation rapidly waned. In 1888 the gift of Constable's remaining studio contents by his daughter, Isabel, to the South Kensington Museum contributed to a recovery, and by the early twentieth century he was hailed – anachronistically – as a prophet of Impressionism.

In Britain, the Republican and Napoleonic wars inhibited foreign travel and encouraged patriotism in the face of a powerful foe. Artists became increasingly aware of the unique beauties of their own landscape and historic buildings, and some patrons consciously sought to foster contemporary British art. From 1813, at Petworth House in West Sussex, the third Earl of Egremont (1750-1837) supplemented the classical marbles assembled by his father with a major collection of statuary by British neoclassical sculptors. And in 1823 – a year before the foundation of the National Gallery – Sir

John Fleming Leicester offered to sell his collection of British pictures to the government as 'the nucleus of a National Gallery of British Art'.[29]

In the 1820s, the wealthy tradesman Robert Vernon (1774-1849) began to acquire British paintings, including works by the past masters Reynolds and Gainsborough, and the principal contemporary figures Turner, Constable, Wilkie, Landseer, William Mulready, Daniel Maclise, William Etty, Thomas Stothard, Augustus Calcott, C. R. Leslie and others.[30] In 1847 he gave 157 paintings to the National Gallery, almost doubling the number of works in its collection and transforming its character, which had previously been dominated by the seventeenth-century Continental schools. Vernon specified that his pictures should remain together, in separate galleries bearing his name, but lack of space meant that they could not be exhibited together until the expansion of the National Gallery in 1876.

John Sheepshanks (1787-1863) was a contemporary of Vernon, and the son of a Leeds cloth manufacturer. He retired to London in the 1820s to pursue his joint passion for gardening and collecting.[31] He initially assembled an exquisite collection of seventeenth-century Dutch and Flemish prints, which was purchased by the British Museum in 1836. Thereafter, he turned to contemporary British paintings. Conditioned by his earlier taste for Netherlandish art, Sheepshanks' preference was for landscapes and scenes by Turner and Constable, Mulready, Calcott, Landseer, Leslie, Charles West Cope, William Collins and William Cook. He rapidly built up a collection of over 200 paintings and a similar number of drawings, and came into the orbit of the formidable civil servant Henry Cole (1808-82), a chairman of the Society of Arts, and the principal administrator of the Great Exhibition of 1851.

One of Sheepshanks' favourite artists was the painter Richard Redgrave (1804-88) who, in 1847, began a distinguished career teaching at the Government School of Design, in London. Redgrave and his colleagues, including William Dyce (1806-64),

believed that understanding 'the higher branches of art' was essential for transforming the quality of manufactured goods. And it is telling that a major early acquisition for the School of Design was a set of full-scale copies after Raphael's frescoes from the Vatican *Loggie*, purchased in 1842 for the considerable sum of £510. Following the huge success of the Great Exhibition, the School of Design and its collection was united with the recently established Museum of Ornamental Art, at Marlborough House, to form the new Department of Science and Art under the directorship of Cole. In 1856 it moved to the site in South Kensington which eventually became the V&A.

In 1857 Sheepshanks decided to give this new institution his collection, with the following aims:

I desire that a Collection of Pictures and other Works of Art, fully representing British Art, should be formed, worthy of national support ... I conceive that such a collection should be placed in a gallery in an open and airy situation ... at Kensington, and be attached to the Schools of Art in connexion with the Department of Science and Art ... in the hope that other proprietors of pictures and other works of Art may be induced to further the same object ...[32]

Sheepshanks made his gift conditional on the immediate erection of 'A well-lighted and otherwise suitable gallery, to be called "The National Gallery of British Art"' for his collection, and 'any other pictures or other works of Art that may be subsequently placed there by other contributors, as it is not my desire that my collection of pictures and drawings shall be kept apart, or bear my name as such ...'[33] In an address thanking the donor, Redgrave praised Sheepshanks' pictures for their 'thoroughly original and English treatment of Englishmen and English beauty', which 'sought a place in men's homes, and addressed itself to their affections'.[34] A gallery built to house his collection opened in 1857, and was rapidly extended, providing temporary accommodation for pictures from the Vaughan Gift and the J. M. W. Turner Bequest, and a home for the Raphael Cartoons which were lent

by Queen Victoria, in 1865, in accordance with the wishes of the late Prince Albert. In 1866 Redgrave and his brother, Samuel (1802-76), supplemented the achievement of 'The National Gallery of British Art' with the publication of *A Century of Painters of the English School*, effectively the first popular account of British painting.

As he had hoped, Sheepshanks' public-spirited gesture encouraged a series of donations of British pictures. In 1860 the widow of Richard Ellison gave 51 watercolours specifically 'to promote the foundation of the National Collection of Water Colour Paintings', and later supplemented them with a further 49 works. The museum's watercolour collection exceeded 500 works by 1876, when it became the subject of a catalogue by Samuel Redgrave, incorporating one of the earliest scholarly accounts of the development of watercolour painting. This emphasized how British 'water-colour art ... has risen to be a purely national and original school. Practised by a succession of men of great genius, a distinct branch of art has been created, taking rank with works in oil'.[35] And, in 1859, the first edition of the museum's catalogue of *Pictures, Drawings and Etchings* mentioned how, 'From the earliest time there was one branch of art in which English artists had a reputation even on the continent, and in which they certainly excelled the artists of other nations, namely miniature painting in water-colours.'[36] Although by this time the portrait miniature had practically succumbed to photography, the monumental loan exhibition of nearly 4,000 miniatures, which was organized at the museum by Samuel Redgrave in 1865, marked the beginning of modern appreciation of this distinguished art form.[37]

The growth of public art collections in Britain reflected Continental developments. Based on the riches of the French royal collections, the Musée du Louvre acquired an international character during the Napoleonic era as art treasures were expropriated from Europe and beyond. From 1795 until 1816, the Musée des Monuments Français pioneered the study of medieval art, which was

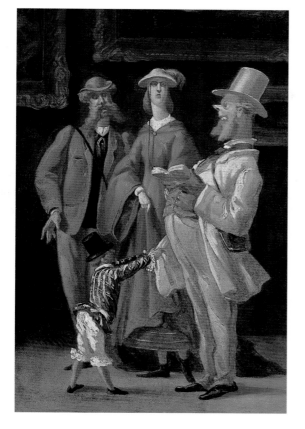

continued by Jules Michelet and Alexandre du
Sommerard, the founder of the Musée du Cluny,
acquired by the French state in 1843. In Cologne,
the brothers Sulpiz and Melchior Boiserée
assembled from secularized religious foundations
the magnificent collection of early German and
Netherlandish paintings which they sold, in 1827,
to Ludwig I of Bavaria, the founder of the Alte
Pinakothek in Munich. Two years later, Johann
David Passavant began to collect similar
'primitives' for the Städelsches Kunstinsitut in
Frankfurt. In 1835 Gustav Waagen, the Director of
the Altes Museum in Berlin and a leading authority
on early northern paintings, toured British
collections in preparation for his ground-breaking
Works of Art and Artists in England, which was
published three years later.

The beginning of widespread interest in
medieval art in Britain is usually associated with
the foundation of the Pre-Raphaelite Brotherhood
in 1848. However, the National Gallery's first
major primitive, Jan van Eyck's *Arnolfini Wedding*,
had been purchased as recently as 1842, and few
early paintings were publicly accessible at that
time. A rare exception was the group of pictures
assembled in 1804-16 by William Roscoe (1753-1831),
with the intention of 'illustrating the rise and
progress of Painting', then displayed at the
Liverpool Royal Institution, and now at the Walker
Art Gallery. The limited extent of the Pre-
Raphaelites' initial acquaintance with art of the
fifteenth century is apparent from the graded
canon of genius, proposed by Holman Hunt and
Rossetti in a surely unconscious *reprise* of de Piles'
Scale of Painters, which they described as:

... a list of Immortals, forming our creed ... The list
contains four distinct classes of Immortality; in
the first of which three stars are attached to each
name, in the second two, in the third one, and in
the fourth none.[38]

The 57 names were headed by Jesus Christ,
followed by Shakespeare and the author of the
Book of Job. The list was dominated by poets and
novelists, ranging from Isaiah and Homer through
the likes of Dante, Chaucer, Spenser and Milton,
to such recent figures as Goethe, Byron and Keats,
and even contemporaries – Thackeray, Longfellow
and Robert Browning. Of the 12 visual artists on the
list, only Leonardo da Vinci received two stars, and
Raphael and Fra Angelico were awarded one each.
Most, including Michelangelo and Tintoretto as
well as Giorgione and Titian, were High Renaissance
painters. Surprisingly, the most recent artists were
Poussin, Hogarth and Flaxman.

In 1855, Sir Charles Eastlake (1793-1865) began a
decade as Director of the National Gallery, and its
collection of early panel paintings grew rapidly.
Analogous developments occurred from 1851 at the
British Museum, where Augustus Wollaston Franks
(1826-97) expanded into areas which had previously
been ignored, notably British and medieval
antiquities, pre-history, ethnography and Islamic
and Oriental art.[39]

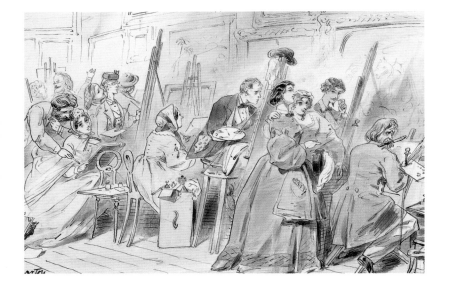

Florence Claxton
(c.1838-89)
*Art Students (South
Kensington)*, 1861
Watercolour and ink
on paper,
15.2 x 23.5cm
Purchased, 2004
E.3613-2004
This lively caricature
shows artists copying
paintings in the
packed display at
the Sheepshanks
Gallery in the South
Kensington Museum,
which opened in 1857.
It was published as
a wood engraving in
The Queen, a ladies
newspaper, in 1861.
The stereotypes of
female artists range
from the bespectacled
professional (on
the left), to the
flirtatious dilettantes
(right) distracting
male students.

At South Kensington, initially under the leadership of the curator John Charles Robinson (1824-1913), collections were assembled which remain definitive in many fields, from European ivory and Italian sculpture to British, Indian and Far Eastern applied arts. Robinson's taxonomic principles were also reflected in his acquisition of painted artefacts, ranging from Florentine birth trays and *cassone* panels, to detached frescoes and entire polyptychs from Valencia and North Germany.

The growing extent of the V&A's collection, and the expertise of its staff, contributed to the definition of artistic canons in new areas which included Persian paintings, Mughal and Khaligat miniatures and Japanese woodcuts, as well as European stained glass and decorated pottery and porcelain.[40] In narrower pictorial terms, the museum's principal contribution was to the study of British watercolours and portrait miniatures. Modern British painting remained an important area of concern until the opening of the Tate Gallery in 1897.

By this time the current agenda had moved on, to address the often uneasy relationship between official taste and 'modern foreign' art in general, and French Impressionism in particular.[41] For this reason, the pictures by Delacroix, Corot, Courbet, Daumier, Millet and Degas, bequeathed by the

Anglo-Greek stockbroker Constantine Alexander Ionides (1833-1900) to the V&A in 1901, arrived at a significant time.[42] Impressionist paintings had been exhibited widely and purchased throughout Europe since the 1870s, but few were displayed in public museums prior to 1896 when Hugo von Tschudi (1851-1911) began a systematic series of acquisitions for the Berlin Nationalgalerie, which brought him into conflict with Kaiser Wilhelm II. In 1905 a major loan exhibition of Impressionist and Post-Impressionist paintings was held at the Grafton Gallery, in London. This inspired the critic Frank Rutter to raise £160 in order to purchase Monet's *Vétheuil: Sunshine and Snow* for presentation to the National Gallery. However, as he then discovered:

A horrible snag loomed ahead. In those days London had no gallery of Modern Foreign Art. The National Gallery could not accept for exhibition work by any living artist. Monet was still alive. So was Renoir. So was Degas. There was no place for any of them in London except South Kensington ... I had to give up my idea about Monet. But, I reflected, Manet, Sisley and Pissarro are all safely dead; what about a painting by one of them? ... "It will be difficult ... they will think them too 'advanced' ... the Trustees of the National Gallery ... will go as far as Boudin."[43]

The irrelevance of such sensibilities to progressive taste was amply demonstrated by Roger Fry's Post-Impressionist Exhibitions, also held at the Grafton Galleries, in 1910-11 and 1912. By this date, the Irishman Sir Hugh Lane (1875-1915) and the Welsh sisters Gwendoline (1882-1952) and Margaret Davies (1884-1963) had acquired significant modern French pictures which were exhibited in Dublin and Cardiff.[44] Lane promised a 'Conditional Gift of Continental Paintings' to an embryonic 'Gallery of Irish and modern art' in Dublin, only to bequeath it instead to the National Gallery when Dublin Corporation seemed to waver in its intention of providing a new building. With the token exception of the Ionides Bequest at South Kensington,

modern Continental painting continued to be eschewed by the London museums until 1917, when the Tate's remit was extended to include it.[45]

This enabled two groups of paintings to be brought together at Millbank, the Barbizon pictures bequeathed to the National Gallery by George Salting (1835-1909), and the Lane Bequest which included works by Corot, Courbet, Daubigny, Daumier, Bonvin, Boudin, Manet, Monet, Pissarro, Renoir and Vuillard. The art dealer Sir Joseph Duveen contributed a picture by Gauguin, and he paid for an extension to the Tate, encouraging Samuel Courtauld (1876-1947) to contribute £50,000 towards major paintings by Manet, Monet, Renoir, Degas, Sisley, Pissarro, Seurat, Cézanne, Van Gogh, Utrillo, Bonnard and Toulouse-Lautrec. The inauguration of the Modern Foreign galleries at the Tate, in 1926, marked the assimilation by the British cultural establishment of what Courtauld called 'the great Frenchmen of the latter half of the nineteenth century'. The extent to which officialdom continued to lag behind the avant-garde is apparent from the two decades which had by then elapsed since Picasso's discovery of African sculpture at the Trocadéro in Paris.

In the 1920s Picasso adopted a severe and monumental figurative style, indebted to Poussin, Renoir and Cézanne, while continuing to work simultaneously in his earlier Cubist mode. He justified this dichotomy with the disarming observation:

The several manners I have used in my art must not be considered as an evolution, or as steps towards an unknown ideal of painting ... If the subjects I have wanted to express have suggested different ways of expression I have never hesitated to adopt them ... This does not imply either evolution or progress, but an adaption of the idea one wants to express and the means to express that idea.[46]

During a long career, Picasso changed his style with sometimes bewildering frequency and rapidity. Nevertheless, his Cubist mode was deemed his fundamental contribution to the modern canon promoted by Alfred H. Barr at the Museum of Modern Art in New York, which, in 1936, mounted the seminal exhibition *Cubism and Abstract Art*. The Second World War limited the progress of modernism in Britain for a further decade, until the *Picasso-Matisse Exhibition* was held at the V&A before visiting Manchester and Glasgow in 1945-6.[47]

Just as the loan exhibitions of Impressionist and Post-Impressionist art at the Grafton Gallery between 1905 and 1912 had polarized the opinion of an earlier generation, so the furore aroused by the *Picasso-Matisse Exhibition*, and the later Paul Klee and Marc Chagall shows, marked a watershed in the acceptance of the avant-garde. Thereafter, under the leadership of the art critic and sometime curator of ceramics at the V&A, Sir Herbert Read (1893-1968), and Sir John Rothenstein (1901-92), Director of the Tate from 1938 until 1964, the future of modernism in Britain was assured. By the 1980s the Tate's collection had outgrown its original home, and in 2000 Britain's own national museum of modern art finally opened at Tate Modern.

Although the art critic Clement Greenberg (1909-94) could powerfully assert the historical inevitability of abstract expressionism as a manifestation of the inherent flatness of painting, the sheer complexity and multiplicity of post-war developments has eroded the grip of such fixed values. In the face of a present flux whose only constant seems change, unimpeachable originality has become the ultimate canon of contemporary art. This is validated less by admission to a 'pantheon' represented by the permanent collections of museums, than through sales to private collectors, such as Charles Saatchi, whose names have become a byword for modernity, and success at prestigious competitions including the Turner Prize, held at Tate Britain since 1983. The role of a 'universal' art museum, encumbered by the cultural baggage of past centuries and distant cultures may, at first sight, appear marginal in such a context. However, as the barriers disintegrate between previously separate art forms and modes of expression, the formative significance of such institutions as the V&A for future generations of artists seems assured.

2 Painting Before the Invention of Art

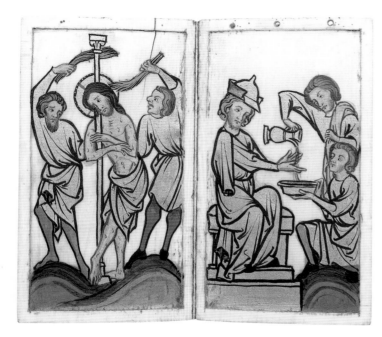

Above: German (Lower Rhine or Westphalia) *c.*1330-40
The Flagellation and Pilate washing his hands
Leaves of a devotional booklet
Painted and gilded elephant ivory,
10.5 x 5.9cm (each leaf)
Purchased, 1872
11-1872
As the seat of an archbishop and a major trading city, Cologne was one of the principal artistic centres of the Holy Roman Empire. Although the carved cover of this ivory picture book is stylistically indebted to Paris, its paintings are characteristic of the Cologne school. It apparently belonged to a monk, and would have been used as a devotional aid to encourage meditation on the suffering of Christ.

Right: English (Canterbury), *c.*1155-60
Leaf with scenes from the Passion, from the Eadwine Psalter
Ink, tempera and gold leaf on vellum,
40 x 30cm
Purchased, 1894
816-1894 (MS 661)
This illuminated leaf comes from a copy of the Psalms written by the scribe Eadwine, a monk at Christ Church Canterbury, which is now in Trinity College, Cambridge. It formed part of the most extensive cycle of the Passion of Christ made in 12th-century England. These miniatures are based on pen drawings in an earlier manuscript, the Utrecht Psalter, made near Rheims around 820.

In the thousand years and more between the establishment of Christianity as the state religion of the Roman Empire, and the Renaissance and Reformation, the concept of 'art' as we understand it did not exist.[1] While countless artefacts produced during this period are now prized for their superlative aesthetic quality, conspicuous display of creativity and profound insight, their makers and original users would not have regarded these masterpieces as creations to be valued for their own sake. The power of medieval images lay in how effectively they embodied the values of a hierarchical society.

The unique balance between naturalism and idealization attained by the painters and sculptors of classical Greece was communicated to the artists of the Roman world, who explored a stricter vein of realism. In turn, the Christian Empire became heir to the literary and artistic achievements of pagan antiquity. Byzantine writers continued the classical tradition of *ekphrasis*, the rhetorical description of a work of art, which was rediscovered by humanist scholars during the Renaissance. While such texts suggest that art should be true to nature, from the outset Byzantine painting demonstrated a tendency towards the abstract and hieratic. This quality, which it shares with early medieval western art, seems to emphasize the inner essence of things rather than their outward appearance. This was firmly stated by the influential fourth-century Bishop Eusebius of Caesarea:

I do not know what impelled you to request that an image of Our Saviour should be delineated. What sort of image of Christ are you seeking? Is it the true and unalterable one which bears His essential characteristics, or the one which He took up for our sake when He assumed the form of a servant?[2]

The principal justification of religious art was formulated around 600 by Pope Gregory the Great. He wrote, 'what writing is to the reader, painting is to the uneducated' who 'can "read" a

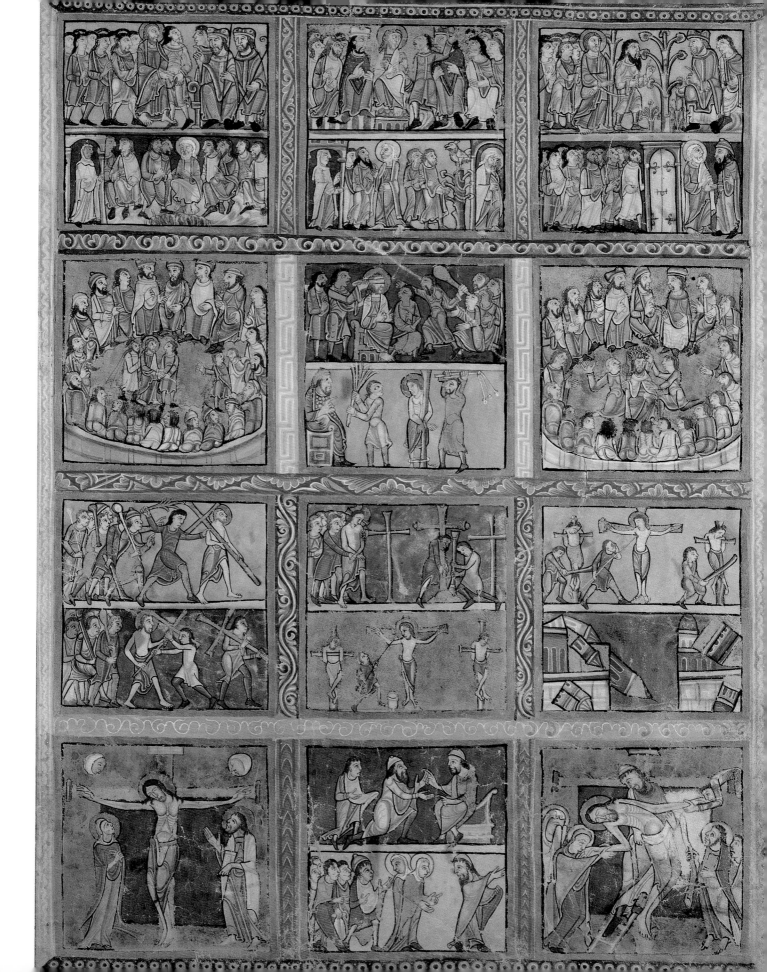

painting even if they do not understand letters'.[3]

After the fall of Jerusalem to Islam in 638, Rome was confirmed as the spiritual capital of Christendom. It was visited no less than five times by the Anglo-Saxon abbot Benedict Biscop, who acquired icons and illuminated manuscripts for copying in his native Northumbria. With the establishment of the Holy Roman Empire in the eighth century, Charlemagne's court became a major artistic centre, providing employment for painters who had fled the iconoclastic controversy in Byzantium which caused the suppression of religious pictures there from 726 until 843. After the reassertion of Orthodoxy, a distinction was formulated between idolatory and the Christian veneration of icons which remains current in the Catholic and Eastern churches. The limits of Christendom were defined by the civilizations which lay beyond its borders. Although the Islamic prohibition of figurative art limited the scope for artistic interchange, works of applied art by Muslim craftsmen were prized in the West.

In the twelfth century, the puritanical Cistercian St Bernard of Clairvaux railed against the 'vanity of vanities' of a 'church ... resplendent in her walls' but 'beggarly in her poor' who 'clothes her stones in gold, and leaves her sons naked'.[4] His urbane contemporary, Abbot Suger of St Denis, celebrated sacred ornaments 'of marvellous workmanship and lavish sumptuousness' and had inscribed above the new entrance to his abbey church the aspiration that 'being nobly bright, the work should brighten the minds, so that they may travel ... to the True Light where Christ is the true door'.[5]

The word of the Gospel and the celebration of the Mass lay at the heart of the Church. While affirming the centrality of 'a saintly mind, a pure heart, a faithful intention', Suger insisted 'that we must do homage also through the outward ornaments of sacred vessels, and to nothing in the world in an equal degree as to the service of the Holy Sacrifice, with all inner purity and with all outward splendour'.[6] As gold, silver and precious stones were regarded as a mundane equivalent to the celestial substance of 'the holy Cherubim and Seraphim', they were especially appropriate for the decoration of religious texts and liturgical artefacts.

One of the fullest accounts of medieval artistic methods appears in *The Various Arts*, a treatise by 'Theophilus', who was probably the early twelfth-century German goldsmith and monk, Roger of Helmarshausen. He believed that human activity represented 'participation in the wisdom and skill of the Divine Intelligence', and justified his work as showing, in some measure, 'the paradise of God', thereby encouraging compassion at the sight of the Passion, and virtue when reminding people of

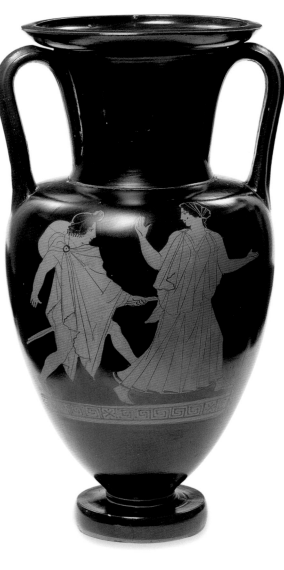

Greek (Athens), 450-40 BCE
Vase
Earthenware, painted in black slip, 34.3 x 17.8cm
Purchased, 1864
738-1864
Greek painted vases of this type were exported in large quantities to Italy during antiquity. Subsequently excavated from tombs, they were already being collected by the 13th century, and were long-believed to have been made by the ancient Etruscans. The English potter Josiah Wedgwood produced copies of such vases in the 18th century.

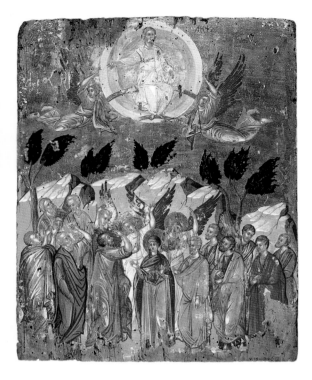

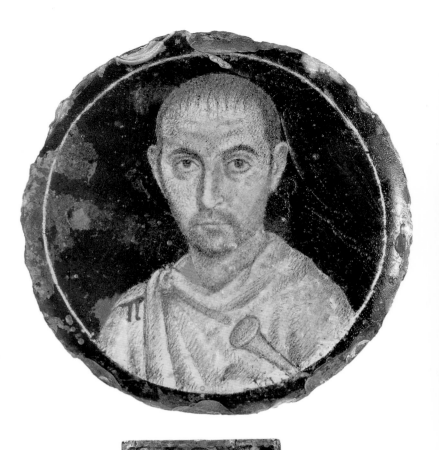

Above: Cretan, 15th century (second half)
The Ascension of Christ
Egg tempera on gold over gesso and canvas laid down on panel, 45.7 x 36.8cm
Bequeathed by Alex Tweedy, 1940
15-1940
Following the Latin conquest of the Byzantine Empire in 1204, Crete belonged to Venice. After the Fall of Constantinople to the Turks in 1453, it was the artistic centre of Greek Orthodoxy. This icon was one of 12 decorating the iconostasis, the screen separating the nave from the chancel of a Byzantine church.

Above, right: Roman, 3rd century AD
Portrait of a Man
Painted gold leaf fused between two layers of glass, diam. 4.4cm
Purchased, 1868
1052-1868
This highly naturalistic portrait medallion is of a type originally made to decorate the bottoms of glass vessels.

Many have been discovered in the Roman catacombs, where they marked the burial places of their owners. By the 7th century such portraits were sometimes revered as relics of early Christianity, and a similar one was re-used to decorate a processional cross.

Right: Italian (Umbria), *c.*1200
Crucifix, with the Virgin and St John
Tempera on canvas on panel, 218.5 x 171.5cm
Given by Lord Carmichael, 1900
850-1900
Large painted crucifixes were common in Italy between the early 12th and late 14th centuries, and were placed behind the altar or hung from the chancel arch. This example depicts Christ as though alive, accompanied by the sorrowing Virgin and St John. Related Passion scenes appear in the terminals: Christ with angels, the Harrrowing of Hell, the Holy Women at the Sepulchre and the Denial of St Peter.

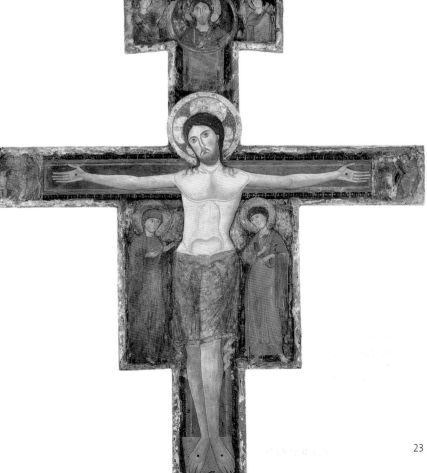

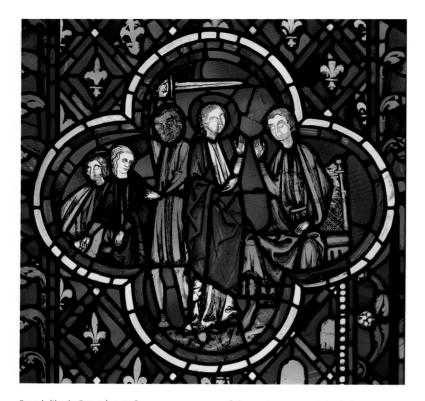

French (Ile-de-France), 1243-8
Scene from the Story of Daniel
From the Sainte-Chapelle, Paris
Panel, painted clear and colour glass,
122 x 85cm
Given by Henry Vaughan, 1864
1221-1864
The Sainte-Chapelle was built by Louis IX
to house prized relics, including the Crown

of Thorns. Enormous stained glass
windows flood its interior with richly
coloured light. This Old Testament scene
depicts the prophet Daniel interceding for
the wise men of Babylon. The fleur-de-lys
and castles in the decorative background
symbolize the alliance of France and
Castile through Louis' marriage to Blanche
of Castile.

the 'many torments the saints endured', 'the joys of heaven' and 'torments in the infernal flames'.[7]

The Various Arts describes the range of Romanesque art, from painting on wall, panel and manuscript, to making glass vessels and stained glass windows, metalworking in silver, gold and brass, the use of niello and enamel, as well as ivory carving and working with precious stones. Theophilus sought the best methods of Europe, Russia and Arabia, from 'whatever kinds and blends of various colours Greece possesses' to 'whatever France esteems in her precious variety of windows'.[8]

Few of the innumerable medieval churches decorated with murals survive intact, and almost no secular wall paintings earlier than the fourteenth century remain. In Northern Europe, stained and painted glass gives a clearer idea of the strong colours and complex subject matter of medieval monumental art, although the depredations of later reformers and revolutionaries have left an often misleading pattern of distribution. Our knowledge of medieval painting is principally dependent upon illuminated manuscripts, which ... across secular and religious themes, ... often datable from their textual co... heir fragile, water-based miniatures we... cted from light by their covers, and from d... ve zeal by their discreet location on librar... s.

As the principal reside... powerful monarch and the seat ... eatest university in Christendom, Paris was ... hallenged as the artistic centre of Europe from the accession of St Louis in 1226 until the resumption of the Hundred Years War in 1415. Today, the achievements of its painters are more apparent in the glittering stained glass of the Sainte-Chapelle or the lavishly decorated books of hours made for members of the French court, than the panel painting of Jean II in the Louvre, one of the earliest surviving independent portraits since classical antiquity.[9]

Although holy images provided a focus for piety, panel painting remained a secondary medium until the fourteenth century. The Latin occupation of Constantinople from 1204 until 1261 facilitated the import of icons to the West. Their arrival coincided with the foundation of the mendicant orders, which promoted the humanization of Christ, the Virgin and the saints, and the elaboration of religious stories. A fascination with symbolism and allegory stimulated the use of pictorial imagery.

Especially in the burgeoning cities of Tuscany and Northern Italy, a wide range of new pictorial genres appeared, from monumental crucifixes to small devotional diptychs, and from processional banners to multi-panel altarpieces of considerable scale and complexity. Such works were often

Below: Nardo di Cione (active 1343-65/6)
The Coronation of the Virgin
Tempera on poplar panel, 118 x 77.5cm
Bequeathed by Constantine Ionides, 1901
CAI. 104
Nardo di Cione belonged to a family of
Florentine artists, and his subject here
was popular in 14th-century Italy. Painted
around 1360, this panel was the centre-
piece of a triptych which may have been
created for the Florentine monastery
of Santa Maria degli Angeli. The panel
originally had wings depicting saints,
and has been reduced at the bottom where
figures of angels may have appeared below
the main figures.

Above: Italian (Umbria), mid-14th century
The Nativity
Painted and gilded glass, 12.8 x 8.5cm
Bequeathed by George Salting, 1910
C.2484-1910
The technique of drawing in reverse on
glass, which was subsequently gilded and
painted with a dark background colour, is
described around 1390 by Cennino Cennini.
It was commonly used in 14th-century
Umbria, mainly for Franciscan patrons, as
an economic substitute for enamelled
metalwork. *The Nativity* probably formed
half a small diptych, including an image
of the Crucifixion.

French (Paris), *c.*1350
Decorated text page with the initial 'O',
(detail)
Leaf of a missal, fol.261r
Ink, tempera and gold leaf on vellum,
23.3 x 16.4cm
Purchased, 1891
MSL 1891-1346

This missal was made for the French
Royal Abbey of Saint-Denis. The grisaille
decoration is by a student of the court
painter Jean Pucelle (d.1333/4), and depicts
scenes from the life of King Dagobert. The
vigorously modelled figures and structures,
were inspired by Tuscan paintings.

Tuscan painters of the later thirteenth and early
fourteenth centuries permeated the more courtly
artistic milieux of France, England, the Holy
Roman Empire and the Iberian Peninsula. This
was accompanied by an expanding range of
subject matter and a taste for iconographic
experimentation.

Meanwhile, the inter-dependence of aristocratic
courts and merchant communities facilitated the
mobility of artists. For example, the Westphalian
Master Bertram of Minden may have studied at
the Imperial capital Prague before settling in the
trading city of Hamburg and making a pilgrimage
to Rome, while the Florentine Gerardo Starnina
(c.1354-1413) and the German Andres Marzal de
Sas were leading painters in the thriving Spanish
maritime city of Valencia. Such artists achieved a
balance between naturalism of detail and
idealization of form and colour, which was a
defining characteristic of most schools of painting
in western Europe around 1400.

Surviving treatises indicate that artistic practice
remained empirical. The anonymous late
fourteenth-century author of *On the art of
illuminating* began with an invocation to the
Trinity and a reference to Pliny's theory of primary
colours, but his text is essentially an account of the
manufacture of different pigments and binding
media.[10] The rather later and better known *Book
of Art*, by the Florentine painter Cennino Cennini
(c.1370-1440), was a more ambitious undertaking,
covering every aspect of the manufacture of panel
painting, with advice on drawing, fresco painting
and illumination, as well as painting on textiles,
using gold on glass, and designing for embroidery,
mosaics, gilding and casting.

The humanist, architect and art theorist Leon
Battista Alberti (1404-72) would have subscribed to
Cennini's assertion that painting 'justly deserves
to be enthroned next to theory, and to be crowned
with poetry'. Leonardo da Vinci (1452-1519) later
echoed his boast, 'let me tell you that doing a panel
is really a gentleman's job, for you may do anything
you want to with velvets on your back'.[11] While

commissioned by wealthy magnates and urban
confraternities instead of the church. Painted
images also migrated from an ecclesiastical to a
domestic setting, and though secular professionals
gradually replaced the monks who had previously
dominated artistic production, artists with a
spiritual vocation certainly still existed. For
example, the painters and illuminators at the
Florentine monastery of Santa Maria degli Angeli
included Silvestro dei Gherarducci, who later
became its prior.

The revolution in artistic naturalism and the
representation of pictorial space pioneered by

Silvestro dei Gherarducci (1339-99)
Decorated text page with the initial 'S',
c.1392-9
From a gradual made for San Michele a Murano, Venice
Ink, tempera and gold leaf on vellum, 57.5 x 40cm
Acquired by 1863
3045 (MS 965)
At the Camaldolese monastery of Santa Maria degli Angeli in Florence, Silvestro dei Gherarducci decorated manuscripts for houses of his order as far away as Venice. This page from a gradual, with the parts of the Mass to be sung by a choir, bears the initial 'S', marking the beginning of the Mass for the Pentecost. Above, the Virgin prays with the Apostles, while below the elders of all nations await the descent of the Holy Spirit.

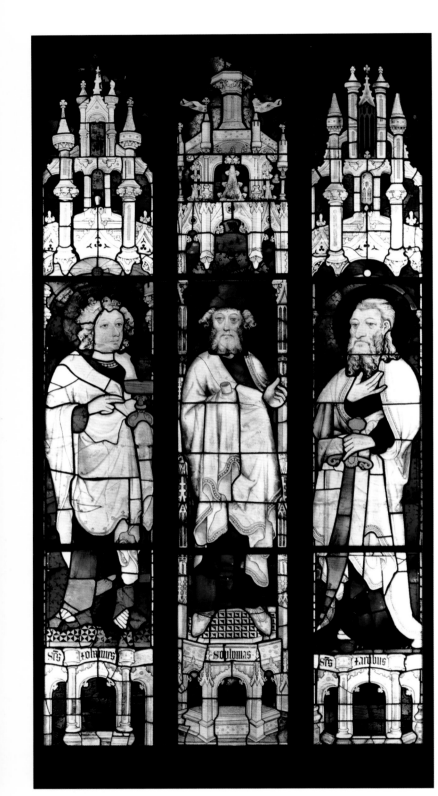

Left: Thomas Glazier of Oxford (active 1380–after 1404)
The Prophet Ezekiel flanked by St John the Evangelist and St James the Less
Lights from the windows of Winchester College Chapel, probably *c.*1393
Panels, painted and stained clear and coloured glass, overall 357 x 165cm
Purchased, 1855
4237-1855
Winchester College was founded by William of Wykeham (1324-1404), Lord Chancellor of England and Bishop of Winchester. Its windows by Thomas Glazier were brought by cart from Oxford in 1393. These lights were not originally juxtaposed; the windows flanking the altar were dedicated to the Apostles, with figures of prophets above. White glass predominates in English windows of the later 14th century.

Below: Italian (Siena), 1402
Tavoletta di Biccherna
Tempera on panel,
43.8 x 31.5cm
Purchased, 1892
414-1892
Between the 13th and early 16th centuries, the account books of the city of Siena were given painted covers. This example, for the period January-July 1402, depicts its chief official Niccolò di Lorenzo della Gazaia and a scribe making a payment to three clients. Above are the arms of Siena, and below those of della Gazaia and the five officials responsible for receiving incoming payments.

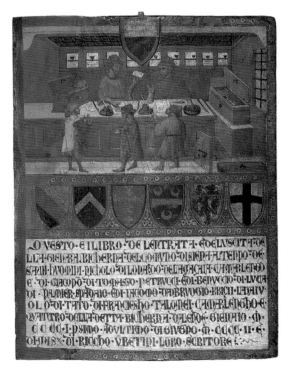

Cennini's emphasis on the primacy of drawing, study from nature, and the fundamental role of the imagination all seem to anticipate Renaissance theorists, his advice that 'a good style for mountains' could be based on the copying of large stones is indicative of his actual limitations.[12]

The greatest advance in naturalistic painting for over a millennium occurred in the Netherlands during the second quarter of the fifteenth century. This was recognized in 1456 by the Genoese humanist Bartolomeo Fazio, who praised the Flemish painter Jan Van Eyck (c.1395-1441) as 'the leading painter of our time', but mistakenly believed him 'to have discovered many things about the properties of colours recorded by the ancients and learned by him from reading Pliny and other authors'.[13] Since Vasari, commentators have tended to equate the revolutionary new developments in fifteenth-century North European art with the supposed invention of oil paint. However, the mixing of pigment with oil to make paint was already known to Theophilus, and this medium was utilized, for example, in the late thirteenth-century retable at Westminster Abbey. The innovation of the early Netherlandish masters lay in their meticulous working method, which combined exploitation of the transparency of oil with painstaking observation and often detailed under-drawing.

North German, c.1400
Altarpiece with scenes of the Apocalypse (central panel)
Tempera and gold leaf on panel, transferred to canvas, overall 137 x 236cm
Purchased, 1859
5940-1859
This triptych was painted by a follower of the leading Hamburg painter Master Bertram (active 1367-1415). The combination of the unusual subject of the Apocalypse with the legend of its traditional author, St John, (which appears with that of St Giles on the outer shutters) suggest that it was made for the Cistercian convent of St John in Lübeck. Its immediate textual source was an earlier commentary on the Apocalypse by a North German Franciscan friar.

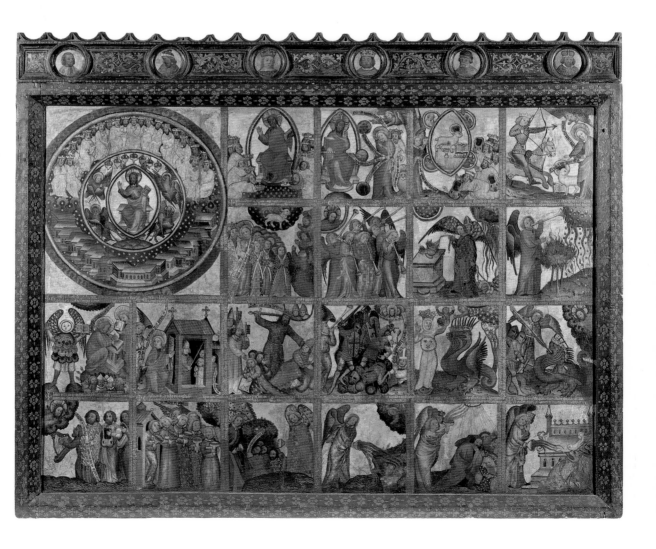

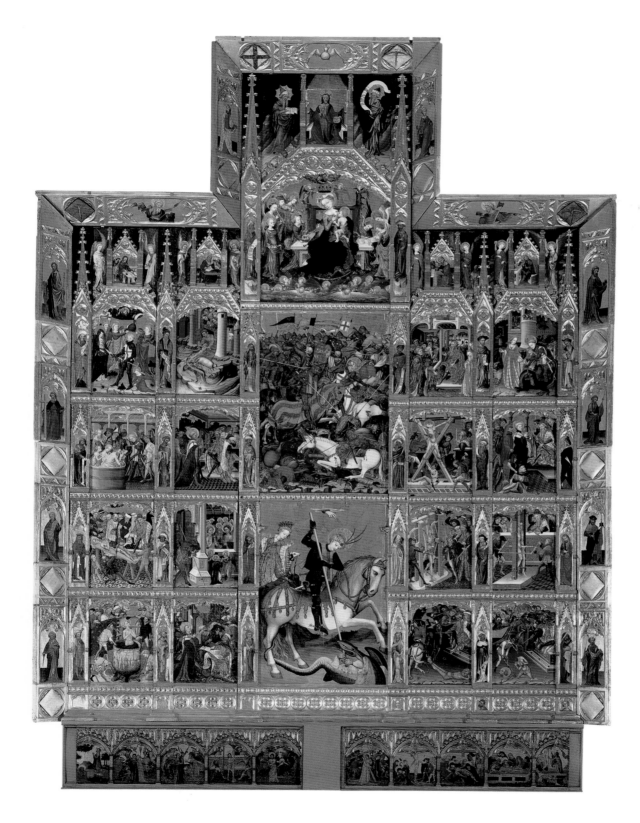

Marzal de Sas
(active 1393–
after 1410)
*Altarpiece of St
George*, c.1410
Tempera and gilt on
pine panel,
660 x 550cm
Purchased, 1864
1217-1864
The German Marzal
de Sas settled in
Valencia, and the
format of this large
altarpiece is
characteristically
Spanish. It was
commissioned by
a confraternity of
Valencian militia
dedicated to St
George. The central
panels depict Christ,
the Virgin and
Child, a 13th-century
Aragonese victory
over the moors, and
St George. The
smaller panels depict
the legend of St
George, the Passion
of Christ, prophets
and saints.

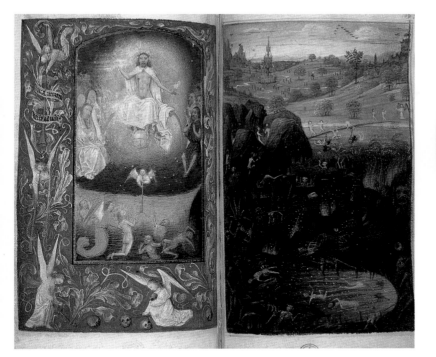

Above: Netherlandish (Bruges), 1470s
The Last Judgement facing Heaven and Hell
Miniatures in a book of hours, fols.152v-153r
Ink, tempera and gold leaf on vellum,
each leaf 11 x 7.6cm
Bequeathed by George Salting, 1910
Salting 1221
Nine of the 13 miniatures in this book were
painted by Simon Marmion, in
Valenciennes, on loose leaves which were
shipped to Bruges for binding. This unusual
double opening was added by another
Flemish master, using the blank reverse of
Marmion's *Raising of Lazarus* for his scene
of *Heaven and Hell*. They illustrate the
Office of the Dead in this prayer book.

Above, right: Spanish (Málaga), c.1425-50
Bowl with a picture of a Portugese carrack
Tin-glazed earthenware decorated with
golden-brown lustre and clear greyish-blue,
diam. 51.2, height 20.1cm
Purchased, 1864
486-1864

This deep lustreware bowl is a masterpiece
of Moorish craftsmanship. Its centre
depicts a three-masted ship, with the arms
of Portugal on its sail, and dolphins in the
sea. The shape is typically Andalusian, and
its decoration recalls earlier bowls from
Mallorca and Tunisia. Málaga was a Muslim
city from the 8th century until 1487, when it
fell to the Christian kings of Spain.

Right: Netherlandish, c.1475-1500
June, and the thirty-six year old
Roundel, painted and stained clear glass,
diam. 20.3cm
1239-1855
The subject of this roundel is a merchant
doing his accounts as he weighs goods on a
scale. A later version of the composition
bears an inscription around the outer edge:
'At the age of 36 one has to work for profits,
as we typify the month of June'. This
indicates that it belonged to a series of 12
images of the Ages of Man, characterized
as the months of the year.

Many fifteenth-century North European masters
were accomplished in the related media of
distemper on cloth and manuscript illumination in
watercolour on vellum. Others excelled as painters
and designers of stained glass, tapestry and
embroidery. In the third quarter of the century,
the recent inventions of copper-plate engraving
and woodcut illustration disseminated subject
matter more widely than had previously been
possible. This included realistic portraiture, as well
as religious, historical and mythological themes
which painters enlivened with breathtaking
landscapes, arresting still lifes and spectacular
effects of light and atmosphere.

The Netherlands, in particular, enjoyed an
international reputation as an academy of
painters and commercial centre of works of art.

Master of the St Ursula Legend (active c.1480-1510)
The Martyrdom of St Ursula and the 11,000 Virgins, c.1492-6
Oil on canvas, 165 x 186.7cm
Purchased, 1857
5938-1857
This is the principal painting in a series of 19 depicting the legend of St Ursula, commissioned by the brothers Wynant and Heinrich von Wickroid of Cologne. They and their wives Lysbet and Hilgen are depicted at the bottom. According to legend, St Ursula and her companions were massacred by the Huns outside Cologne. In the background is a panorama of the city as it appeared in the 15th century.

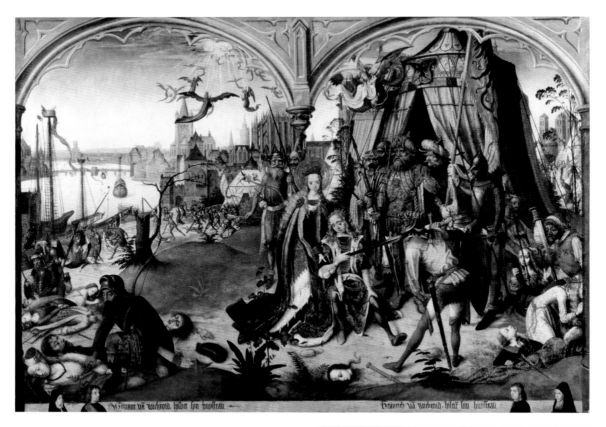

Right: Carlo Crivelli (active 1457-94)
Virgin and Child
Tempera on panel, 48.5 x 33.6cm
Bequeathed by John Jones, 1882
492-1888
The Venetian painter Carlo Crivelli worked mainly at Ascoli Piceno in the Marches of Central Italy. In this provincial region, a conservatively minded public prized his highly decorative religious works, enriched with gilded gesso patterns. This small painting was probably intended for private devotion. Its various fruits and flowers are symbols of Christ and the Virgin, while the fly at the right alludes to mortality.

In Nuremberg, Albrecht Dürer (1471-1528) recalled how his father, who was originally from Hungary, had spent 'a long time with the great artists in the Netherlands'.[14] Flemish paintings were especially influential in Spain, and a contract of 1488 from Toledo specified that an altarpiece should be 'of brushwork of the very fine order of the new art and of very fine colours, worked in oil ... and graceful foreign faces'.[15] A letter of 1435 from Philip the Good, Duke of Burgundy, written at a time when art criticism remained almost unknown, nevertheless indicates an appreciation of Van Eyck's unique artistic qualities: '...we would retain him for certain great works ... and we would not find his like more to our taste, one so excellent in his art and science'.[16] In time, the culture of humanism fostered a purely aesthetic rationale for patronage and collecting, but the traditional, religious function of works of art endured, and fuelled a bitter controversy about the validity of images during the Reformation.

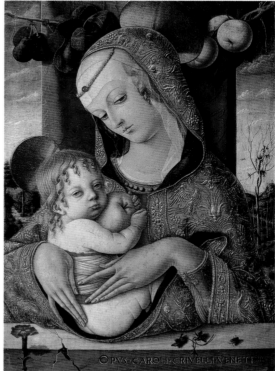

Jean Bourdichon (1457-1521)
The Nativity, c.1499
Miniature from a book
of hours
Ink, tempera and gold leaf
on vellum, 29.3 x 17cm
Purchased, 2003
E.949-2003
Bourdichon worked
in Tours for four
kings of France. The
Nativity belonged to a
prayer book made for Louis
XII. Its dramatic lighting
expresses St Bridget's
account of how the Christ
Child 'radiated such an
ineffable light and
splendour, that the sun
was not comparable to it,
nor did the candle, that St
Joseph had put there, give
any light'. The painted
frame imitates that of
a panel painting.

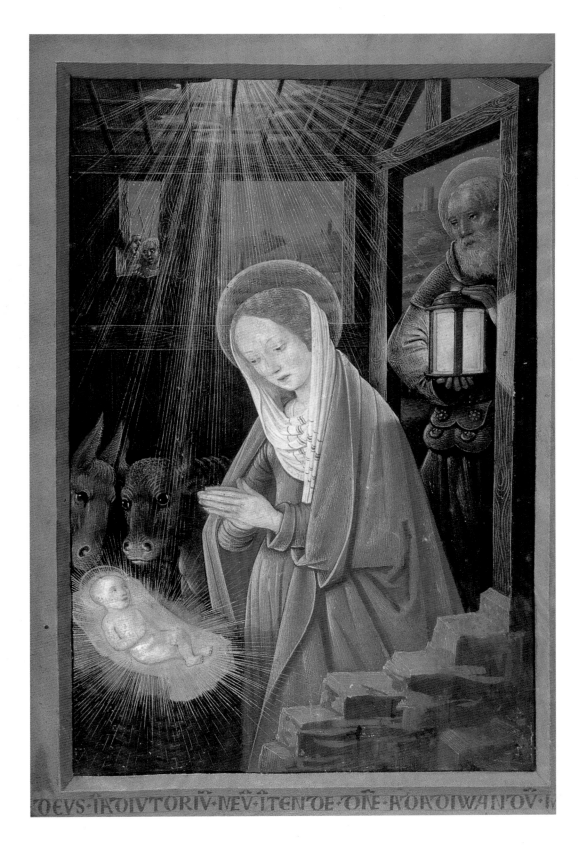

3 Images of Splendour and Significance

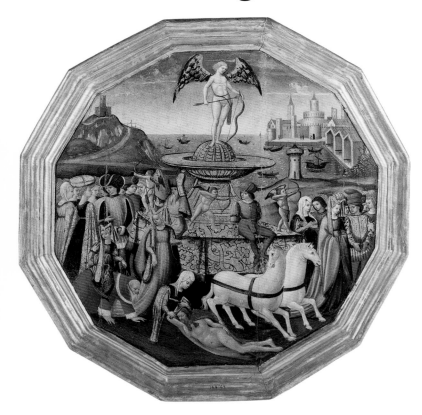

Above: Apollonio di Giovanni (1415-65)
Birth tray with The Triumph of Love
Tempera on poplar panel, diam. 59.7cm
Purchased, 1869
144-1869
Cupid in his triumphal chariot is a common subject in *deschi da parto* (birth trays). The subject derives ultimately from Petrarch, and is here accompanied by two representations of female domination: the courtesan Phyllis riding on the back of Aristotle, and Delilah cutting Samson's hair. The arms of Samminiato and Gianfigliazzi on the reverse may have been repainted to commemorate a marriage in 1537.

Right: Simon Benninck (1483-1561)
The Month of May, c.1550
Ink and tempera on vellum, 14 x 9.5cm
Bequeathed by George Salting, 1910
E.4575-1910
Full-page miniatures of the activities of the *Months* began in the early 15th century with the *Très Riches Heures* of Jean de Berry. This scene of people making merry in May is one of eight surviving from a calendar cycle. They are among the most ambitious landscapes found in Flemish miniature painting. Such compositions were influential on Pieter Bruegel, but were mocked by Michelangelo.

The revival of interest in the culture of antiquity, which began in Italy in the fifteenth century, was accompanied by an explosion in the demand for works of art. Much more was spent by a wider range of patrons on a growing range of artefacts, which were increasingly made for secular use. In an era when labour costs were comparatively low, the expense of pictures remained modest in comparison with works made from precious or exotic materials.

This emergent 'culture of consumption' differed considerably from the narrower, primarily ecclesiastical and courtly outlook which had characterized the taste of an earlier Italian elite, and which was still the norm in northern Europe.[1] Writing in the 1460s, the sculptor Antonio Filarete (c.1400-69) felt no need to excuse the time spent by the invalid Piero de' Medici admiring works of art in his study:

... when it is a matter of acquiring worthy or strange objects he does not look at the price ... he has such a wealth and variety of things that if he wanted to look at each of them in turn it would take him a whole month and he could then begin afresh, and they would again give him pleasure since a whole month had now passed since he saw them last.[2]

Humanists justified magnificence as a virtue with an argument from Aristotle's *Nicomachean Ethics* which ran, '... great expenditure is becoming to those who have suitable means ... for all these things bring with them greatness and prestige'.[3]

The ancient authorities Pliny and Quintilian had praised the art of painting, and the poet Petrarch already used classical terms in the fourteenth century to praise the pictures of his friend Simone Martini (c.1284-1344).[4] A century later, painters and sculptors began to appear beside orators, lawyers and princes in exemplary compendia of *Famous Men*.[5] As works of art took on a new significance for humanist commentators, so they acquired enhanced status in the eyes of a new generation of patrons. When consulted about the new bronze

doors for the Florence Baptistery, the humanist and politician Leonardo Bruni replied that they:

... should mainly have two qualities; one that they should show splendour, the other that they should have significance. By splendour I mean that they should offer a feast to the eye through the variety of design; significant I call those which are sufficiently important to be worthy of memory ...[6]

The treatise *On painting*, written in 1435-6 by the humanist and architect Leon Battista Alberti was a new departure in literature on art, albeit founded on unimpeachable antique sources. Claiming to be 'the first to write of this most subtle art', its author begged to be considered 'not as a mathematician but as a painter'.[7] The first section of his book comprises the earliest

Below: Luca della Robbia
(1400-82)
October
Roundel from the study of Piero de' Medici, c.1450
Tin-glazed terracotta, diam. 60.3cm
Purchased, 1861
7641-1861
Luca della Robbia worked principally in the new technique of tin-glazed terracotta. This is one of 12 roundels of the Months from the ceiling of the study of Piero de' Medici. The room was described as '... most ornate ... with glazed terracotta made in fine figures so that it causes admiration in anyone who enters it.' These roundels are similar to those which decorate the calendars of books of hours.

Above: Donatello
(1386/7-1466) and Paolo di Stefano (1397-1478)
Virgin and Child in a contemporary frame painted with figures of Eve, God the Father and Angels bearing a canopy, c.1435
Painted and gilded stucco and painted wood, 36.2 x 17.8cm (overall) Given by the National Art Collections Fund in memory of Lord Carmichael of Skirling, 1926
A.45-1926

The relief is a cast from a bronze plaquette, and was originally protected by closing wings which have been lost. Eve is represented as the mother of Mankind, whose sins were redeemed by the Child of the Virgin, 'the second Eve'. The Florentine Paolo di Stefano specialized in small-scale painting and manuscript illumination. He was a follower of Masolino and was acquainted with the painter Masaccio; another leading figure in the Florentine avant-garde.

**Sandro Botticelli
(1444/5-1510)**
*Portrait of a lady
known as Smeralda
Bandinelli*, 1470s
Tempera on poplar
panel, 65.7 x 41cm
Bequeathed by
Constantine Ionides,
1901
CAI. 100

According to an old
inscription, of
questionable
accuracy, this work
depicts the
grandmother of the
sculptor Baccio
Bandinelli. The lady
is simply attired, in a
loose cotton dress
over an expensive red
gown. This likeness
has a conscious
indoor feel, and the
device of a window
embrasure
emphasizes its
domesticity. Earlier
Florentine portraits
had been painted in
profile. This three-
quarter turned pose
was revolutionary.

Below: Giuliano Amedei
(active 1446-96)
Initial 'M' historiated with a
scene of painters at work,
1460s
Detail of a decorated text
page from a copy of Pliny
the Elder, Historia naturalis,
fol. 485r.
Ink, tempera and gold leaf
on vellum, 42.5 x 30cm
Purchased, 1896
MS A.L.1504-1896
Pliny's encyclopaedic *Natural
History* dates from the 1st
century AD, and was much
read by humanist students of
antiquity. This copy was made
for Gregorio Lolli Piccolomini,
a secretary of Pope Pius II.
It abounds in illustrations
of geography, zoology and
botany. This decorated letter
depicts painters at work on
a ceiling and *cassoni*, and
grinding colours. The patron's
coats of arms appear at
centre-right.

Right: Apollonio di Giovanni
(1415-65)
*Cassone panel with The
Generosity of Scipio*, c.1460
(detail)
Tempera on poplar panel,
43.5 x 134cm
Purchased, 1859
5804-1859
The subject of this panel,
derived from Livy's account of
the life of the Roman general
Scipio, was highly appropriate
for a wedding gift. It appears
in several cassone panels by
Apollonio di Giovanni. On the
left, after his capture of
Carthago Nova, Scipio returns
a rich ransom to the family of
a beautiful girl. She is
reunited with her betrothed,
and their wedding is depicted
to the right.

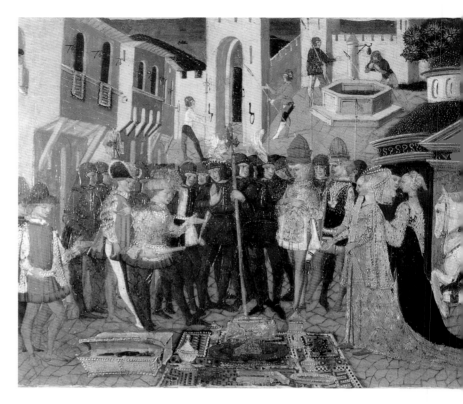

systematic account of one-point perspective.
Its analytical tone, when compared with earlier
'recipe books' on painting, is apparent from the
following passages:

The painter is concerned solely with representing
what can be seen ... The outline and the surface ...
take their variations from the changing of place
and of light ... This has to do with the power of
sight, for as soon as the observer changes his
position these planes appear larger, of a different
outline or of a different colour ... Shade makes
colour dark; light, where it strikes, makes colour
bright ... nothing can be seen which is not
illuminated and coloured ... In shadows colours
are altered ... Thus all things are known by
comparison, for comparison contains within itself
a power which immediately demonstrates in
objects which is more, less or equal ... Know that
a painted thing can never appear truthful where
there is not a definite distance for seeing it ... the
best artist can only be one who has learned to

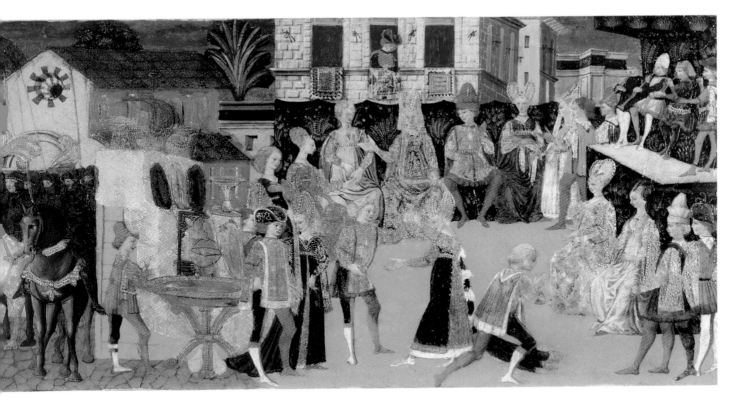

understand the outline of the plane and all its qualities.[8]

The second part of Alberti's book characterizes the elements of design as outline drawing, composition, and the depiction of tone and hue. It boldly asserts:

All the smiths, sculptors, shops and guilds are governed by the rules and art of the painter. It is scarcely possible to find any superior art which is not concerned with painting, so that whatever beauty is found can be said to be born of painting. Moreover, painting was given the highest honour by our ancestors. For, although almost all other artists were called craftsmen, the painter alone was not considered in that category.[9]

In conclusion, Alberti outlined an ideal programme of study:

The aim of painting: to give pleasure, good will and fame to the painter more than riches. If painters will follow this, their painting will hold the eye and soul of the observer ... It would please me if the painter were as learned as possible in all the liberal arts, but first of all I desire that he know geometry ... For their own enjoyment artists should associate with poets and orators who have many embellishments in common with painters...[10]

On painting was the first genuine theoretical treatise on art, by turns an exposition of applied geometry, a codification of extant practice and a manifesto, all cast in an approved humanist form.

However, portraiture is not mentioned by Alberti, and it only began to emerge as a significant, independent genre around the time that he composed his treatise. It was initially a princely art form, and less than 20 Florentine portraits survive from the first half of the fifteenth century. Even as late as the 1480s, portraits retained their power to surprise, as is apparent from a poem by Bernardo Bellincioni, inspired by Leonardo's portrait of the courtesan *Cecilia*

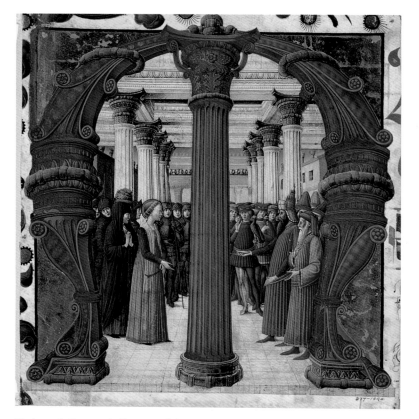

Girolamo da Cremona (active 1451-1483)
Initial 'M' historiated with a scene of Saint Giustina of Padua disputing, 1451
Cutting from a leaf of an antiphonal
Ink, tempera and gold leaf on vellum,
21 x 19cm
Purchased, 1894
817-1894

Saint Giustina was a 4th-century martyr who gave her name to a basilica in Padua. Signed Ieronimus. F., this miniature is an early work by this Paduan illuminator. The crowd of figures, classical architecture and dramatic perspective derive from the bronze altarpiece which Donatello made for the church of the Santo, also in Padua, from 1443-50.

Gallerani, now in Cracow. This begins with a conversation between the poet and nature:

Poet: What's angering you? Whom are you envious of, Nature?

Nature: Of Vinci, who has portrayed one of your stars:Cecilia! So supremely beautiful is she today that compared with her fair eyes the sun seems a dark shadow.[11]

More everyday painted artefacts among the household furnishings of the Italian elite included decorated *spalliere* or wainscotting, and *cassoni* or storage chests, which were frequently

commissioned as wedding gifts, and *deschi da parto* or birth trays, used for serving meals to mothers who had just given birth. They were typically decorated with appropriate narrative subjects from the poems of Petrarch, classical history and mythology, or the Old Testament. Apollonio di Giovanni's surviving order book indicates that his workshop produced 170 decorated *cassoni* between 1446 and 1463. He was also busy as an illuminator of secular manuscripts by Virgil, Dante and Petrarch. Apollonio introduced new themes from classical history and mythology into Florentine art, and a contemporary likened his work to the most famous poems of antiquity:

Once Homer sang of the walls of Apollo's Troy burned on Greek pyres, and again Virgil's great work proclaimed the wiles of the Greeks and the ruins of Troy. But certainly the Tuscan Apelles Apollonius now painted burning Troy better for us.[12]

Around 1500, inspired by painted Islamic pottery and Chinese porcelain, the potters of central Italy began to produce the brightly painted tin-glazed earthenware known as *maiolica*, after the island of Majorca which was a major centre for the manufacture of lustreware. This was decorated with a variety of religious and secular subjects, coats of arms and portraits. The finest pieces were collectors' items, and some of the best *maiolica* painters signed and dated their works. Vasari noted that ancient pottery lacked its 'brilliance of glaze' and 'charm and variety of painting', and around 1557 Cipriano Piccolpasso of Castel Durante wrote an illustrated treatise on its manufacture, a manuscript copy of which can be found in the V&A.

Italian artists excelled in a wide range of media including panel and fresco painting and, at the turn of the fifteenth and sixteenth centuries, the popularity of humanist script and de luxe printed books stimulated book illumination in Florence and Venice. Other art forms were essentially northern specialities. They included enamel and

stained glass painting, which was revived in France following the end of the Hundred Years War. Giorgio Vasari's first teacher was the French stained glass painter Guillaume de Marcillat, who worked in Rome between 1509 and 1515, and whose late frescoes reflect the style of Michelangelo and Raphael.

Despite sporadic attempts to establish tapestry weaving in northern Italy, the Netherlandish workshops based around Brussels retained a virtual monopoly of such work until the

Below: Italian (Milan)
Tarot card, with Death as a cardinal, c.1460-70
Watercolour, varnished, on illuminated background with diaper pattern, 17 x 8.5cm
Croft Lyons Bequest, 1926
E.1470-1926
One of four surviving cards, all of which are at the V&A, from a deck of 78. Their pattern is one associated

with the Sforza court at Milan. The deck probably belonged to the mercenary general Bartolomeo Colleoni (1395-1475), as another of the cards bears his arms. The characterization of Death as a Cardinal relates to the iconography of The Dance of Death. The Latin inscription reads 'I am the end'.

Above: Italian (Faenza or Urbino)
The Resurrection of Christ, c.1510-1520
Tin-glazed earthenware, painted in colours, 25 x 20.5cm
Purchased, 1865
69-1865
This plaque is a major work by an anonymous painter responsible for several pieces signed T. B. or B. T. Its composition

indicates a knowledge of north Italian paintings of the late 15th century and Albrecht Dürer's large woodcut of The Resurrection, which is dated 1510. The dramatic foreshortening of the tomb, and the complex foreshortening of the group of foreground figures, are particularly accomplished.

seventeenth century. Tapestry cartoons had been produced by local painters until 1515, when Pope Leo X commissioned Raphael to design the cartoons for 10 tapestries of *The Acts of the Apostles* to decorate the Sistine Chapel. Woven in wool, silk and gold thread in the Brussels workshop of Pieter van Aelst, they were largely complete by late 1519. Their design and weaving reputedly cost 16,000 ducats, over five times that of Michelangelo's Sistine Chapel ceiling.[13]

Guillaume de Marcillat (c.1467-1529)
The Adoration of the Magi, 1516
Window, painted and stained clear and
coloured glass from Cortona Cathedral,
281 x 153.5cm
Purchased, 1902
634-1902
Marcillat's pupil Vasari observed that '...
painting in colours ... is little or nothing,

and rendering them transparent is not of
much moment, but the baking in the fire to
render them everlasting and impervious to
water is a labour worthy of praise ... this
excellent master ... has never been equalled
in this profession in invention of colouring,
design and excellence'. The arms are those
of Pope Leo X (r.1513-21).

The Acts of the Apostles enjoyed enormous
prestige, and repeat weavings were made for
the principal European monarchs. The tapestries
played an important role in the apotheosis
of Raphael's style as a fundamental tenet of
academic art.

By the sixteenth century, Italian artists were
more inclined than ever to express their views in
writing. The analogies between painting and
poetry, which had fascinated an earlier generation,
had given way to the *paragone*, a debate over the
comparative merits of painting and sculpture.
Leonardo argued the superiority of the former on
account of its greater intellectual range:

The painter has ten different subjects to consider
in carrying his work to completion: light, shadow,
colour, volume, outline, location, distance, nearness,
motion, and rest. The sculptor has to consider only
volume, outline, location, motion, and rest. He does
not need to be concerned about darkness and light,
because nature itself creates these for his sculpture,
and about colour there is no concern at all.[14]

In 1549, Michelangelo expressed an alternative
point of view:

I used to consider that sculpture was the lantern
of painting and that between the two things
there was the same difference as that between
the sun and the moon. But ... I now consider that
painting and sculpture are one and the same
thing, unless greater nobility be imparted by the
necessity for a better judgement, greater
difficulties of execution, stricter limitations and
harder work.[15]

In his seminal *Lives of the Artists*, first published
in 1550, Vasari argued that art had attained a
level of perfection in the lifetime of his hero
Michelangelo (1475-1564), thereby implying a
forthcoming decline. Following the devastating
Sack of Rome in 1527, the sense of idealism which
had characterized Italian painting gave way to
growing subjectivity, and a conscious pursuit of
stylistic elegance.

Raphael Santi (1483-1520)
The Miraculous Draught of Fishes, 1515-6
Watercolour on paper laid down on canvas,
319 x 399cm
On loan from Her Majesty The Queen
One of the seven surviving cartoons from
the series of 10 which were made for Pope
Leo X, as designs for tapestries of the lives
of St Peter and St Paul for the Sistine
Chapel. It depicts the scene from Luke V,
3-10, when Christ names Peter as a fisher
of men, while the fishermen struggle with
the abundant catch which threatens to
sink their boat. The figures are left-handed
because the scenes would be reversed
when woven.

Imported Flemish pictures and German prints
retained their popularity in Italy, but Michelangelo
was scathing in his assessment of north European
art:

In Flanders they paint, with a view to deceiving
sensual vision, such things as may cheer you and
of which you cannot speak ill ... They paint stuffs
and masonry, the green grass of the fields, the
shadow of trees, and rivers and bridges, which
they call landscapes, with many figures on this
side and many figures on that. And all this, though
it pleases some persons ... attempts to do so many
things well (each one of which would suffice for
greatness) that it does none well. It is practically
only the work done in Italy that we can call true
painting ... it is a music and a melody which only
intellect can understand.[16]

Italian (Faenza), after
Raphael Santi
*Dish with The Death
of Lucretia, c.*1525
Tin-glazed
earthenware, painted
in colours,
diam. 27.5cm
Bequeathed by
George Salting, 1910
C.2228-1910
This anonymous
maiolica painter was
responsible for
several pieces signed
F. R. or F. L. R. made
around 1522-30.
This scene is copied
from an engraving
by Marcantonio
Raimondi after a
drawing by Raphael.
It depicts the Roman
heroine Lucretia
committing suicide
in shame after her
rape by King Tarquin.
The Greek inscription
to the left reads,
'Better to die than
shamefully to live'.

However, from the start of the sixteenth century, humanism played a significant role in the patrician and court cultures of northern Europe. Italian artists received preferential treatment at Nuremberg, Malines, Blois and Westminster, and a visit to Italy was becoming part of the curriculum of ambitious painters from Germany, the Netherlands and France. According to Vasari, Albrecht Dürer sought:

... to imitate the life and to draw near to the Italian manners, which he always held in much account ... Of a truth, if this man, so able, so diligent, and so versatile, had had Tuscany ... for his country, and had been able to study the treasures of Rome ... he would have been the best painter of our land ...[17]

Dürer's treatises *Instructions on Measurement* (1525) and *Four Books on Human Proportion* (1528) reveal how he sought to reduce the elements of beauty to a mathematical system. The Dutch humanist Erasmus (1467-1536) praised him for achieving – with only the black lines of his prints – the full range of effects, emotions and sensations which the ancient painter Apelles had needed colours to represent.[18]

On a visit to the Low Countries in 1521, Dürer admired the art collection of Margaret of Austria, the Regent of the Netherlands, and purchased a miniature by Susanna Horenbout, the daughter of Margaret's illuminator Gerard Horenbout. By 1525 this family of artists had moved to London, where

Gerard's son Lucas was employed as a 'pictor maker' in the service of Henry VIII. He pioneered the portrait miniature as an autonomous art form, independent of manuscript illumination. In 1526 Erasmus encouraged Hans Holbein the younger to seek employment in London. The startling realism of his portraits earned commissions from expatriate German merchants and courtiers, and in 1536 he became the King's painter. Holbein's oil portraits were based on careful chalk drawings, and it was reputedly Horenbout who taught him the technique of miniature painting.

After their deaths, the English portrait miniature languished for a generation. Henry VIII had broken with Rome in 1534 and ordered the dissolution of the monasteries in 1540, but he was equivocal in his attitude towards the Reformation, and many traditional forms of religious patronage survived until the prolonged period of conflict between Protestants and Catholics during the reigns of Edward VI (1547-53) and Mary I (1553-8). The growing acceptance of humanist educational values and Italian secular culture was marked by

South German (Nuremberg), after an artist in the circle of Albrecht Dürer
The Virgin and Child, c.1505-10
Panel, painted and stained clear and coloured glass, diam. 33cm
Purchased, 1937
C.353-1937
This composition depicts the Virgin, as described in the Apocalypse of St John 12:1-2, 'wearing the sun for her mantle with the moon under her feet'. Dürer and his workshop specialized in paintings and prints, and also produced designs for sculpture, metalwork and stained glass. Stained glass was a specialized craft, but the absence of guild restrictions in Nuremberg made it easier for artists wanting to work in a range of media.

Jacopo Tintoretto (1519-94)
Self-portrait as a young man, c.1548
Oil on pine panel, 45.7 x 36.8cm
Bequeathed by Constantine Ionides, 1901
CAI. 103
Artists made drawings of themselves as a training exercise, but oil self-portraits were rare before the invention of flat mirrors in Venice in the late 15th century. This is probably the earlier, and less highly finished, of the two versions of this portrait. One may have belonged to the Venetian sculptor Alessandro Vittoria, who owned portraits of Tintoretto and several other leading Venetian painters.

Sir Thomas Hoby's translation into English of Baldassare Castiglione's *Book of the Courtier*, in 1561. On the European mainland religious upheaval remained so violent that many Flemish painters sought refuge in England, including Hans Eworth (*fl*.1540-73), Quentin Metsys the Younger (*c*.1543-89) and Marcus Gheeraerts the Elder (*c*.1525-90).

Nicholas Hilliard and Isaac Oliver, the principal miniaturists of the Elizabethan court, also had a refugee background. The family of Hilliard had fled to Geneva during the reign of the Catholic Mary I, and returned on the accession of Elizabeth. Hilliard was apprenticed to the Queen's Goldsmith and, in 1571, began producing miniatures as well as jewellery for Elizabeth I. A visitor to France in

1576-8/9, he was probably familiar with miniatures by the court artists Jean and François Clouet, as well as those of Horenbout and Holbein. In 1598 the physician Richard Haydocke aspired to the 'skilful pen of George Vasari' because:

Then would Mr. Nicholas Hilliard's hand, so much admired among strangers, strive for a comparison with the mild spirit of the late world's wonder Raphael Vrbine; for (to speak a truth) his perfection in ingenious Illuminating or Limning, the perfection of Painting, is (if I can judge) so extraordinary ...[19]

Haydocke persuaded Hilliard to write a treatise on miniature painting known as *The Art of Limning*, which survives in a manuscript copy. The earliest surviving essay on art by an English painter, this speaks eloquently of Hilliard's cultural horizons, as well as his working methods:

I wish it were so that none should meddle with limning but gentlemen alone, for that it is a kind of gentle painting, of less subjection than any other; for one may leave it when he will, his colours nor his work taketh any harm from it. Moreover, it is secret: a man may use it, and scarcely be perceived of his own folk. It is sweet and cleanly to use, and it is a thing apart from all other painting or drawing, and tendeth not to common men's use, either for furnishing of houses, or any patterns for tapestries, or building or any other work whatsoever. And yet it excelleth all other painting whatsoever in sundry points ...[20]

Hilliard revered Holbein as '... the most excellent painter and limner ... the greatest master truly in both those arts after the life that ever was ...', and thought Dürer '... as exquisite and perfect a painter and master in the art of engraving as ever was since the world began ... which also hath written the best and most rules of and for painting ...'[21] His principal criticism of the latter was 'that he never saw those fair creatures that the Italians had seen, as Rosso, Raphael, and

English, decoration attributed to Lucas Horenbout (*c.*1490/5-1544), in part after Hans Burgkmair
The lid of the writing desk of Henry VIII, *c.*1525-27
Walnut and oak, lined with painted and gilded leather; outer covering of shagreen added in 1690, 29.2 x 50.5cm
Purchased with the assistance of the Murray Bequest, 1932
W.29-1932
The inside lid of this portable writing desk bears the arms and devices of Henry VIII and Catherine of Aragon. The figures of Mars and Venus flanking the royal arms are based on woodcuts, of around 1510, by the German artist Hans Burgkmair. The heads set within roundels are Netherlandish in style, and have been attributed to the miniaturist Lucas Horenbout who was in Henry's service from 1525.

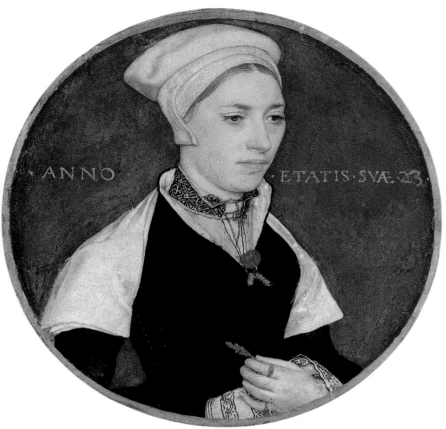

Lambertus Suavius, etc. For besides a certain true proportion, some of theirs do excel his in kind of beautifulness and spirit in the lineament and gesture, with delicacy of feature and limbs, hands and feet, surpassing all other portraitures of the Dutch whatsoever...'[22] Unsurprisingly, Hilliard considered his own nation the fairest:

... rare beauties are, even as the diamonds are found among the savage Indians, more commonly found in this isle of England than elsewhere, such surely as art ever must give place unto. I say not the face only, but every part; for even the hand and foot excelleth all pictures that yet I ever saw ...[23]

Isaac Oliver was the son of an immigrant Protestant goldsmith from Rouen, and became Hilliard's 'well profiting scholar' around 1587. He visited northern Italy in 1596, and was familiar with Netherlandish art, especially the engravings of Hendrick Goltzius (1558-1617) which

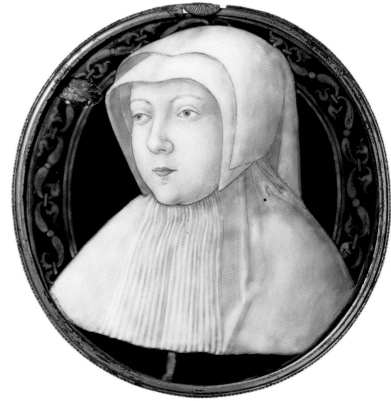

had also impressed Hilliard. Initially under his
master's shadow, he enjoyed considerable success
at court following the accession of James I.
The later commentator Edward Norgate, repeating
Vasari's praise of Giulio Clovio (1498-1578), likened
him to 'a new Michelangelo'. Oliver was the only
British painter of the day whose work was attuned
to the exquisite technique and ambitious subject
matter of European Mannerism, the elegant
style current at the turn of the sixteenth and
seventeenth centuries.

At the beginning of the seventeenth century,
the engravings of Dürer and Goltzius and the
miniatures of Hilliard and Oliver were finding their
way as far afield as the court of the Mughal
Emperor Jahangir, at Agra. They popularized
Christian subject matter, provided compositional
models and encouraged the development of
naturalistic portraiture.[24] However, by this time
the most progressive European painters were

looking back, beyond the extravagant virtuosity
which characterized art of the second half of the
sixteenth century, to the measure and repose of
classical antiquity, and Raphael.

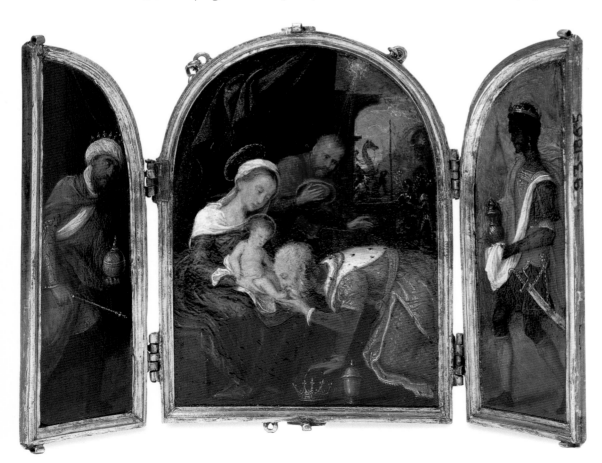

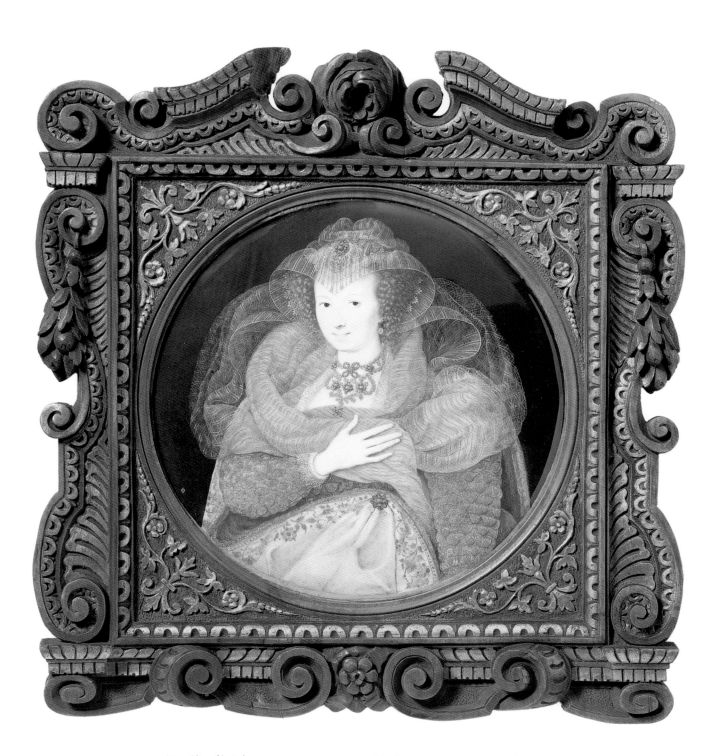

Isaac Oliver (d.1617)
Portrait of an unknown woman,
c.1596–1600
Watercolour on vellum, diam.13cm
Purchased, 1971
P.12-1971
Both the large scale and the ostentatiously
skilful depiction of the exquisite, but
virtually monochrome, costume indicate
that this was a painstaking commission for
a lady of high rank. Her fashionable indoor
attire and hand on heart suggest a love
token. The softly modelled light and shade,
and the sitter's elusive smile, recall High
Renaissance paintings which Oliver would
have seen in Italy.

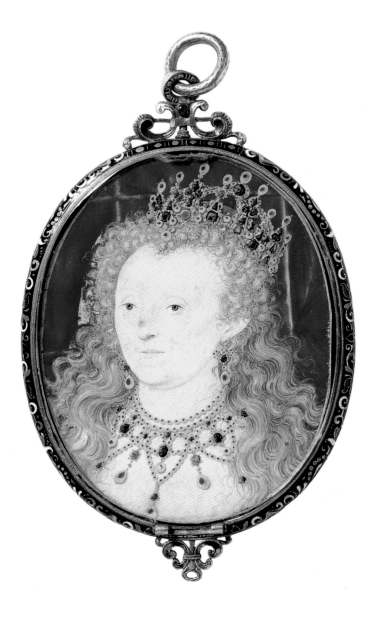

Above: Nicholas Hilliard (1547-1619)
Portrait of Elizabeth I, 1600
Watercolour on vellum in a gold locket, 6.2 x 4.7cm
Purchased, 1857
4404-1857
Elizabeth wears unbound hair, symbolic of her virginity, and a crown with an arched top indicative of her absolute sovereignty. Set in its open-work jewelled case, this miniature has the air of a secular icon which could be worn as a sign of allegiance. In his treatise, Hilliard boasted of how miniature painting gave 'the true lustre to pearl and precious stone ... being fittest ... to put in jewels of gold.

Opposite, left: Nicholas Hilliard (1547-1619)
Portrait of a young man among roses, c.1587
Watercolour on vellum, 13.6 x 7.3cm
Bequeathed by George Salting, 1910
P.163-1910
Wearing the black and white colours of Elizabeth I, this courtier stands in an attitude of heartfelt devotion by an eglantine rose symbolizing the Queen. The Latin inscription from Lucan suggests the pain of faithful love: 'a praised faith is her own scourge, when it sustains their states whom fortune hath depressed'. This celebrated Elizabethan image is one of the earliest full-length cabinet miniatures.

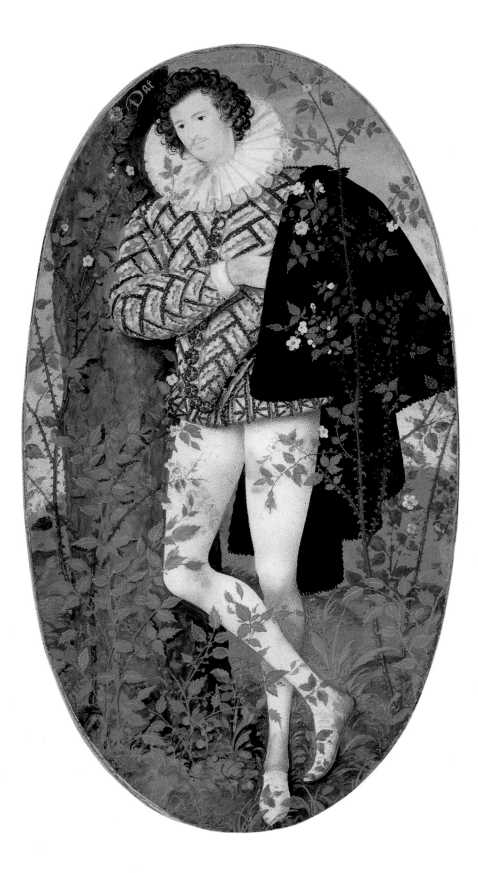

Above: Mughal, after Hans Sebald Beham
St. Luke, c.1600-4
Watercolour and gold on paper, 10.6 x 5.7cm (excluding calligraphy)
Given by Col. T. G. Gayer-Anderson, CMG, DSO, and his brother Major R. G. Gayer-Anderson, Pasha, 1952
IS.218-1952
One of several pictures of holy figures, mainly Hindu and Christian, from the 'Salim Album' commissioned by the Mughal Emperor Jahangir. He was curious about Christian art, which had been introduced to Hindustan by Jesuit missionaries. This miniature is based on a tiny engraving, of 1541, by the Nuremberg artist Hans Sebald Beham. The Mughal artist has simplified his model, omitting the saint's wings and symbolic ox.

4 The Noble Art of Painting

Above: Gaspard Dughet (1615-75)
Italian landscape, c.1633-35
Oil on canvas, 68.5 x 50cm
Bequeathed by Constantine Ionides, 1901
CAI.107
Dughet was the brother-in-law and
student of Nicolas Poussin. This is one of
a group of lyrical scenes with pastoral
figures in classical dress, amidst a shifting
pattern of light and shadow cast by
silvery trees. Its celebration of the
untamed landscape of the Roman
Campagna invites comparison with the
poetry of Virgil. Dughet's works were
immensely popular in Britain during the
18th century.

Right: Samuel Cooper (?1608-72)
Henrietta Anne, Duchess of Orleans, c.1661
Watercolour on vellum, 7.2 x 5.5cm
Bequeathed by George Salting, 1910
P.110-1910
Cooper was brought up by the
miniaturist John Hoskins, and at the start
of his career was associated with Van
Dyck. After the Restoration, his pre-
eminence was confirmed by his
appointment as miniaturist to Charles II.
Henrietta Anne (1644-70) was the
youngest child of Charles I. This fresh and
direct likeness probably dates from her
marriage in 1661 to the Duke of Orleans,
brother of Louis XIV.

In 1600 Europe seemed both enlarged and
diminished. Its horizons had advanced as far as
America and the Far East, but the ideal of a united
Christendom had succumbed to the Reformation
and Counter-Reformation.

In spite of Dürer's enthusiasm for art treasures
from the New World, its flora and fauna aroused
far more widespread interest than its rich pictorial
tradition, which was generally despised by the
conquistadores as pagan idolatry. Japanese
lacquer and porcelain were added to the inventory
of desirable oriental imports, but the conventions
of eastern painting were too distant from those
of Europe to be readily assimilable in the West.
To many, the foundations of Christian art now
appeared under threat. While the Lutherans
accepted religious images which promoted
worship, the Calvinists insisted 'It is unlawful
to attribute a visible form to God' and required
that the 'practice of art should be kept pure and
lawful'. In the face of this challenge, in 1563 the
Council of Trent formulated guidelines for
religious art:

... the images of Christ, of the Virgin mother of
God, and of the other saints are to be placed and
retained especially in the churches, and that due
honour and veneration is to be given them ... the
people are thereby reminded of the benefits and
gifts bestowed on them ... all superstition shall be
removed ... and all lasciviousness avoided, so that
images shall not be painted and adorned with a
seductive charm ... no-one is permitted to erect ...
any unusual image unless it has been approved ...[1]

Thus purified, altarpieces and cult images
retained their central role in the Catholic church,
while in Protestant countries religious art was
reduced to a limited range of edifying themes.
Throughout Europe, artists turned increasingly to
producing secular paintings for domestic display.

In the Netherlands, painters increasingly
specialized in particular themes or sub-themes
including different kinds of portraiture, urban and
rural scenes, still life, flower and animal

compositions, and a variety of landscapes ranging from townscapes to sea views. Such specialization is clearly apparent in the products of the Antwerp dynasty of painters founded by Pieter Bruegel (1525-69), whose landscapes and peasant scenes were perpetuated by his elder son Pieter II and grandson Pieter III. His younger son Jan and grandson Jan II concentrated on small paintings of landscapes and still lifes. Like many of his contemporaries, Jan Bruegel collaborated with specialists in other subjects, notably his friend Peter Paul Rubens, the court painter to the governors of the Spanish Netherlands.

The Antwerp painters and dealers flooded the European art market with their products, sending consignments of still lifes and landscapes to Paris and beyond. Ebony-veneered collector's cabinets, with drawers and folding doors decorated with small paintings, were an Antwerp speciality intended principally for export. Dutch artists also produced a wide range of paintings, including the landscapes and flower pieces which Roelandt Savery introduced to the Imperial court in Prague. At Delft, a plentiful supply of good clay and a series of technical improvements stimulated the development of pottery, painted in blue and white enamel, in imitation of Chinese and Japanese ceramics imported by the Dutch East India Company. Delft pottery rapidly became the largest industry in Europe, and between the 1630s and 1680s it was even exporting to Japan items decorated by painters such as Frederik van Frytom.

The curiosity engendered in England by the appearance of these new secular genres of painting is conveyed by Edward Norgate's digression on landscape in his treatise *Miniatura*, written in 1627-8:

An art so new in England, and so lately come ashore, as all the language within our four seas cannot find it a name, but a borrowed one ... Now landscape ... is nothing but a picture of ... fields, cities, rivers, castles, mountains, trees or whatsoever delightful view the eye takes pleasure in ... I owe much to this harmless and honest recreation, of all kinds of painting the most innocent, and which the Devil himself could never accuse of or infect with Idolatory ... it does not appear that the ancients made any other account or use of it, but as a servant to their other pieces, to illustrate, or set off their historical painting, by

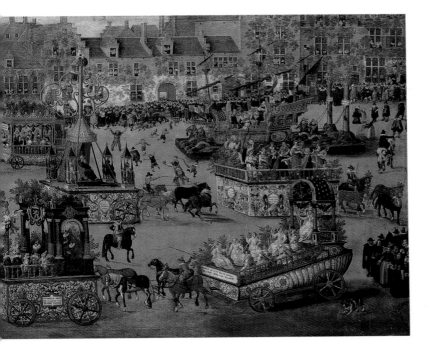

that the art of their own day directly continued that of the Renaissance. However, compared with earlier paintings, those of the seventeenth century now seem to be animated with a sense of time and motion. This new dynamism is clearly apparent in the complex, sweeping compositions of Rubens. One of the best-read artists of his generation, steeped in the classics, he mused upon the gulf separating the art of his own day from that of antiquity:

... the ancient painters can now be followed only in the imagination, and comprehended by each one of us, more or less, for himself ... how few among us, in attempting to present in visual terms some famous work by Apelles ... will not produce something that is insulting or alien to the dignity of the ancients? But each one indulging his own talent, will offer an inferior wine as a substitute

filling up the empty corners, or void places of figures ... as may be seen in those incomparable *Cartoni*, of the *Acts of the Apostles* ... so rarely invented by the Divine *Raphael d'Urbino* ... But to reduce this part of painting to an absolute and entire art ... is as I conceive an invention of these later times, and though a novelty, yet a good one.[2]

Charles I acquired the Raphael Cartoons in 1623, and commissioned Rubens to execute the decorated ceiling of the Banqueting Hall at Whitehall. In 1632 he appointed Rubens' former student Anthony Van Dyck as official portraitist. Both painters were knighted, and Van Dyck received numerous privileges and a generous pension. In the face of such competition British artists were sidelined, and tried to adapt to the flamboyant imported style loved by the Stuart court. This proved to have a fragile base, and it succumbed to the death of Van Dyck in 1641, and the outbreak of the Civil War in 1642.

The painters and writers Karel van Mander and Joachim von Sandrart (1606-88) took Vasari's *Lives* as a starting point for their own accounts of Netherlandish and German artists. Both believed

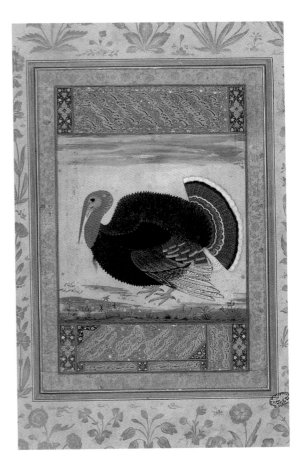

Roelandt Savery (1576-1639)
Flowers in a niche, 1621
Oil on oak panel
Bequeathed by Alexander Dyce, 1869
D.4
This was painted in Utrecht, after the artist
had returned to the Netherlands following
many years in central Europe. A lizard peers
at the vase of flowers, which include a large
pink rose, yellow tulip, white daffodil with
a fly, flag iris and a martagon lily with a
butterfly. Black cumin flowers overhang the
edge of the niche. Most of the flowers have
symbolic associations with the Virgin Mary.

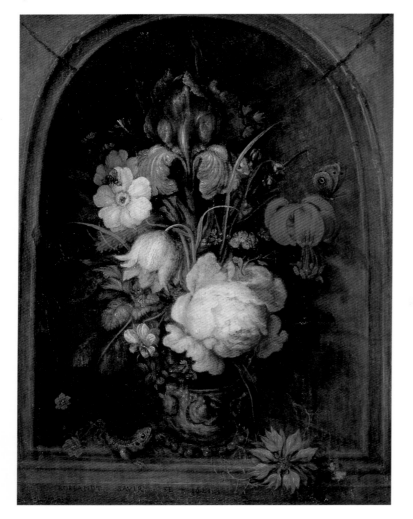

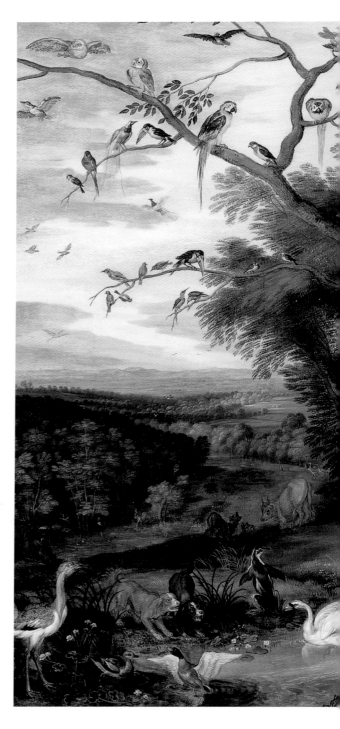

Jan Brueghel the elder (1568-1625)
The Garden of Eden, c.1620
Oil on oak panel
Bequeathed by George Mitchell, 1878
340-1878
Brueghel's workshop produced so many paintings of Paradise that he was nicknamed 'Paradise Brueghel'. Adam and Eve are confined to the background of a scene of creatures from every continent, including guinea pigs, toucans, macaws and a penguin from South America, African grey parrots, and leopards and birds of paradise from South-East Asia. All were believed to live in harmony before the Fall of Man.

Netherlandish (Antwerp), c.1630-50
*Cabinet with scenes from the Parable
of the Prodigal Son* (detail)
Oak, veneered with ebony veneer, wood, oil
paintings on oak, on a later stand
Given by Mrs E. Hearn, 1923
W.61:1,2-1923
The doors and drawers of cabinets provided
a new commercial outlet for the large

school of painters in Antwerp. St Luke (15:11-
32) tells of the prodigal son who
squandered his father's goods in riotous
living, was reduced to a swine herd,
repented, and was joyfully received on his
return home. This parable of compassion
and redemption was popular with both
Catholics and Protestants.

narrative themes of ancient and Christian art
with variable effects of light and climate. In a
remarkable way, Poussin embodied narrative
and passion within formal designs of profound
harmony. His intellectual lucidity is evident in
the following lines which are taken from his
'Observations on Painting':

Painting is nothing else than the imitation of
those human actions which are imitable ... Art is
not something different from nature, nor can it
pass the bounds of nature ... Painting will possess
elegance when its farthest limits are joined with
the nearest ... in such a way that they do not come
together too awkwardly, or with roughness in line
or colour ... There are two instruments which
affect the souls of the listeners: action
and diction. The first, in itself, is of such value and
so efficacious that ... without it lines and colour
are likewise useless ... The grand manner consists

for that bittersweet vintage, and do injury to
those great spirits whom I follow with the
profoundest veneration. It is rather that I adore
their footsteps, than that I ingenuously profess
to be able to follow them, if only in thought.[3]

The range of Rubens' activity, from Protestant
England to Catholic Spain and Bavaria, defined
the European scope of a new style. The French
painters Poussin (1594-1665), Claude Lorrain
(1604-82) and Gaspard Dughet were similarly
international figures. At Rome they created
the 'ideal' landscape, which imbued the great

of four elements: subject or theme, concept, structure, and style ... The idea of beauty ... [requires] three things: order, mode, and form ... painting is ... more concerned with the idea of beauty than with any other ... this alone is the mark and, as it were, the goal of all good painters.[4]

Poussin was revered in his lifetime as the only painter since Raphael to have equalled the art of the ancients. His biographer, André Félibien (1619-95), likened his pictures to the modes of music, expressing 'either happiness or sadness, fury or sweetness according to the nature of his story'.[5] Félibien was deeply critical of the 'low and often ridiculous actions' which he perceived in the peasant scenes of the Le Nain brothers, Poussin's contemporaries and fellow members of the Académie Royale. Yet the air of quiet dignity and lack of idealization or sentimentality in their work has analogies with the stoical severity of Poussin's compositions. His rational approach was codified

into a 'classical method' which remained current at the Académie for almost a century.

While Roger de Piles endorsed Félibien's analogy between pictorial and musical composition, he emphasized the importance of colour over design:

The painter therefore who is a perfect imitator of nature ... ought to make colouring his chief object, since he only considers nature as she is imitable; and she is only imitable by him, as she is visible; and she is only visible, as she is coloured. For this reason, we may consider colouring as the *difference* in painting, and design as its *kind*.[6]

De Piles was thinking principally of the painterly style of Rubens, who shared top place in his *Scale of Painters*, which he published towards the end of his life. With the exception of the immigrants Holbein and Van Dyck, British artists did not feature at all in his reckoning. When patronage and collecting did revive in England after the

Japanese, 1636-39
Lid of a document box, known as the Van Diemen box
Wood covered with black lacquer, with gold, silver and red lacquer, and gold and silver details,
16 x 48 x 26.7cm
Given by the children of Sir Trevor Lawrence, Bart., 1916
W.49-1916
The Japanese term *maki-e* meaning 'sprinkled picture' describes how gold and sliver dust was sprinkled on wet lacquer. The dust was also built up and modelled in layers. This box is unique among exported Japanese lacquer ware for its outstanding quality. It was made for Maria van Diemen, the wife of the Governor of the Dutch East Indies. Later owners included Madame de Pompadour and William Beckford of Fonthill.

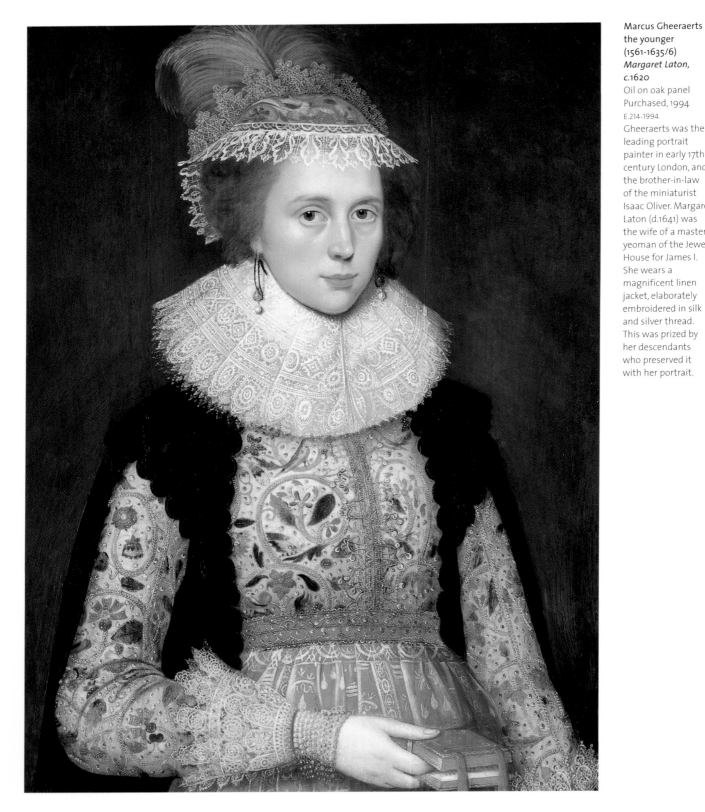

Marcus Gheeraerts
the younger
(1561-1635/6)
*Margaret Laton,
c.1620*
Oil on oak panel
Purchased, 1994
E.214-1994
Gheeraerts was the
leading portrait
painter in early 17th-
century London, and
the brother-in-law
of the miniaturist
Isaac Oliver. Margaret
Laton (d.1641) was
the wife of a master
yeoman of the Jewel
House for James I.
She wears a
magnificent linen
jacket, elaborately
embroidered in silk
and silver thread.
This was prized by
her descendants
who preserved it
with her portrait.

Protectorate, Charles II had neither his father's means nor his temerity, and was content to reassemble what he could of the dispersed royal collections. The principal portrait painters in Restoration England were the Dutch-born Sir Peter Lely (1618-80) and the German Sir Godfrey Kneller (1646-1723). Miniature painting remained the preserve of native artists, and Samuel Cooper enjoyed a significant international reputation. The Grand Duke of Tuscany sat for him, and after Cooper's death attempted to acquire further miniatures from his studio.

Below: John Hoskins (c.1590-1664/5), after Van Dyck
Lady d'Aubigny, late 1630s
Watercolour on vellum, 10.4 x 8.6cm
Bequeathed by George Salting, 1910
P.157-1910
Hoskins was granted a generous annuity by Charles I which lapsed with the King's fall, and he died impoverished. His early style, derived from that of Hilliard, was transformed by contact with Anthony Van Dyck. This portrait of the court beauty Catherine Howard (d.1650) is a copy of an oil painting by Van Dyck, and probably dates from her marriage to Lord d'Aubigny in 1638.

The long-standing claim of miniature painting to gentility, articulated earlier by Hilliard and Norgate, was maintained by Thomas Flatman, who was also a lawyer and poet. His 'On the noble Art of Painting' (1658) includes the following haunting lines:

Gaze up, some winter-night, and you'll confesse
Heaven's a large Gallery of Images ...
What e'er we see ... hangs by Painting's thread
Thus ... our subtle Art,
Insinuates itself through every part.
Strange Rarity! ...
That spans and circumscribes the sea and Land:
That draws from Death to th'Life, without a Spell,
As Orpheus did Eurydice from Hell![7]

Towards the end of the century the poet John Dryden translated one of the earliest essays on art criticism to appear in English, Charles du Fresnoy's *Art of Painting* (1695). This was supplemented by Richard Graham's 'A short Account of the most

Peter Oliver (1589–1647), after Titian or Palma Vecchio
Tarquin and Lucretia, c.1630
Watercolour on vellum, 11.4 x 9.9cm
Purchased, 1869
1787-1869
Peter Oliver was the son and pupil of the miniaturist Isaac Oliver. The story of the virtuous Roman matron, Lucretia, who committed suicide after her rape by Sextus Tarquin, was recounted by the Roman historian Livy. This miniature, which was commissioned by Charles I, is a copy of an oil painting variously attributed to Titian and his student Palma Vecchio, which was formerly in the royal collection.

Peter Paul Rubens (1577-1640)
War and Victory: model for a title page, 1634-5
Grisaille on oak panel, 16.8 x 13cm
Purchased, 1891
D.1399-1891
This allegorical design was made for the frontispiece of a book by Diego de Aedo y Gallaert, which was published in 1635, and recounted the journey of Cardinal Ferdinand from Spain to the Netherlands, where he became governor. The eagle supporting the Cardinal's arms symbolizes his journey, and the figures of Victory and Mars refer to his role in the Imperial victory over the Protestants at Nördlingen in 1634.

Adriaen Brouwer (1605/6-38)
Interior of a room with a man playing a lute and an old woman, c.1635-8
Oil on oak panel, 37 x 29.2cm
Bequeathed by Constantine Ionides, 1901
CAI.80
The Flemish painter Brouwer studied in Amsterdam and settled in Antwerp. He specialized in small scenes of low-life characters with coarse expressions, and often portrayed drinking, smoking or brawling. His dark, unsentimental subjects have moralizing overtones. This is apparently one of 17 of his works which belonged to Rubens.

eminent painters, both ancient and Modern'. In 1706, de Piles' *Art of Painting* also appeared in English translation, together with a series of 100 biographies of deceased British painters by Bainbrigge Buckeridge, titled 'An essay towards an English School'. This argued that miniature painting, pastel drawing and mezzotint engraving were British specialities, and claimed:

If discretion would have permitted me to do it, I might have enlarged our School so much, that neither the Roman, nor the Venetian, would have had cause to be ashamed of its company. As it is, it is more than a match for the French; and the German, and Flemish schools, only excel it by the performances of those masters whom we claim as our own. Hans Holbein and Van Dyck ... Nor have we a small title to Sir Peter Paul Rubens ... if they have had their Vouets, their Poussins, and le Bruns, we have had our Fullers, our Dobsons, and our Coopers; and have not only infinitely out-done

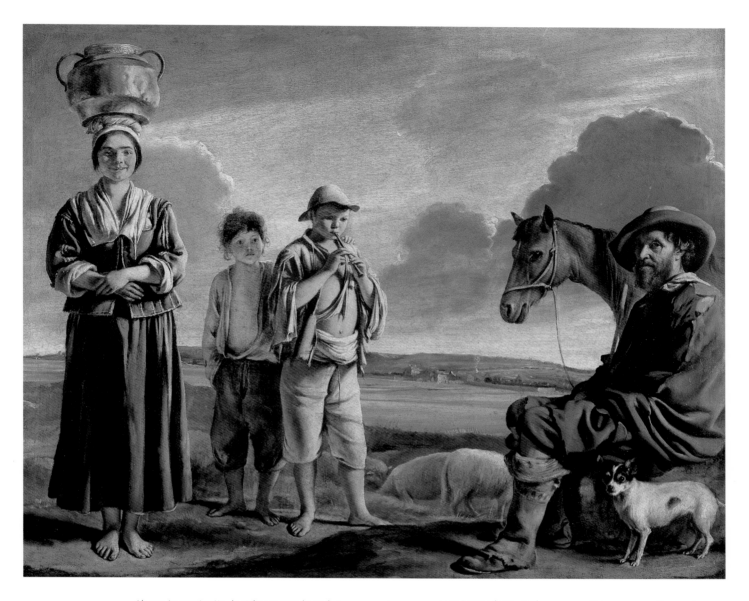

them in portraits, but have produced more masters in that kind, than all the rest of Europe ... Had we an Academy we might see how high the English genius would soar, and as it excels all other nations in poetry, so, no doubt, it would equal, if not excel, the greatest of them all in painting.[8]

This combative stance heralds the arrival of a nationalist perception of schools of painting, which was to colour art criticism for the next three centuries.

Louis le Nain (1593-1648)
The resting horseman, c.1640
Oil on canvas, 54.6 x 67.3cm
Bequeathed by Constantine Ionides, 1901
CAI.17
The brothers Antoine, Louis and Mathieu Le Nain shared a studio, and their styles are almost indistinguishable. They specialized in scenes

of the poor, sometimes set in a landscape like that of Laon. This particular scene depicts a landowner resting, apparently at ease with a peasant family. Its implicit concern for the poor parallels that of the pious clergy of St Sulpice, the Parisian parish where the Le Nain brothers lived.

Top left: Frederik van Frytom (c.1632-1702)
Rocky Italianate landscape, c.1660-70
Tin-glazed earthenware, painted in cobalt blue, diam. 37cm
Purchased, 1938
Circ.167-1938
Van Frytom was probably trained in Rotterdam, but was living in Delft by 1652. He was a leading pottery painter who, unusually, also painted in oil on canvas. Although familiar with a wide range of landscape styles, he devised his own compositions rather than copying prints. Italianate landscapes were extremely popular in the Netherlands in the late 17th century.

Bottom left: French (Limoges, Jean I Laudin, c.1627-95)
Pan and Syrinx, c.1660
Copper, painted in grisaille enamel on a blue enamel ground, 16.2 x 20.3cm
Purchased, 1855
2049-1855
Laudin was the most skilled enamel painter of his generation, and specialized in grisaille scenes. This is one of a pair of enamels after engravings by Hendrik Goltzius (1589-1615), depicting subjects from Ovid's *Metamorphoses*. Here Pan, the woodland god, pursues the nymph Syrinx who is transformed into reeds in response to her prayer to elude him.

Opposite, top: French, c.1670
A lady, perhaps Madame de Montespan, surrounded by treasures
Watercolour on vellum, heightened with gold, 27.5 x 47.5cm
Purchased, 1987
P.39-1987
This is a fan leaf, enlarged to form a cabinet miniature. The lady is surrounded by a host of playful putti, symbolic of love, while the beaming sun emblem of Louis XIV appears on the frame of the mirror and the oval painting. The lady may represent the King's mistress, Françoise-Athénaïs de Rochechouart, Madame de Montespan (1641-1707), who was famous for her love of lavish possessions.

Opposite, bottom left: Peter Cross (?1645-1724)
Robert Kerr, fourth Earl of Lothian, 1667
Watercolour on vellum, 7.5 x 6.3cm
Purchased, 1981
P.41-1981
Cross was of French ancestry, and may have studied with Hoskins and Samuel Cooper. He was appointed miniaturist to Charles II in 1678. This softly modulated portrait depicts the Scottish soldier Robert Kerr (1636-1702/3). Despite his father's 'implacable malice' to the King, Kerr enjoyed a highly successful political career, and was eventually made a marquis.

Opposite, bottom right: Charles Beale (1660-?1714), after Sir Peter Lely
Sir Peter Lely, 1679
Watercolour on vellum, 19.4 x 16.9cm
Purchased, 1905
555-1905
Charles Beale was the son of a collector and Mary Beale, a successful painter of oil portraits. He sketched in the studio of Sir Peter Lely, and studied with Thomas Flatman, but his own career was cut short by failing eyesight. This large miniature is a copy of Lely's oil self-portrait of 1660. It expresses the social ambition of the court painter who is portrayed as a proud gentleman connoisseur, here holding a statuette.

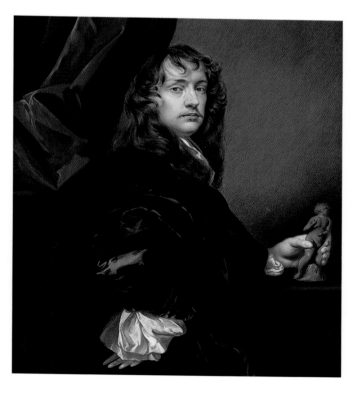

Below: Italy (Venice), *c.*1700
Lid of a harpsichord, with The Judgement of Midas (detail)
Oil on wood, 86.4 x 182.9cm
Purchased, 1887
444-1887
Venice was a major centre for the production of musical instruments, and the home of one of the principal schools of painting in Europe. This harpsichord lid is decorated with a highly appropriate subject from Ovid's *Metamorphoses*. Midas, in the centre, is shown choosing the woodland god Pan as victor in a musical competition with the sun god Apollo. In revenge, Apollo transformed Midas' ears into those of an ass.

Right: Thomas Flatman (1635-88), after Domenico Fetti
David with the Head of Goliath, 1667
Watercolour on vellum, 18.5 x 13.6cm
Purchased, 1937
P.83-1937
Flatman was an accomplished poet, a graduate of Oxford and Cambridge, a lawyer and Fellow of the Royal Society, as well as a talented miniaturist. This cabinet miniature copies an oil painting by Domenico Fetti (*c.*1588-1623), a court painter of the Duke of Mantua, whose collection was purchased by Charles I. After the Restoration, it hung at Whitehall Palace.

James Thornhill
(1675-1734)
*Design for the Painted
Ceiling of the Great
Hall, Greenwich, c.1710*
Oil on canvas, 96.5 x
66cm
Purchased, 1877
812-1877
Thornhill was the
first native painter
to challenge the
domination of large-
scale decorative
schemes by
immigrant French
and Italian artists.
This is a preparatory
oil sketch for a
ceiling at Greenwich
Hospital, designed by
Christopher Wren. It
depicts King William
and Queen Mary
presenting Peace
and Liberty to Europe.
Thornhill was
knighted, but the
taste for such
elaborate decorations
rapidly waned.

5 The Consummate Painter

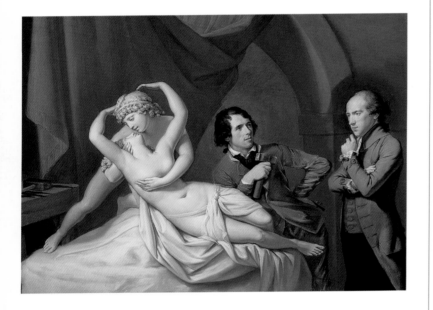

The insistence of earlier commentators – from
Alberti to Hilliard – on the equality of painting
and sculpture with the liberals arts was formally
acknowledged by the establishment of the
French Académie Royale in 1648. Its founders
argued that as artists served the glory of princes,
their status was incompatible with the guild
restrictions of the artisan classes. In return for
this freedom, artists acknowledged the statutes
and rules of their peers, under the ultimate
authority of an absolute monarch.

The Académie institutionalized the supremacy
of history painting, embodying the values of
antique sculpture and an approved canon of
sixteenth- and early seventeenth-century
masters. Two influential models were provided,
Rubens, a knight and diplomat with refined
manners, on the closest terms with the
aristocracy, and Poussin, a modest and learned
figure, utterly devoted to his chosen genre.
Both were seen as essentially moral and social
personalities. While the art theorists Félibien and
de Piles disagreed over the relative importance
of colour and design, they were united in their
emphasis on the value of good manners and
agreeable behaviour. From 1737 exhibitions at the
Salon of the Académie became regular events,
attracting hosts of visitors, and stimulating the
development of art criticism as a literary genre.
Acclimatization to polite society encouraged
painters to demonstrate good taste and
emotional decorum, and to eschew extremes
of naturalism and emotion.[1] Despite the rise
of increasingly vocal and eloquent arguments
to the contrary, these values remained current
throughout the eighteenth century.

The international reputation of Claude and
Poussin, the prestige of the Académie, and the
power of Louis XIV all contributed to the success
of French art abroad. This extended from the
Bourbon cadet branches who ruled Spain and
Naples, to the monarchies of northern and
eastern Europe. The Akademie der Künste,
founded in Berlin as early as 1697, had been

Jean François de Troy (1679-1752)
The alarm, 1723 (detail)
Oil on canvas, 69.5 x 63.8cm
Bequeathed by John Jones, 1882
518-1882
This scene of a lady and her lover, warned
of an unwelcome visitor, exemplifies the
tableau de mode, illustrating contemporary
manners, invented by de Troy. The clarity of
the narrative reflects his specialization as a
history painter. He also designed tapestries
for the Gobelins factory, and ended his
career as Director of the Académie
Française in Rome.

the Protestant states of Germany and England.
If anything, this haemorrhage of talent actually
enhanced France's international standing as a
centre of the arts and crafts, from tapestry to
furniture, and from dress to chronometers. Johann
Friedrich Böttger was seeking to equal imported
Chinese and Japanese wares when he created the
first European 'hard-paste' porcelain, but the
state-subsidized factory established in 1710 by the
Elector of Saxony at Meissen for its manufacture
was modelled on the Gobelins, where tapestries
and furnishings were made for the French court.
The success of the Meissen factory led to the
foundation of the Manufacture Royale de
Porcelaine de France, based at Sèvres from 1756.

England was visited by the great French
painter Watteau in 1719-20, and in 1729 the
Huguenot expatriate Philip Mercier was
appointed Principal Painter to Frederick, Prince of
Wales. Sir James Thornhill, the Sergeant-Painter
to the King, was succeeded by his son-in-law,
the engraver and painter William Hogarth
(1697-1764). He was co-founder of a consciously
anti-hierarchical drawing school at St Martin's
Lane in London. Hogarth remained profoundly
sceptical about the validity of the Académie
Royale as a model for art education in England,
observing sourly:

As to electing presidents, directors, professors,
&c. I considered it a ridiculous imitation of the
foolish parade of the French Academy, by the
establishment of which Louis XIV got a large
portion of fame and flattery on very easy terms.
But I could never learn that the arts were
benefited ... Voltaire asserts that, after its
establishment, no one work of genius appeared
in the country; the whole band, adds the same
lively and sensible writer, became mannerists
and imitators ... We cannot vie with these Italian
and Gallic theatres of art, and to enter into
competition with them is ridiculous; we are a
commercial people, and can purchase their
curiosities ready made, as in fact we do, and

based on the French model, and Frederick the
Great was a confirmed Francophile, assembling
French pictures at Sanssoucci, his favourite
palace in Potsdam. The Swedish Count Tessin,
and Catherine the Great of Russia, were also
enthusiastic collectors of works by Boucher,
Lancret and Greuze.

The revocation of the edict of Nantes in 1685
precipitated the emigration of numerous
Huguenot artists and craftsmen from France to

Johann Georg Platzer (1704-1761)
Spring
Oil on copper,
43.8 x 57cm
Bequeathed by Mrs. J.
A. Bonnor, 1901
367-1901
The Tyrolean artist
Platzer entered the
Vienna Academy
in 1728, and worked
principally in the
Habsburg capital.
He was deeply
influenced by the
numerous 17th-
century Flemish
pictures in the
Imperial collection,
and those of the
Austrian nobility.
Platzer specialized
in minutely painted
festive scenes, in oils
on copper. This is
one of a series of
four representing
the Four Seasons.

thereby prevent their thriving in our native clime
... Portrait painting therefore ever has, and ever
will succeed better in this Country than in any
other; the demand will be as constant as new
faces arise ... Who can be expected to give forty
guineas for a modern landscape, though in
ever so superior a style, when he can purchase
one, which, for little more than double the
sum, shall be sanctioned by a sounding name,
and warranted original by a solemn-faced
connoisseur? This considered, can it excite
wonder that the arts have not taken such deep
root in this soil as in places where the people
cultivate them from a kind of religious necessity,
and where proficients have so much more profit
in the pursuit?[2]

Believing that 'everything requisite to
complete the consummate painter' was readily
available in London, Hogarth proposed 'modern
moral subjects' to compete with imported
works in the Grand Manner. He recognized that
British artists excelled in portraiture, which
was constantly in demand. His remarks on the
dilemma of landscape painters in the face of
foreign competition may be exemplified by
Richard Wilson's difficulty in finding a market
for his Claudian landscapes, in comparison with
the buoyant demand for the views of Canaletto,
who visited England in 1746-55.

When, in 1753, Dr John Brown (1715-66) sought
to characterize the beauty of the Lake District,
he utilized the respective styles of the then
canonical trio of seventeenth-century landscape
painters – Claude Lorrain, Salvator Rosa and
Gaspard Dughet, then known as Poussin:

the full perfection of KESWICK consists of three

Luca Carlevarijs
(1663-1730)
*A lady seen from
behind, holding a fan*
Oil on canvas,
22 x 9.8cm
Purchased, 1938
P.71-1938
Carlevarijs was
described in 1789 as
'The first of any note
who painted views of
Venice'. He published
a series of 104
engravings of the city
in 1703, and
specialized in large,
painted views. They
abound with figures
and local character,
and were influential
on his younger
colleague Canaletto.
This is one of a group
of 53 lively oil studies
of figures and other
motifs, for inclusion
in larger paintings.

circumstances, *Beauty, Horror* and *Immensity*
united ... [which would] ... require the united
powers of *Claude, Salvator, and Poussin*. The first
should throw his delicate sunshine over the
cultivated vales. The second should dash out
the horror of the rugged cliffs, the steeps, the
hanging woods, and foaming waterfalls; while
the grand pencil of *Poussin* should crown the
whole with the majesty of the impending
moutains.[3]

In 1765 Horace Walpole noted ironically that
the persistent fashion for Italian scenery
encouraged neglect of the British landscape:

As our poets warm their imaginations with sunny
hills, or sigh after grottos and cooling breezes, our
painters draw rocks and precipices and
castellated mountains ... Our ever-verdant lawns,
rich vales, fields of hay-cocks, and hop-grounds,
are neglected as homely and familiar objects.[4]

This taste for naturalism, in opposition to
the perceived artificiality of much French or
Italianate painting, was not confined to English
writers. It was also expressed by the French
writer and critic Denis Diderot (1713-84), best
known as editor of the *Encyclopédie*, but also
one of the most acute commentators on art
of the eighteenth century. Diderot's diatribe
against the works of François Boucher at the
1765 Salon is a celebrated critique of the taste
of the *Ancien Regime*:

I don't know what to say about this man.
Degradation of taste, colour, composition,
character, expression, and drawing have kept
pace with moral depravity. What can we expect
this artist to throw onto the canvas? What he
has in his imagination. And what can be in the
imagination of a man who spends his life with
prostitutes of the basest kind? ... I defy you to
find a single blade of grass in any of his
landscapes. And there's such a confusion of
objects piled one on top of the other, so poorly
disposed, so motley, that we're dealing not so
much with the pictures of a rational being as
with the dreams of a madman ... He makes the
prettiest marionettes in the world; he'll end up
as an illuminator. Well, my friend, it's at precisely
the moment Boucher has ceased to be an artist
that he's appointed first painter to the king ...
And then in his landscapes there's a drabness
of colour and uniformity of tone such that,
from two feet away, his canvas can be mistaken
for a strip of lawn or bed of parsley cut into a
rectangle. But he's no fool, he's a false good
painter, like there are false wits. He doesn't
command the wisdom of art, only its *concetti*.[5]

Diderot championed the naturalistic still lifes
of Jean-Siméon Chardin (1699-1779), and wrote
encouragingly of the landscapes of the young
Jacques-Philippe de Loutherbourg:

Above: After Maria Felicita Tibaldi Subleyras
(1707-70)
Fan painted with The Triumph of Harlequin,
*c.*1750
Watercolour on kid leather, with carved
and pierced mother-of-pearl sticks inlaid
with silver-gilt foils and yellow gold,
30 x 55cm (open)
Bequeathed by Emily Beauclerk, 1920
T.153-1920
A design by the miniaturist Maria Subleyras
provided the source for the composition
on this fan, which was made in Rome.
It depicts figures in the costume of
Harlequin, a stock character from Bergamo
in the Italian popular theatre known as
commedia dell'arte. This theme became
widely known as a result of the annual
carnival in Venice, which attracted visitors
from all over Europe.

Right: German (Meissen, Porcelain
Manufactory), *c.*1735
Dish
Hard-paste porcelain, painted in enamels,
diam. 57.2cm
Given by Mrs Charles Staal in memory of
her husband, 1957
C.75-1957
The German painter of this large dish has
confronted two distinct Japanese styles of
decoration. They are divided into separate
fields by a line resembling a leaf edge, an
idea copied from Japanese ceramics. The
upper, with a squirrel on a hedge with a
vine, imitates the export porcelains known
as *kakiemon.* The lower is in the style
known as *imari.* Both wares were imported
into Europe in large quantities.

Here is a young artist who in making his debut
puts himself, with the beauty of his sites
and rustic scenes, with the freshness of his
mountains, with the truth of his animals,
on a par with old Berchem, and who dares
challenge him with the vigor of his brush, his
understanding of natural and artificial light, and
other qualities ... Take up the brush you've just
dipped into light, water, clouds; the various
phenomena filling your head that you have only
to fix to the canvas. While you busy yourself
during the brilliant midday hours painting the
freshness of the morning, the sky is preparing
a new spectacle ...[6]

Between the conclusion of the Seven Years
War in 1763 and the French invasion of Italy
in 1796, the Grand Tour was at the height of
fashion. Inundated with commissions by visitors
to Rome, Pompeo Batoni typically depicted
his sitters posing at ease before well-known
antiquities and views of the city.

The first systematic account of the aesthetics
and development of ancient Greek and Roman
art was *The History of the Art of Antiquity* by
Johann Joachim Winckelmann (1717-1768), the
papal Commissioner of Antiquities, published in
1764. This hugely influential treatise was widely
disseminated by works by other authors, and
remained current throughout Europe well into
the nineteenth century.

Winckelmann also hailed his close friend
Anton Raphael Mengs as 'a phoenix arisen from
the ashes of Raphael'. This cosmopolitan figure
was initially a court painter to the Elector of
Saxony in Dresden, and later served the King of
Spain. From 1751 he lived principally in Rome,
where his pre-eminence was acknowledged by
his election as Principal of the Academy of St
Luke. In addition to antique sculpture, Mengs'
principal models were the sixteenth-century
masters Raphael, Correggio and Titian, whom
he considered to exemplify, respectively, design,
shading and colour. He believed that:

To arrive therefore to perfection in Painting, it
is necessary first to accustom the sight to the
greatest exactness; then to put in practice the
rules of Art, and of representing all things:
these are the fundaments. In the second place,

Above: Canaletto (1697-1768)
Capriccio: ruined bridge with figures, 1740s
Oil on canvas, 35 x 68.6cm
Bequeathed by Chauncey Hare Townshend, 1868
1352-1869
The demand of visitors on the Grand Tour for pictures of eminent monuments, frequently ruins, engendered the fashion for a poetic assemblages of buildings from different places. These were known as 'capricci', a term derived from the Italian word for the erratic jumping of a young goat. Many of the pictures were painted in Venice. This example has been attributed both to Canaletto and his nephew Bernardo Bellotto (1722-80).

Left: Italian (Venice, Miotti glasshouse), c.1741
Plate with view of S. Simione Piccolo, after Canaletto
Opaque white glass, painted in enamels, diam. 22.5cm
Transferred from the Museum of Practical Geology, 1901
5272-1901
This plate is made of white glass, made opaque with an arsenic compound, in imitation of porcelain. Its decoration is based on an engraving by Antonio Visentini, after Canaletto, published in 1735. It is one of a set of 24, each with a different view of Venice, commissioned by the English wit, author and antiquarian Horace Walpole as a souvenir of his visit to Venice in 1741.

Pompeo Batoni (1708-1787)
Edward Howard, 1766
Oil on canvas, 139 x 101.5cm
Purchased, 1949
W.36-1949
Edward Howard, brother of the Duke of
Norfolk, visited Rome in 1764. David Garrick
thought him 'a very worthy good natured

Young Man'. He stands before a classical
vase and the Temple of Vesta. The
neoclassical frame with a medallion
showing the Roman goddess Minerva with
Cupid was made in London, perhaps by the
leading cabinet maker John Linnell (1729-
before 1796).

who have more mechanism than science, are
low imitators of Nature ... Those who limit
themselves only to the ideal, will never produce
more than sketches ... The ideal, nevertheless, is
as much more noble than the mechanical part,
as the soul is superior to the body ... With these
principles it is easy to judge of the merit of
Painters, since between two equals, one in the
imitation and the other in the ideal, it is just to
prefer the last to the first; and if a third unites
the two qualities he will be the most estimable
of all, as he possesses the art entire.[7]

Winckelmann and Mengs were leading
spokesmen for the increasingly idealized and
archaeological classicism which flourished
during the later eighteenth and early nineteenth
centuries.

Through the foundation of the Royal Academy
in 1768, its first president Sir Joshua Reynolds, and
a group of his friends and associates, effectively
gained control over taste and patronage in
England. This aroused immense discontent
among those who came into conflict with its
leaders, or remained outside its circle. Reynolds'
style had been formed in Italy, but history
paintings enjoyed little commercial popularity,
and he remained dependent on a lucrative
portrait practice. In 1784 he was appointed
Principal Painter to the King, despite the greater
popularity at court of Thomas Gainsborough. The
latter was a founder member of the Academy,
but he frequently quarrelled with it, and ceased
to exhibit there after a disagreement over the
hanging of a portrait. In his fourteenth and
penultimate *Discourse*, delivered to the Academy
in 1788, Reynolds considered the legacy of his
recently deceased rival:

When such a man as Gainsborough arrives
to great fame, without the assistance of an
academical education, without travelling to Italy
... he is produced as an instance, how little such
studies are necessary; since so great excellence
may be acquired without them ... However ... no

it is necessary to accustom the sight to good
objects, in order to separate them from the bad;
to distinguish the beautiful from the good, and
the best among the beautiful. The third
requisite is to know the reasons by which one
thing is more beautiful than another ... Those

Left: Anton Raphael
Mengs (1728-79), after
Raphael
The School of Athens,
1755
Oil on canvas,
425 x 840cm
Given by the Duke of
Northumberland,
1926
P.36-1926
This almost full-scale
copy of Raphael's
celebrated *School of
Athens* in the Vatican
was commissioned as
the centrepiece of
the picture gallery in
Northumberland
House, London, which
was demolished in
1874. It was originally
flanked by copies of
other famous
paintings by Raphael,
Guido Reni and
Carracci, whose work
was then regarded as
exemplifying the
classical ideal. Critics
considered Mengs'
copy to be the best
of the group.

John Robert Cozens (1752-1797)
The two great temples at Paestum, 1782
Pencil and watercolour on paper, 24.5 x
37.2cm
Purchased, 1973
P.2-1973

Cozens was one of the leading
watercolourists of his generation, with a
poetic style, expressed through transparent
washes. The ancient Greek temples at
Paestum, near Salerno in southern Italy,
were rediscovered in the 18th century and
much admired by visitors on the Grand
Tour. Cozens visited them with his patron
William Payne Knight in 1782, and made
pencil drawings, on which this watercolour
was based.

**Thomas Rowlandson
(1756-1827)**
*Vauxhall Gardens,
1784*
Watercolour on paper,
48.2 x 74.8cm
Purchased, 1967
P.13-1967
Rowlandson's first
major group
composition includes
over 50 recognizable
figures attending
an evening open
air concert at the
'Orchestra', one of
the principal
buildings at Vauxhall
Gardens. On the
first floor, above the
supper boxes, is the
singer Mrs Weichsel
accompanied by
musicians. The ladies
under the central tree
are reputedly the
beautiful Duchess
of Devonshire and
her sister Lady
Duncannon.

Richard Cosway (1742-1821)
Mrs Lowther, c.1780
Watercolour on ivory, 4.4 x 3.6cm, set in
the lid of an ivory and gold piqué snuff box
Given by Mr W. A. J. Floersheim, 1931
P.101-1931
In 1781 Cosway married the Anglo-
Florentine artist Maria Cosway, née
Hadfield (1759-1838). They lived in
considerable style, and their studio was
a centre of fashionable London society.

His work displays a virtuoso use of line.
This portrait purposefully exploits the
synergy between the flesh tones of the
sitter, the whiteness of her dress and the
ivory of the miniature's support, and the
box in which it is set.

Francis Towne (1739-1816)
The Source of the Arveiron: Mont Blanc in the Background, 1781
Watercolour on paper, 42.5 x 31.1cm
Purchased, 1921
P.20-1921
Towne was trained as a coach painter and became a drawing master, but was repeatedly rebuffed in his attempts to become a Royal Academician. He visited Italy in 1780-1, travelling via Savoy, where he made this watercolour. Towne made watercolour sketches out of doors, with careful notes of the weather and light conditions. His distinctively spare and geometric style was revolutionary for its time.

apology can be made for this deficiency, in that style which this academy teaches, and which ought to be the object of your pursuit ... you may be corrupted by excellencies ... and become bad copies of good painters, instead of excellent imitators of the great universal truth of things.[8]

Reynolds recognized that Gainsborough's natural talent allowed him to flout academic rules, and to exceed some of its most celebrated exponents, but he could not endorse this bad example, and emphasized instead the imitation of the ideal.

Given the insistence of Reynolds and his successor, Sir Benjamin West, on the centrality of oil painting in the Grand Manner, it is ironic that British artists continued to excel in portraiture and landscape painting, and especially at watercolours.[9] Yet despite the ancient and honourable traditions of the portrait miniature, and the emergence of an able new generation of practitioners, such as John Smart and Richard Cosway, the genre steadily declined in status. This was partly on account of its commercial success with an expanding pool of middle-class patrons solely concerned with obtaining a good likeness, and also because its traditional practice seemed peripheral to a method founded on careful figure drawing from the nude.

In contrast, the new medium of the landscape watercolour, which had quickly developed during the second half of the eighteenth century, was stigmatized as an artisan activity redolent of the colouring of prints, or as a fundamentally amateur pursuit, both incompatible with the dignity of an academy. Although the founder members of the Royal Academy had included the miniaturists Nathaniel Hone (1718-1784) and Jeremiah Meyer (1735-1789), as well as the watercolourist Paul Sandby (1731-1809), in 1772 draughtsmen were denied election to the Academy, and no miniaturists were elected between 1791 and 1842. In consequence, the Society of Painters in Water Colours was founded in 1804, and the short-lived New Society of Painters in Miniature and Water-Colours in 1807.

Despite its marginalization by the official hierarchy, the miniature continued to flourish while the watercolour went from strength to strength. The miniaturist Ozias Humphry (1742-1810) was appointed Portrait Painter in Crayons to the King in 1792, and Richard Cosway frequently styled himself 'Principal Painter of his most serene Prince of Wales' from 1785. Both

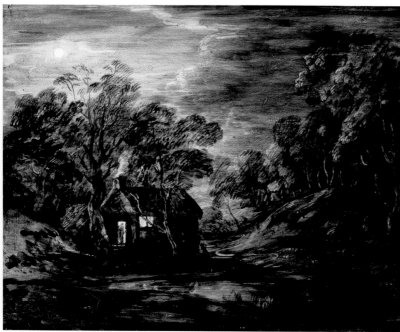

Left: Thomas Gainsborough (1727-1788)
Cottage and pond, moonlight
Oil on glass, 28 x 33.6cm
Bequeathed by E. E. Cook through the National Art Collections Fund, 1955
P.33-1955
Gainsborough had made a 'showbox' for viewing painted glass transparencies, illuminated by candles. In 1824 this work was described as 'Representing a most powerful effect of fire-light in the interior ... the contrast between the light of the cottage and that of the moon, excite the most pleasing association in the mind, and never fail to produce an instantaneous effect of pleasure and approbation'.

Above: Philippe Jacques de Louatherbourg (1740-1812)
The Falls of the Rhine at Schaffhausen, 1788
Oil on canvas, 134.6 x 198.2cm
Bequeathed by Joshua Dixon, 1886
1028-1886
De Loutherbourg settled in London in 1771, and visited Switzerland from 1787-8. This is his topographical masterpiece. It depicts visitors and local peasants admiring the largest waterfall in central Europe, near Zurich, likened by Goethe to 'the source of the ocean'. When exhibited at the Royal Academy a critic misidentified the scene as the Nile and complained 'The agitation of the waters ... resembles soap-suds'.

John Smart (1742-1811)
Unknown Indian Gentleman, 1789
Watercolour on ivory,
5.5 x 4.4cm
Bequeathed by Mrs.
K. Gifford Scott, 1984
P.16-1984
Smart was born in Norfolk and studied at Shipley's Art School in London. He was a highly successful miniaturist, with a painstaking technique. Smart spent 1785-95 working for the expatriate community and local Indian dignitaries at the great trading centre of Madras, in India. The powerful characterization of this likeness is typical of his strikingly direct style.

Humphry and John Smart sought commissions in the lucrative Indian market, as did the portrait painter Johann Zoffany (1733-1810) and the topographical artists Thomas Daniel (1749-1840) and William Daniel (1769-1837).

The flexibility of watercolour made it especially amenable for depicting landscapes, whether at home, on the Grand Tour, or as far afield as China, where William Alexander accompanied the first British embassy from 1792-94. Other watercolourists explored the spontaneity of their medium, and its capacity to capture transient effects of light and weather. By the end of the eighteenth century, public

Right: William Alexander (1767-1816) *The Emperor of China's Gardens, the Imperial Palace, Beijing,* 1793 (detail)
Watercolour on paper, 23.5 x 35.5cm
Bequeathed by William Smith, 1876
2930-1876
From 1792-4 Alexander accompanied the first embassy from Britain to China, led by Lord Macartney, with the objective of easing trade restrictions. Alexander made many drawings of China, some of which were reproduced in the published account of the embassy and other illustrated books. They were enthusiastically received by a public acquainted with the fashion for Chinese-style decoration known as chinoiserie.

Left: Chinese, Qing dynasty, period of Quianlong, c.1736-95
Vase, with landscapes of the four seasons
Porcelain with celadon green glaze and overglaze enamel decoration, 36.5 x 27.5 x 20cm
Bequeathed by George Salting, 1910
C.1466-1910
This vase was made at the Imperial porcelain factory at Jingdezhen, in Jiangxi province in central-southern China. It is characteristic of the finest Chinese porcelain produced in the 18th century. Such works were reserved for the highest echelons of Chinese society. Its finely painted scenes depict landscapes of the four seasons with appropriate short poems, a common and auspicious theme.

exhibitions, auctions, new illustrated media and the growth of art literature and journalism made painting accessible to an ever-wider public. Aristocratic courts remained important centres of patronage, and in some areas the hegemony of the academy created new restrictions, but the art world was hugely enlarged, more diverse and increasingly plural in outlook.

6 Painting is but Another Word for Feeling

Although the Royal Academy never attained the dictatorial powers of its French model, it was the dominant force in British art from the reign of George III until that of Queen Victoria. The very existence of its approved curriculum invited dissent. In his fifth *Discourse on Art*, delivered in 1772, Sir Joshua Reynolds cautioned that:

If you mean to preserve the most perfect beauty *in its most perfect state*, you cannot express the passions, all of which produce distortion and deformity ... [and continued] ... we need not be mortified or discouraged at not being able to execute the conceptions of a romantick imagination. Art has its boundaries, though imagination has none.[1]

While Reynolds drew back – on grounds of propriety – from extremes of emotion or flights of the imagination, younger painters colonized this new territory, pushing their subject matter to the limits of the naturalistically portrayable including dreams, nostalgia, desire and despair.

The annotations made by William Blake in his own copy of the second (1798) edition of Reynolds' *Discourses*, epitomize a widening fault line in art at the turn of the eighteenth and nineteenth centuries.[2] Despite the passion of Blake's celebrated tirade against 'the Opression of Sr Joshua & his Gang of Cunning Hired Knaves', the visionary poet, painter and printmaker actually shared substantial common ground with the urbane and influential Reynolds, the past master of the Grand Manner. Consequently, the expletives which Blake liberally sprinkled over his copy of the *Discourses* range from 'Villainy!', 'A Lie!' and 'Nonsense!' to 'True!', 'Excellent!' and 'Well Said!'.

The contradictions in Reynolds' arguments which irritated Blake, arose from his attempt to reconcile increasingly subjective thinking with the rational traditions of European art criticism. Blake tended to skip over their points of agreement with a perfunctory word of assent, while damning 'Reynolds's Opinion ... that Genius May be Taught & that all Pretence to Inspiration is a Lie & a

Above: John Constable (1776-1837)
Study of cirrus clouds, c.1822
Oil on paper, 11.4 x 17.8cm
Given by Isabel Constable, 1888
784-1888
Constable devoted considerable time to making studies of the sky because it was the 'source of light in nature', and 'the chief Organ of sentiment'. The inscription cirrus on the reverse of this sketch suggests that he had studied Thomas Forster's *Researches About Atmospheric Phaenomena*, published in 1815 'with a series of engravings, illustrative of the modifications of the clouds'.

Right: William Blake (1757-1827)
Christ in the Sepulchre, guarded by angels
Watercolour on paper, 42.2 x 31.4cm
Given by the heirs of Esmond Morse, 1972
P.6-1972
Blake here interprets the New Testament subject of Christ in the tomb in terms of the Old Testament description of the Tabernacle (Exodus, xxv, v. 20): 'the cherubims shall stretch forth their wings on high, covering the mercy seat'. The composition recalls the Gothic arches above the medieval tombs in Westminster Abbey, which the artist had drawn while a young apprentice engraver.

Deceit'. He continued, 'if it is a Deceit, the whole Bible is Madness', and scornfully concluded 'The Enquiry in England is not whether a Man has Talents & Genius, But whether he is Passive & Polite & a Virtuous Ass & obedient to Noblemen's Opinions in Art & Science. If he is, he is a Good Man. If Not, he must be Starved'.

A growing number of artists dissented from Reynolds' urbane ideal. John Robert Cozens painted Alpine watercolours for the connoisseur and author Richard Payne Knight (1750-1824), which informed his theory of picturesque landscape. His solemn interpretations of Italian scenery hint at the melancholia which eventually overwhelmed him, and moved Constable to observe 'Cozens was all poetry'.[3] Blake planned a poem in memory of the Irish painter James Barry, whose ferocious concentration on history painting had alienated him from society, and recalled bitterly that he had 'Lived on Bread & Apples' and remained 'Poor & Unemploy'd except by his own energy', although he 'Painted a Picture ... equal to Rafael or Mich. Ang. or any of the Italians'.[4] Blake also strove to visualize the visionary imagery of the Bible, and the poetry of Gray, Milton, Bunyan and Dante. His political radicalism, religious

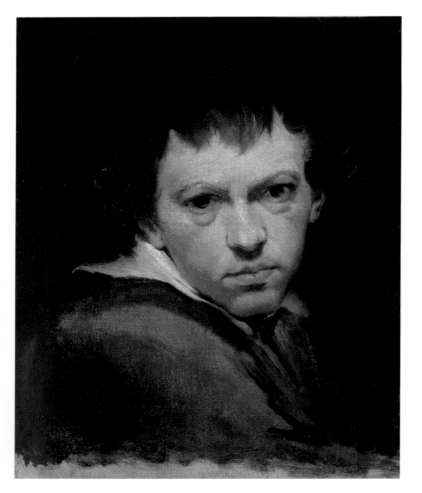

nonconformity and highly personal aesthetics limited his influence, although he was hailed as a heroic figure by younger men, including Samuel Palmer. Blake was not such a lonely figure as his admirers liked to think, but he expressed the essence of his creed in characteristically uncompromising terms as the 'Principal 1st' of his early tract *All Religions are One* (1788) arguing, 'the Poetic Genius is the true Man'.[5] Even the Swiss immigrant Henry Fuseli, an ordained clergyman with an extensive art historical education who became Professor of Painting and Keeper of the Royal Academy, perceived man to be the helpless victim of dark forces and inexpressible longings.

In 1793 Republican France declared war on Britain and, with only brief intervals, the two countries remained in conflict until the defeat of Napoleon at Waterloo in 1815. For a generation it was almost impossible for the British to visit mainland Europe. The tradition of the Grand Tour was broken, and painters and poets sought inspiration in their native landscape. As young men, Joseph Mallord William Turner and Thomas Girtin were employed by Dr Thomas Monro (1755-1833), the physician who tended Cozens after he lost his sanity, to copy drawings by Cozens and others. Both were initially watercolourists, but recognized how oil painting was esteemed above this humbler technique. Girtin failed to obtain a single vote in his candidature for associate membership of the Academy in 1801, the year before Turner was elected a full academician, submitting as his diploma work the large oil painting *Dolbadarn Castle, North Wales*.

The Academy became the lynchpin of his social existence, and he was elected its Professor of

J. M. W. Turner (1775-1851)
Warkworth Castle, Northumberland – thunderstorm approaching at sunset, 1799
Watercolour on paper, 50.8 x 75cm
Given by Mrs Ellison, 1860
FA 547
The sketch for this ambitious watercolour was made during a visit to the North of England in 1797. It was exhibited at the Royal Academy with lines from James Thomson's poem *The Seasons*: 'Behold slow settling o'er the lurid grove/Unusual darkness broods; and growing, gains/The full possession of the sky; and on yon baleful cloud/A redd'ning gloom, a magazine of fate,/Ferment.'

Perspective. Through his long career, Turner sought to confirm the status of landscape as a serious art form, striking overt comparisons with old master paintings, and favouring themes with historical subjects or literary associations. His literary sources ranged from Ovid and the Bible to English authors, such as Milton, Scott and Byron. By 1812 he was engaged on a long manuscript poem titled *The Fallacies of Hope*, which was never completed, but supplied numerous quotations for display beside his later works. Turner explored the psychological, emotional and symbolic range of the landscape genre, and investigated the emotional associations of colour, developing spectacular colour effects which dazzled his audience. Acutely aware of his relationship to the art of the past, he was no less alert to the work of his contemporaries, and particularly that of John Constable.

While Turner travelled extensively, and painted a wide range of subjects, Constable focused almost obsessively on his native Suffolk, and a handful of other locations in London and the South of England which he knew intimately. He reputedly claimed, 'When I sit down to make a sketch from nature, the first thing I try to do is, *to forget that I have ever seen a picture*'.[6] His spontaneous outdoor oil sketches provided a store of compositional motifs, and sometimes the basis for entire compositions.

Constable met William Wordworth (1770-1850) several times, and admired his poetry. Towards the end of his life, the painter copied out one of the poet's most famous verses:

My heart leaps up when I behold
 A rainbow in the sky:
So was it when my life began;
So is it now I am a man;
So be it when I shall grow old,
 Or let me die!
The Child is father of the Man;
 I could wish my days to be
Bound each to each by natural piety.

J. M. W. Turner (1775-1851)
East Cowes Castle: the Regatta starting for their Moorings, 1827-8
Oil on canvas, 91.4 x 123.2cm
Given by John Sheepshanks, 1857
FA.210
The yachts are returning to their moorings watched by onlookers, and the castle is silhouetted by the setting sun, on the hill, centre-left. This painting was originally one of a pair, the other a scene of the yachts racing at sea. It was a favourite of John Ruskin, who considered it 'not only a piece of the most refined truth ... but, to my mind, one of the highest pieces of intellectual art existing'.

This poem, written in 1802, links the innocence and profundity of childhood experiences with the feelings of joy and enlightenment evoked by the wonders of nature.[7] It seems peculiarly apt that it moved the elderly Constable, whose spontaneous oil sketches of the sky, clouds and rainbows have a similar force and acuity. Wordsworth's hymns of praise to natural phenomena, such as an oak tree or waterfall, a season of the year or twilight, bring to mind Constable's fascination with the effects of nature, of which he famously observed:

But the sound of water escaping from Mill dams, so do Willows, Old rotten Banks, slimy posts, & brickwork. I love such things ... As long as I do paint I shall never cease to paint such Places. They have always been my delight ... Painting is but another word for feeling.[8]

The artists of the Norwich school, in particular, found common cause with the Suffolk-born Constable. John Crome was a founder of the Norwich Society of Artists. His direct vision and limpid colour reflect observation of nature, as well

Thomas Girtin
(1775-1802)
Kirkstall Abbey,
Yorkshire: Evening,
c.1801
Watercolour on
paper, 31.7 x 52cm
Purchased, 1885
405-1885
One of Girtin's most
spectacular
conceptions, this
work of around 1801
is based on sketches
of a ruined Cistercian
abbey near Leeds. Its
dramatic lighting,
solemn palette and
panoramic scale
recall 17th-century
Dutch landscapes.
The powerful impact
of this composition is
achieved by the
contrast between the
sombre colours and
simple forms, and the
vivid streak of sunset
light between the
horizon and clouds.

John Constable
(1776-1837)
Brighton beach, with
colliers
Oil on paper,
14.9 x 24.8cm
Given by Isabel
Constable, 1888
591-1888
This sketch depicts
coal brigs against the
horizon. It is
inscribed: '3d tide
receding left the
beach wet - Head of
the Chain Pier Beach
Brighton July 19 Evg.,
1824 My dear Maria's
Birthday Your
Goddaughter – Very
lovely Evening –
looking eastward –
cliffs & light off a
dark grey [?] effect –
background – very
white and golden
light'. Constable sent
it to John Fisher, the
godfather of his
daughter Maria
Louisa.

John Constable (1776-1837)
Boat-building near Flatford Mill, 1814/5
Oil on canvas, 50.8 x 61.6cm
Given by John Sheepshanks, 1857
FA.37

This scene portrays a subject well-known to the artist: the construction of a grain barge in a dry dock which belonged to Constable's father. It is based on a tiny pencil drawing, dated 1814, in a sketchbook also at the V&A. Long before the practice was common, Constable painted this landscape entirely in the open air. His friend and biographer C. R. Leslie praised its 'atmospheric truth' such 'that the tremulous vibration of the heated air near the ground seems visible'.

Opposite, bottom left: John Constable (1776-1837) *Study of the trunk of an elm tree, c.1821* Oil on paper, 30.6 x 24.8cm Given by Isabel Constable, 1888 786-1888 Constable made numerous studies of trees, and exhibited a highly finished drawing of a stand of elms in 1818. This sketch was probably painted in Hampstead. Its uncompromising realism has a photographic quality. C. R. Leslie recalled, 'I have seen him admire a fine tree with an ecstasy of delight like that with which he would catch up a beautiful child in his arms'.

Opposite, bottom right: John Crome (1768-1821) *Landscape with cottages* Watercolour on paper, 52 x 42.3cm Puchased, 1877 620-1877 Crome was a leading master of the naturalistic landscape. He believed in 'one grand plan of light and shade', and that 'Trifles in Nature must be overlooked that we may have our feelings raised by seeing the whole picture at a glance, not knowing how or why we are so charmed'. His work was criticized for its lack of finish, but shortly after his death collectors were reputedly 'crazy for his pictures'.

as the study of Dutch seventeenth-century landscapes, and the work of Wilson and Gainsborough. Crome's work is sometimes mistaken for that of the watercolourist John Sell Cotman. Like Girtin and Turner, Cotman belonged to the circle of Dr Monro, and was also hugely impressed by the ample landscape and ancient monuments of Yorkshire and North Wales. And like Constable, Cotman often felt thwarted in his ambitions, and was prone to depression. Disappointed not to be elected a member of the Society of Painters in Water Colours, he withdrew to his native Norfolk. His customary subjects – seemingly informal glimpses of old buildings and overgrown landscape – belong to the established repertory of landscape, lightened by a sensitivity to the organization of line, plane and volume.

In 1817, following the end of the Napoleonic Wars, Cotman was able to make the first of several tours of Normandy, whose southern region he described as 'everything a painter could wish for ... the Wales of France'. The same year, the family of Richard Parkes Bonington moved from Nottingham to France, where he studied in Calais and Paris, before embarking on a series of sketching tours of the coastal region of northern France. The Birmingham-born watercolourist David Cox also toured France and the Netherlands before discovering the mountainous landscape of North Wales, to which he returned annually for over a decade.

Even as these painters celebrated the rural landscape, large tracts of it were rapidly disappearing beneath spreading cities and factories. Nostalgia for the fruitfulness and simplicity of a world untouched by the Industrial Revolution became an enduring theme in painting. From 1819-21 the elderly William Blake produced the series of woodcut illustrations to an edition of Virgil's *Eclogues* which stirred the imagination of the group of young artists, known as the 'Ancients', who assembled at the village of Shoreham, in Kent, in the late 1820s and early '30s. Their principal member, Samuel Palmer, was

George Henry Harlow (1787-1819) *Self-portrait, 1818* Watercolour on ivory, 13.1 x 9.9cm Purchased, 1988 E.1081-1988 Harlow was a student of Thomas Lawrence, and was admired for his technical facility. In 1818 he visited Italy and was elected a member of the Academy of St Luke in Rome, as well as the Academy of Fine Arts in Florence, to which he presented the oil self-portrait on which this miniature is based. Clad in a cloak, Harlow clearly presents himself as a dashing Byronic hero.

thrilled by Blake's woodcuts, which he described thus:

They are visions of little dells, and nooks, and corners of Paradise; models of the exquisitest pitch of intense poetry. I thought of their light and shade, and looking upon them I found no word to describe it. Intense depth, solemnity, and vivid brilliancy only coldly and partially describes them. There is in all such a mystic and dreamy glimmer as penetrates and kindles the inmost soul, and gives complete and unreserved delight, unlike the gaudy daylight of this world. They are like all that wonderful artist's works the drawing aside of the

**Left: John Sell Cotman
(1782-1842)**
*Chirk Aqueduct,
c.1806-7*
Watercolour on paper,
31.6 x 23.2cm
Purchased, 1892
115-1892
Cotman toured Wales
in 1800, and may have
seen Chirk Aqueduct,
near Wrexham, but
the identification of
this arresting
structure has been
disputed. Its
monumentality is
expressed by the
implied infinity of the
arches and the low
viewpoint, mirrored by
the reflection below.
This abstract, formal
quality has a
remarkable
timelessness,
challenging the canon
of Grand Tour
architectural
topography.

**Right: Richard Parkes
Bonington (1802-28)**
*The Corso
Sant'Anastasia, Verona,
with the Palace of
Prince Maffei,* 1826
Watercolour on paper,
23.5 x 15.9cm
Bequeathed by
William Smith, 1876
3047-1876
In 1817 Bonington and
his family moved from
England to France,
where he and his
friend Eugene
Delacroix helped
create a fashion for
medieval 'troubador'
subjects. Bonington's
fresh and sparkling
watercolours were
appreciated by
collectors in both
countries. In 1826 he
visited northern Italy,
and made several
drawings in Verona
which were later
worked up as
watercolours.

fleshly curtain, and the glimpse which all the
most holy, studious saints and sages have enjoyed
of the rest which remaineth to the people of God.[9]

Despite Palmer's vow that 'I will, God help me,
never be a naturalist by profession', the
transcendental fervour of his youthful Shoreham
period receded, and he pursued a rather

conventional career as a landscape watercolourist.
Only towards the end of his life, in a series of
etchings, did he recapture much of his youthful
vision. The gulf between the inner life of the spirit
and the outward world of experience remained a
central conditioning factor in nineteenth-century
painting.

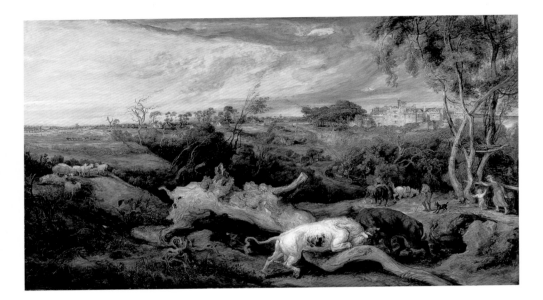

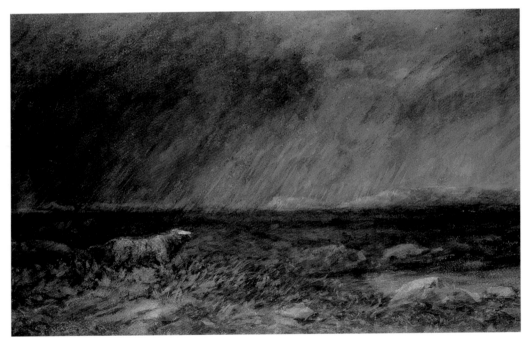

Top: James Ward (1769-1859)
Bulls Fighting, with a view of St Donats Castle, Glamorganshire, 1804
Oil on panel, 132 x 228cm
Given by C.T. Maud, 1871
220-1871
Ward specialized in animal paintings. This work is based on Rubens' *View of the Château de Steen, Autumn*, now in the National Gallery. The President of the Royal Academy, Benjamin West, considered that its 'perfection of execution' made Rubens seem 'gross and vulgar'.

John Constable thought it 'showed how inferior a production made upon a picture is to one that is founded on original observation'.

Above: David Cox (1783-1859)
On the Moors, Near Bettws-y-Coed
Watercolour on paper, 45.4 x 64.8cm
Bequeathed by Chauncey Hare Townshend, 1869
1427-1869
Cox often depicted, as here, landscapes assaulted by driving rain and strong winds. The image is of a

lone and powerful animal confronting the brute force of nature; in a vast landscape the bull withstands the devastating storm raging about him. In keeping with the wild subject matter, the watercolour has been applied to the paper in a rapid, rough and expressive way.

Right: Samuel Palmer (1805-81)
In a Shoreham garden, c.1829 (detail)
Watercolour and gouache on paper, 28.3 x 22.3cm

Purchased, 1926
P.32-1926
Palmer's religious faith pervades his early work produced at Shoreham in Kent. This magical work with its apple tree in blossom, woman and snake-like creeper, lower-right, suggests the Garden of Eden. He wrote that '... spring showers, blossoms and odours in profusion ... Breathe on earth the air of Paradise'. The unnaturalistic colour and clotted paint are consciously at variance with traditional watercolour practice.

7 The Heroism of Modern Life

Above: Gustave Moreau (1826-1898)
Sappho, c.1884 (detail)
Watercolour on paper, 18.4 x 12.4cm
Given by John Gray, in memory of André
Raffalovich, 1934
P.11-1934
Moreau emphasized the spiritual nature
of art rather than realism. This work was
inspired by an opera by Charles-François
Gounod. It depicts the ancient Greek
poetess Sappho, who committed suicide
after being abandoned by her lover.
Sappho belonged to André Raffalovich,
a patron of Beardsley, and later to John
Gray, the poet who reputedly inspired
Oscar Wilde's *The Picture of Dorian Gray*.

**Right: Dante Gabriel Rossetti
(1828-1882)**
The Daydream, 1880
Oil on canvas, 158.7 x 92.7cm
Bequeathed by Constantine Ionides, 1901
CAI.3
The sitter was Jane Morris, the wife of
William Morris, who often posed for
Rossetti. He first conceived this work
as a representation of Spring, but later
changed it to the present subject, about
which he also wrote a sonnet which ends:
She dreams; till now on her forgotten
book
Drops the forgotten blossom from her
hand.

The revival of classical art in the later eighteenth
and early nineteenth centuries, subsequently
dubbed 'neoclassicism', actually sought a timeless
'true style'. It differed from previous revivals
through the archaeological accuracy with which
it reflected its model, and its co-existence with
alternative styles ranging from 'Gothick' to
chinoiserie.

In France, neoclassicism was firmly established
as the official style of the Académie des Beaux-
Arts, and painters led by Jacques Louis David
(1748-1825) placed it at the service of the dynamic
new regime which rose from the debris of the
French Revolution. The study of antiquity, Raphael
and the old masters was central to its artistic
curriculum, and its coveted *Prix de Rome*, awarded
to outstanding students, was won by Jean
Auguste Dominique Ingres in 1801. He was
rehabilitated after the fall of Napoleon, elected
to the Académie, and appointed director of the
French school in Rome.

Ingres' great rival, Eugène Delacroix, came to
prominence during the 1820s. Inspired by Rubens
and the great Venetian colourists, by the works of
Shakespeare and Lord Byron, and acquainted with
the pictures of Constable, Delacroix revitalized
painting in the Grand Manner, and was acclaimed
as the leader of the Romantic movement.
The contrast between his brushwork and Ingres'
draughtsmanship revived the old dispute over
the relative importance of colour as opposed to
design, exemplified for earlier generations by the
difference between Raphael and Titian or Rubens
and Poussin.

In a review of the 1845 Salon, the poet and critic
Charles-Pierre Baudelaire (1821-67) distinguished
between 'two types of drawing, the drawing of the
colourists and the drawing of the draughtsmen':

We know of only two men in Paris who draw as
well as M. Delacroix – the one in an analogous
manner, the other adopting a contrary method.
The one is M. Daumier, the caricaturist; the other
M. Ingres, the great painter, the cunning admirer

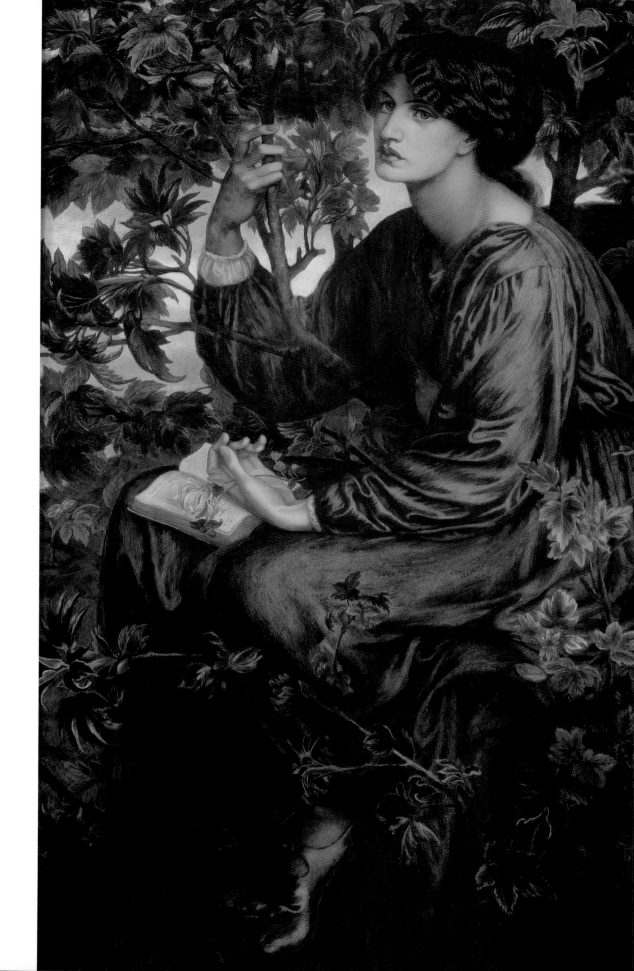

Jean Auguste Dominique Ingres (1780-1867)
A sleeping odalisque, c.1839
Oil on canvas, 29.8 x 47.6cm
Bequeathed by Constantine Ionides, 1901
CAI.57

Ingres was thoroughly familiar with Reniassance paintings of the reclining female nude, and it became one of his favourite themes. This oil sketch is probably a study for his partially draped *Odalisque with a Slave*, dated 1839, at the Fogg Art Museum in Harvard. As in that painting, the figure's right arm was formerly folded back behind her head. The artist later changed it to its present position.

Eugène Delacroix (1798-1863)
The Shipwreck of Don Juan, c.1840
Oil on canvas, 81.3 x 99.7cm
Bequeathed by Constantine Ionides, 1901
CAI.64

Lord Byron's epic poem *Don Juan* was published in 1819. In the incident depicted here the shipwrecked hero and his companions draw lots 'in silent horror' to decide 'who should die to be his fellows' food'. Thirty figures are depicted crowded into the boat, the exact number which is mentioned in the text. This sketch served as the basis for a larger painting, exhibited at the Salon in 1841, now in the Louvre.

of Raphael ... Daumier draws better than Delacroix perhaps, if, that is, we choose to prefer healthy and robust qualities to the striking powers of a great genius, sick with genius. M. Ingres, so fond of detail, draws better, perhaps, than either of the other two, if we like painstaking delicacy better than a well-proportioned whole, and a composition studied bit by bit rather than seen and rendered as a whole, but ... let us love them all three.[1]

Meanwhile, the central significance of history painting gradually declined after the establishment in 1816 of a second *Prix de Rome*, awarded for landscape. At the village of Barbizon, on the edge of the forest of Fontainbleau, Jean Baptiste Camille Corot (1796-1875) and Theodore Rousseau specialized in *plein air* sketches painted outdoors. The latter earned the ironic nickname *le grand refusé* on account of his exclusion from the

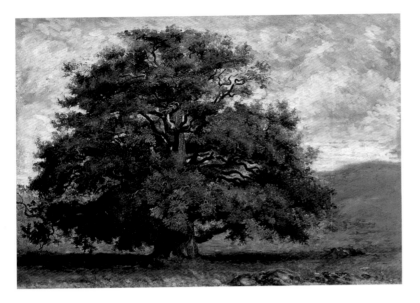

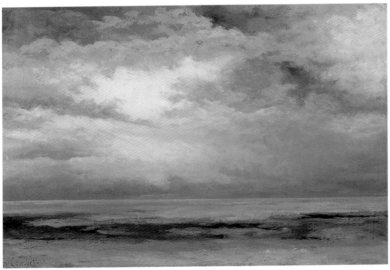

Left: Theodore Rousseau
(1812-1867)
*An oak tree in Fontainebleau
Forest, c.1840*
Oil on paper, laid down on
canvas, 40.4 x 54.2cm
Bequeathed by Constantine
Ionides, 1901
CAI.54
From 1836 Rousseau worked
at Fontainebleau, south-east
of Paris. He was the leader of
the Barbizon School which
specialized in naturalistic
landscapes. Rousseau painted
a number of individual
studies of trees which have a
portrait-like character, and an
air of pathos. An inscription
describes this one as a
dormoir: a shady place where
herds sheltered.

Salon, where he did not exhibit from 1836-49.
But Baudelaire considered Corot and Rousseau
to be the leading landscape painters of his time.
While disparaging the 'general tendency of our
artists to clothe all manner of subjects in the
dress of the past', he also praised Delacroix as
'decidedly the most original painter of ancient
and modern times', and held that 'Romanticism
and modern art are one and the same thing, in
other words: intimacy, spirituality, colour, yearning
for the infinite, expressed by all the means the
arts possess'.[2]

Some of Baudelaire's most prophetic remarks
on painting concern 'Of the heroism of modern
life', set out in his review of the 1845 Salon:

It is true that the great tradition is lost and that
the new one is as yet unformed. What was that
great tradition if not the ordinary and customary
process of idealizing life ... Before trying to isolate
the epic quality of modern life and to show ... that
our age is no less rich than ancient times in
sublime themes, it may be asserted that since
every age and every people have had their own
form of beauty, we invariably have ours ... As for
the frock-coat, that outer skin of the modern hero
... has it not got its own beauty and native charm
... Parisian life is rich in poetic and wonderful
subjects. The marvellous envelops and saturates
us like the atmosphere; but we fail to see it.[3]

As a consequence of the 1848 Revolution, the
Salons of 1848 and 1849 were open to all, and that
of 1850-1 was selected by a republican committee.
Consequently the painters of everyday life,
Gustave Courbet, Jean-François Millet and Honoré

Gustave Courbet
(1818-1877)
Immensity, 1869
Oil on canvas, 60 x 82.2cm
Bequeathed by Constantine
Ionides, 1901
CAI.59
Courbet spent the late
summer of 1869 at Etratat,
a village on the Normandy
coast popular with painters.

Unusually for its date, this
powerful seascape is entirely
devoid of human reference. It
may have been influenced by
the panoramic views of the
early French photographer
Gustave Le Gray. A critic
praised its portrayal of 'the
grand impassiveness of
nature'.

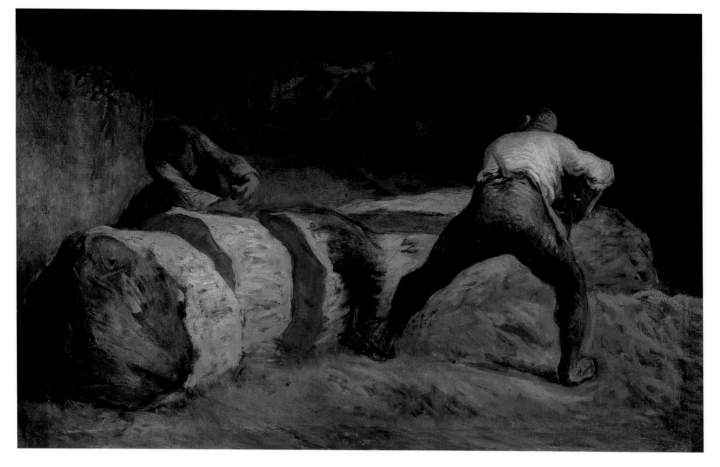

Jean-Francois Millet (1814-1875)
The wood sawyers, c.1850-2
Oil on canvas, 57 x 81cm
Bequeathed by Constantine Ionides, 1901
CAI.47
This vigorous work was painted after Millet
moved to Barbizon, near Fontainebleau.
X-ray photography shows that it is painted
over an allegorical figure of The Republic,
which he had submitted unsuccessfully
to a state competition in 1848. An early
example of Millet's epic naturalism, it
utilizes strong contrasts of light and
shade in order to emphasize the muscular
exertion of the sawyers, imbuing them
with a heroic quality.

Daumier, were well represented for the first time.
To the naturalism of the earlier Barbizon School of
painters, such as Corot and Rousseau, they added
an element of social criticism. While Courbet was
applauded as 'the first of the socialist painters', he
insisted in his 1855 essay – which has become
known as 'The Realist Manifesto' – that:

The title of Realist was thrust upon me just as the
title of Romantic was imposed upon the men of
1830 ... I have studied, outside of any system and
without prejudice, the art of the ancients and the
art of the moderns. I no more wanted to imitate
the one than to copy the other; nor, furthermore,
was it my intention to attain the trivial goal of *art
for art's sake*. No! I simply wanted to draw forth
from a complete acquaintance with tradition the
reasoned and independent consciousness of my
own individuality. To know in order to be able to
create, that was my idea. To be in a position to
translate the customs, the ideas, the appearance
of my epoch, according to my own estimation; to
be not only a painter, but a man as well; in short to
create living art – this is my goal.[4]

In correspondence with sympathetic critics in
the early 1860s, Millet denied allegations of
socialist leanings and explained: '... the beings I
represent look as though they are pledged to their
positions, so that it would be impossible to
imagine that they could be different ...'[5]

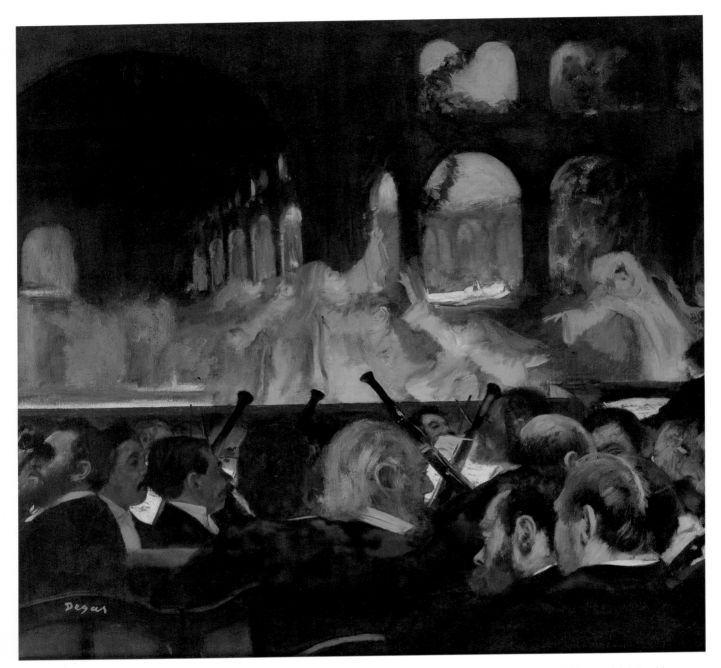

Following the example of Corot and Rousseau, outdoor painting became increasingly widespread, and was adopted by Claude Monet (1840-1926) around 1856. Shortly after, Edouard Manet (1832-83) began to reinvigorate the figurative tradition of French painting by turning afresh to Spanish and Dutch seventeenth-century pictures. He was initially rejected by the academic establishment, but was championed by liberal critics, such as Baudelaire and Emile Zola (1840-1902).

In recognition of the growing number of paintings by Manet and others which had been rejected by the Salon, a *Salon des Refusés* was organized in 1863 (because of official disapproval and public incomprehension the experiment was never repeated). Later, a number of younger artists assembled around Manet, and the first exhibition of the *Société Anonyme des artistes, peintres, sculpteurs, graveurs, etc.* was held in 1874. Its self-consciously non-partisan title reflects the extreme diversity of its outlook. The term 'Impressionist' subsequently applied to this exhibition, and

Opposite: Edgar Degas
(1834-1917)
*The ballet scene from
Meyerbeer's opera
'Robert le Diable'*, 1876
Oil on canvas,
76.6 x 81.3cm
Bequeathed by
Constantine Ionides,
1901
CAI.19
This macabre opera
with a medieval
setting was first
performed in Paris in
1831. This scene
features the ghosts
of nuns who had been
unfaithful to their
vows. The foreground
figures include
Degas' friends –
the collector Albert
Hecht, the bassoonist
Désiré Diahu and
the amateur painter
Vicomte Lepic.
Degas was fascinated
by the effects of
stage lighting,
and the exaggerated
movements of
dancers.

Right: Teisai Hokuba
(1771-1844)
Geisha by a river,
1830–44
Hanging scroll, ink
and colours on silk,
59 x 41cm
Purchased, 1903
D.175-1903
Scenes of the
entertainment district
of Edo (now Tokyo),
known as *ukiyoe*
('pictures of the
floating world'), were
popular in Japan
between the 17th and
19th centuries. One
genre was known as
bijinga ('pictures of
beautiful women').
Hokuba was a student
of Hokusai, and is
better known for his
prints. Numerous such
works were exported
after the opening of
Japan to the West in
the 1850s.

several that followed, was taken from the title of one of Monet's submissions, *Impression, soleil levant*, and a satirical dialogue published in the newspaper *Le Charivari*.

While Edgar Degas never shared the Impressionists' preoccupation with painting outdoors, he subscribed wholeheartedly to their desire to capture the distinctive visual experience of the modern world. He exhibited with the *Société Anonyme* from its foundation until its last exhibition in 1886, by which date the growing commercial success of its members had made its original terms of reference largely redundant. Degas was particularly fascinated by subjects from ballet, and developed a distinctive practice of viewing scenes from unusual angles. His perception of a composition in seemingly formal terms of colour and shade, instead of subject matter, is strikingly apparent from these notes of 1872 for *The ballet scene from Meyerbeer's opera 'Robert le Diable'*:

Shadow carried from the score on to the rounded back of the rostrum – dark grey background – bowstring brightly lit by the lamps, head of Georges in silhouette, light red shadows – flesh tones.

In the receding arches the moonlight barely licks the columns – on the ground the effect pinker and warmer than I made it – black vault, the beams indistinct ...

The tops of the footlights are reflected by the lamps – trees much greyer, mist around the receding arcades – the last nuns more in flannel colour but more indistinct – in the foreground the arcades are greyer and merge into one another ...

The receding vault is black, apart from a little reflection in the centre ...

The theatre boxes a mass of dark lacquered brick red – in the director's box, light red pink face, striking shirts, vivid black.

Near the lamp a dancer from behind on her knees, light falls only on her skirt. The back and the rest in quite deep shadow – striking effect.[6]

Degas' taste for asymmetrical compositions with abruptly cropped margins, and for scenes from the theatre and bathing, was schooled by his study of Japanese woodcuts. These were at the height of their popularity during the 1870s, and he owned over 100, some of exceptional quality. A Japanese art historian has aptly compared his work with that of the print maker Hokusai (1760-1849):

Hokusai and Degas are never satisfied with ordinary things or conventional visions. They seek out eagerly the bizarre and the unusal which are concealed in the underside of superficial reality. They scour this reality from every angle ceaselessly in their search for the unusual and the unexpected, because they believe, perhaps, that the essence of reality must be extremely bizarre and extraordinary.[7]

Francis Danby
(1793-1861)
Disappointed Love, 1821
Oil on canvas,
60.5 x 111cm
Given by John
Sheepshanks, 1857
FA.65
Disappointed Love
was the first painting
Danby exhibited, and
it became one of his
most popular works. It
depicts a heartbroken
young woman. Her
bonnet, shawl and a
miniature portrait of
her lover are beside
her, and a torn-up
letter floats away on
the pond. A Victorian
commentator
assumed that the girl
was on the verge of
suicide, and observed
that Danby 'sought to
treat his painting as a
poem'.

Edwin Landseer
(1802-1873)
*The Drover's Departure
– A Scene in the
Grampians*, 1835
Oil on canvas,
125.8 x 191.2cm
Given by John
Sheepshanks, 1857
FA.88
This painting depicts a
Highland drover
setting out from the
Grampian mountains
to drive cattle and
sheep to the English
markets. In 1855 a
French critic described
it as 'a curious picture
of national manners –
interesting as a page
of Sir Walter Scott.
There are a thousand
delicacies of detail in
this charming picture
... Landseer has given
the place of honour to
animals – man is but
an accesory on his
canvas'.

William Mulready (1786-1863)
The Sonnet, 1839
Oil on panel, 35 x 30cm
Given by John Sheepshanks, 1857
FA.146
This is one of the artist's most popular
works. A commentator described it as

follows: 'A bit of true character that will tell
with all who have been lovers. The youth is
fiddling with his shoe-tie, but casting
upwards a sly look, to ascertain what effect
his lines produce upon the merry maid who
reads them ... placing her hand before her
lips to suppress her laughter'.

John Everett Millais (1829-1896)
My Second Sermon, 1864
Watercolour on paper, 24.2 x 17.2cm
Purchased, 1901
399-1901
In 1863 Millais exhibited an oil portrait titled *My First Sermon*, depicting his daughter Effie wearing her best clothes, eagerly listening to a sermon in church. The following year he exhibited a sequel, which was reproduced in this watercolour version. The Archbishop of Canterbury described it as 'a warning of the evil of lengthy sermons and drowsy discourse'.

The paintings of Degas were initially more popular in Britain than those of his Impressionist contemporaries; the first of several being purchased by Henry Hill (1812-92) of Brighton in 1874, the year of the 'First Impressionist Exhibition'. Although Monet first encountered the work of Turner when he sought refuge in England from the Franco-Prussian War in 1870, Constable had received a gold medal for his *Haywain* at the Salon back in 1824. In fact, a high degree of literary and artistic interchange between Britain and France had existed since the end of the Napoleonic Wars[8] and, in 1846, Baudelaire mused:

Romanticism is a child of the North, and the North is a colourist; dreams and fairy tales are children of the mist. England, that homeland of out-and-out colourists, Flanders, half of France are plunged in fogs.[9]

Such a characterization may aptly be applied to the work of an artist such as Francis Danby, described after his death as 'England's most distinguished painter of the Romantic School'. He rivalled John Martin (1789-1854) in the depiction of highly coloured apocalyptic scenes, set in exotic or mythical locations. Other artists utilized the rapidly improving means of transport to explore Wales, Scotland and other distant regions of Britain. Edwin Landseer combined the everyday with the outlandish by specializing in rural subjects from the Scottish highlands. Like his friend David Wilkie, William Mulready specialized in highly finished genre scenes, ultimately inspired by seventeenth-century Dutch paintings. By working with transparent glazes on a white background, Mulready achieved effects of brilliant colour which foreshadow the techniques of the Pre-Raphaelites.

The invention of photography in the 1830s encouraged a re-assessment of the character and purpose of pictorial naturalism. While the dauguerrotype rapidly superseded the miniature as a form of portable portrait, the new medium rapidly provided painters with an enormous stock of images drawn from all times and places. They fed the growing eclecticism of Victorian painting.

In 1848 the Pre-Raphaelite Brotherhood was founded by three young painters, John Everett Millais, Dante Gabriel Rossetti and William Holman Hunt (1827-1910). Disenchanted with the tired conventionality of the Royal Academy, they

sought inspiration from nature, fifteenth-century art and subjects from the Bible, historical novels, and especially the poetry of Keats. Rossetti, the son of a refugee Italian professor, was also a poet, and his combined interests made a major contribution to the range and sensibility of Pre-Raphaelite art.

The submissions of Millais and Holman Hunt to the 1851 Royal Academy received a drubbing from the critics. This attracted the attention of John Ruskin (1819-1900), the most influential British art critic of the century, who had passionately advocated the pre-eminence of Turner as a landscape painter, and Gothic architecture as a moral building style. He wrote twice to *The Times* in defence of the Brotherhood:

These Pre-Raphaelites (I cannot compliment them on common-sense in choice of a *nom de guerre*) do *not* desire nor pretend in any way to imitate antique painting as such ... They intend to return to early days in this one point only – that, as far in them lies, they will draw either what they see, or what they suppose might have been the actual facts of the scene they desire to represent, irrespective of any conventional rules of picture-making; and they have chosen their unfortunate though not inaccurate name because all artists did this before Raphael's time, and after Raphael's time did *not* this, but sought to paint fair pictures, rather than represent stern facts; of which the consequence has been that, from Raphael's time to this day, historical art has been in acknowledged decadence ... And so I wish them [the Pre-Raphaelites] all heartily good-speed, believing in sincerity that if they temper the courage and energy which they have shown in the adoption of their systems with patience and discretion ... and if they do not suffer themselves to be driven by harsh or careless criticism ... they may, as they gain experience, lay in our England the foundations of a school or art nobler than the world has seen for three hundred years.[10]

Thereafter the Pre-Raphaelites rapidly achieved

Designed by William Burgess (1827-1881), made by Harland and Fisher, London; painted by Edward J. Poynter (1836-1919)
The Yatman Cabinet, 1858
Pine and mahogany, painted, stencilled and gilded, 236 x 140 x 40.5cm
Given by Lt. Col. P.H.W. Russell, 1961
Circ.217-1961
The architect William Burgess was an extremely knowledgeable medievalist, and based the design of this cabinet on painted cupboards in the French cathedrals of Noyon and Bayeaux. Its scenes from ancient myth and medieval history were painted by Edward Poynter, whose work was famed for its anatomical and historical accuracy. This cabinet was exhibited in the London International Exhibition of 1862.

Edward Burne-Jones (1833-1898)
The Mill, 1870-82
Oil on canvas, 90.8 x 197.5cm
Bequeathed by Constantine Ionides, 1901
CAI.8
This painting of the Three Graces dancing to the music of Apollo was inspired by the work of Piero della Francesca and other Renaissance masters. The sitters for the principal figures came from the Anglo-Greek circle of its patron, Constantine Ionides. They are, from the left: his cousin Mary Zambaco, who was Burne-Jones's lover, his sister Aglaia Coronio and their friend Marie Spartali, a noted beauty.

acceptance, both from the art establishment and a circle of wealthy, middle-class patrons. Assimilation into the mainstream of the Victorian art world swiftly caused the break-up of the original Brotherhood, but it attracted a wider circle of artists to its ideals. A leading figure in this movement was Edward Burne-Jones. As students at Oxford, he and his friend and collaborator William Morris devoted themselves to art. Despite being virtually self-taught, in the 1870s Burne-Jones became the leader of a new school inspired by Italian Renaissance art, and acquired a considerable reputation in Britain and further afield, in France and Germany. With Rossetti he was a partner in Morris & Co., the co-operative founded in 1861 to produce well-designed decorative work, usually inspired by medieval or Renaissance themes. Similar, elaborately ornamental furniture was designed by the architect William Burges.

While the Pre-Raphaelites sought inspiration in the art of the past, others explored distant lands. Despite the support of Lord Byron and Delacroix for the Greek war of independence, most Europeans

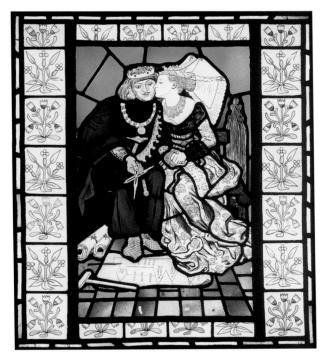

THE LAPSE OF THE YEAR

Top, right: Designed by Ford Madox Brown (1828-1882), made by Morris, Marshall Faulkner & Co.
Architecture, from a series of King Rene's Honeymoon, c.1863
Stained and painted glass,
64.2 x 54.8cm
Purchased, 1953
Circ. 516-1953
This panel is one of four designed for the home of the painter Myles Birket Foster. They depict incidents from the life of the 15th-century René of Anjou, the art-loving King of Sicily and Jerusalem. The designs were originally made to decorate an oak cabinet designed by John Pollard Seddon. This was exhibited in the London International Exhibition of 1862, and is now also in the V&A.

Right: William Morris (1834-96) and Charles Fairfax Murray (1849-1919)
The Four Seasons, 1870
Decorated page in A Book of Verse, p.40
Ink, watercolour and gold on paper,
27.9 x 21.6cm
Purchased, 1953
NAL L.131-1953
This book imitates the medieval manuscripts which fascinated Morris. He wrote the text in a hand based upon 16th-century Italian script, and Fairfax-Murray did most of the decoration, assisted by George Wardle and Edward Burne-Jones. It was made for the latter's wife Georgiana. The subject matter of *The Four Seasons* recalls the illuminations of The Months which often appear in the calendars of books of hours.

now regarded the Ottoman Empire as a colourful curiosity rather than as a threat. Egypt became a popular destination for tourists, and by the late nineteenth century over 5,000 visitors a year were being registered at Thomas Cook's offices in Cairo. A pamphlet described this ancient stronghold of the mameluke sultans as 'no more than a winter suburb of London'.[11] This fascination with the Levant was shared by visiting artists, including Delacroix and David Roberts, as well as Holman Hunt and John Frederick Lewis. As European painters explored the Orient, artists from Morocco to Japan were drawn to the art of the West, which had acquired prestige from its association with technological and industrial progress.

The style and subject matter of the Pre-Raphaelites appeared increasingly old-fashioned in the face of the creed of 'art for art's sake' espoused by James McNeill Whistler (1834-1903). Throughout Europe, artists became impatient with contemporary materialism and the artistic supremacy of realism in its many guises, including the novels of Zola and the paintings of the Impressionists. Burne-Jones had spoken of a mysterious land which 'no-one can define or

Top left: Isma'il Jalayir (active *c*.1860–70) *Ladies round a samovar*, 1850s or 1860s (detail) Oil on canvas, 143.8 x 195cm Given by Lady Janet Clerk, 1941 P.56-1941 The Persian ruler Nasir al-Din Shah (reg.1848-96) patronized indigenous art forms while assimilating Western innovations. This characteristic is also evident in the superficially European style of his court painter Isma'il Jalayir. Here harem ladies enjoy afternoon tea from an imported tea set with a samovar, on a verandah overlooking a garden. Each detail of their splendid, but modestly cut, court dresses is minutely differentiated.

Bottom left: John Frederick Lewis (1805–1876) *Life in the Harem, Cairo*, 1858 Watercolour on paper, 60.6 x 47.7cm Purchased, 1893 679-1893 Lewis spent the years 1841-51 in Cairo, where he made numerous studies of Arab life. They provided the subject matter for watercolours which he painted after his return to England. The brilliant colour and meticulous detail of this work are irresistibly suggestive of exact reportage, although the composition of a lady awaiting her maid servant is actually derived from 17th-century Dutch genre scenes.

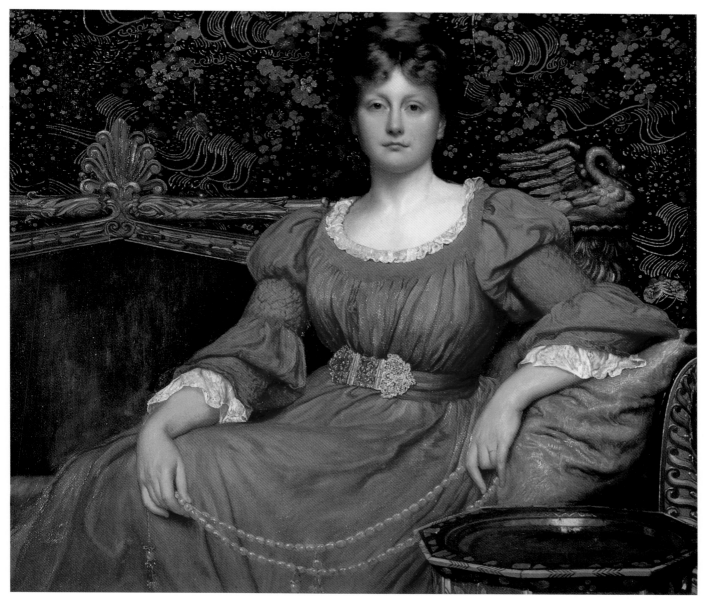

William Blake Richmond (1842-1921)
Mrs Luke Ionides, 1879
Oil on canvas, 102.2 x 115.2cm
Purchased, 2003
E.1062-2003
The sitter was the sister-in-law of the
Anglo-Greek art collector Constantine
Ionides. She is wearing a loose, flowing

'reformed' dress and amber beads. The
Empire sofa on which she is seated was
illustrated in 1881 in a book on advanced
interior decoration. Behind it is a screen
of embroidered Japanese kimono silk.
Her costume and setting epitomize
the taste of the Aesthetic movement.

remember, only desire'. His paintings, and the
poetic imagery of Rossetti, suggested how feelings
could be expressed rather than merely
represented. In France, the works of the American
author Edgar Allen Poe (1809-49) and Baudelaire's
Les Fleurs du Mal inspired the poets Arthur

Rimbaud (1854-91) and Jean Moréas (1856-1910),
whose 'Symbolist Manifesto' of 1886 provided an
apt label for this new movement.

Around the same time, the French art critic and
novelist J. K. Huysmans (1848-1907) celebrated the
visionary compositions of Gustave Moreau, whose
sources ranged from Burne-Jones and Delacroix to
the religious art of the fifteenth century. Burne-
Jones introduced the young Aubrey Beardsley to
the playwright and poet Oscar Wilde (1854-1900),
and encouraged him to pursue an artistic career,
but was appalled when his illustrations to
Malory's *King Arthur* appeared to parody the Pre-

Raphaelite style. Beardsley ironically acknowledged his own empiricism in a letter of 1893, in which he describes himself as :

... the coming man, the rage of artistic London, the admired of all schools ... I struck for myself an entirely new method of drawing and composition, something suggestive of Japan, but not really japonesque ... Strange hermaphroditic creatures wandering about in Pierrot costumes or modern dress ... My next step was ... Malory's Morte D'Arthur. The drawings were to be done in medieval manner ... nobody gave me credit for caricature and wash-work, but I have blossomed out into both styles ... Of course the wash drawings are most impressionist ...[12]

By the end of the century Beardsley and his friend Conder were fascinated by the flamboyant French poets known as the Decadents, after their Journal *Le Décadent*, and by eighteenth-century Rococo painting, which was again fashionable with collectors.

The broad consensus in the European art world around 1815 had been disrupted by a series of combative cultural movements which roughly coincided with the principal political upheavals between 1830 and 1871. In France and Britain the subversion of the authority of the Salon and the Royal Academy was confirmed by the foundation of the Société des Artistes Indépendants in 1884, and the New English Art Club in 1886. In their quest to reaffirm the emotional, spiritual and mystical in art, the Symbolists revived traditional forms of allegory which made their work moderately successful with the dispensers of official patronage. Their fascination with the ineffable fuelled the increasingly elaborate subject matter of modern art, while the discoveries of the Impressionists stocked its formal repertory. The future belonged to numerous alignments and groupings of artists, whose brief duration and often highly specific aims express the complexity and specialization of twentieth-century art.

Charles Conder (1868-1909)
Scene in Seville, 1905
Watercolour and gouache on silk, 192 x 203cm. (irregular)
Bequeathed by Amy Sarah Halford, 1963
P.38-1963
Conder lived for some years in Australia and France before returning to England. He visited Seville in 1905 for the Holy Week ceremonies. The 19th and 20th centuries witnessed a revival of interest in French Rococo art and decoration. Conder specialized in painting watercolours on silk, including fans, panels and even ball dresses. This work has the shape of a fire screen.

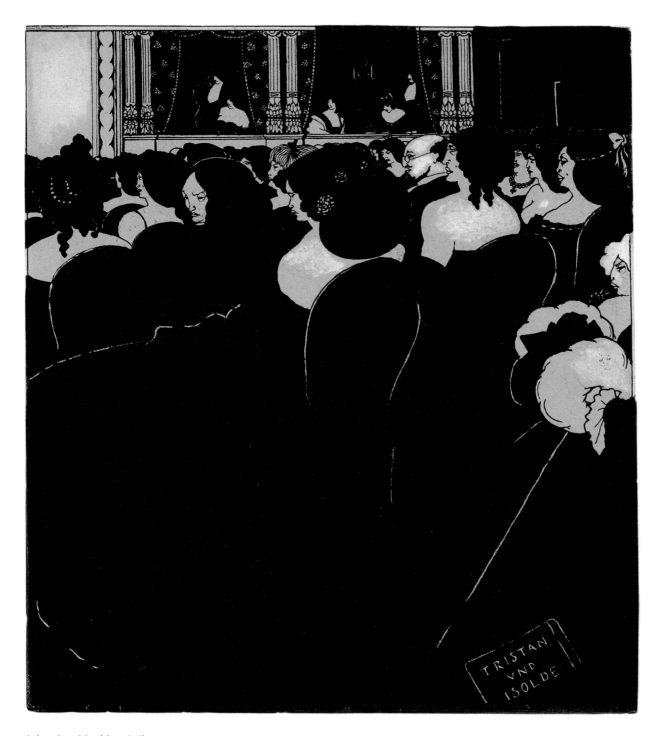

Aubrey Beardsley (1872-1898)
The Wagnerites, 1894
Indian ink, highlighted with white on paper,
20.6 x 17.8cm
E.136-1932
This is a study for an illustration in *The Yellow Book*, published in October 1894. Beardsley was fascinated by Wagner.

The programme, bottom-right, identifies the opera as *Tristan und Isolde*, one of the composer's most radical compositions, first performed in London in 1882. Here Beardsley ignores W. R. Sickert's aesthetic rule that the area of black in a composition should never exceed that in white.

8 The Future of Painting

Above: A. R. Penck (b.Ralf Winkler, 1939)
Untitled, 1980
Gouache on paper,
52 x 84cm.
Given by the Contemporary Art
Society, 1983
P.3-1983
Penck left the Communist German
Democratic Republic for the West in
1980. His anonymous stick figures
embody his own feelings of alienation,
but are also universal archetypes of
human experience. Set out like a diagram,
with autobiographical symbols and
hieroglyphic motifs, this illustrates
Penck's assertion, 'I think in pictures'.

Right: Peter Blake (b.1932)
Tattooed Lady, 1958
Black gouache and collage, mounted
on red paper, 68.6 x 53.4cm
Given by the Contemporary Art
Society, 1972
P.3-1972
From childhood, Blake has been
fascinated by the imagery of fairgrounds.
Here, transfers of children and flowers,
cigarette cards and magazine cuttings
are pasted to a schematic line drawing of
a bust-length woman. The title suggests
a tattooed lady from a side-show, but the
'tattoos' in question are the temporary
skin decorations of children. The effect
is self-consciously innocuous rather
than ironic.

Three nineteenth-century thinkers equipped the twentieth century with radical values, which prompted a fundamental re-appraisal of the nature and aims of art.[1]

The philosopher and philologist Friedrich Nietzsche (1844-1900) believed that grammar was a social convention which constrained belief, and viewed art in opposition to morality. His emphasis upon individual values and antagonism to the norm was characterized as a conflict between 'superman' and 'the herd instinct'. The founder of psychoanalysis, Sigmund Freud (1856-1939), disagreed with the notion that man was inherently rational and argued that repressed and often irrational desires provided the motor of ideas. And the economist Karl Marx (1818-1883) rejected the elitist view that art was the product of divinely gifted individuals. Viewing art simply as a form of economic production, whose specialization flowed from the division of labour, he demanded its democratization. Together, these arguments overturned the humanist perception of art as an essentially moral and intellectual activity, and called into question its role in society at a time when artists, writers and musicians were expressing increasing unease with inherited notions of artistic progress.

Paul Cézanne's letters to his friend Emile Bernard indicate that in 1904-5 he still regarded the Louvre as 'the book in which we learn to read', and argued that 'the real and immense study that must be taken up is the manifold picture of nature'.[2] However, in old age, he found that 'the sensations of colour, which give light, are the reason for the abstractions which prevent me from either covering my canvas or continuing the delimitation of the objects ... from which it results that my image or picture is incomplete ...', and he affirmed that 'I owe you the truth and shall tell it to you in painting'.[3] He also famously advised, 'treat nature by the cylinder, the sphere, the cone, everything in proper perspective'.[4]

In 1910 the term 'Post-Impressionism' was coined by Roger Fry as a 'somewhat negative label'

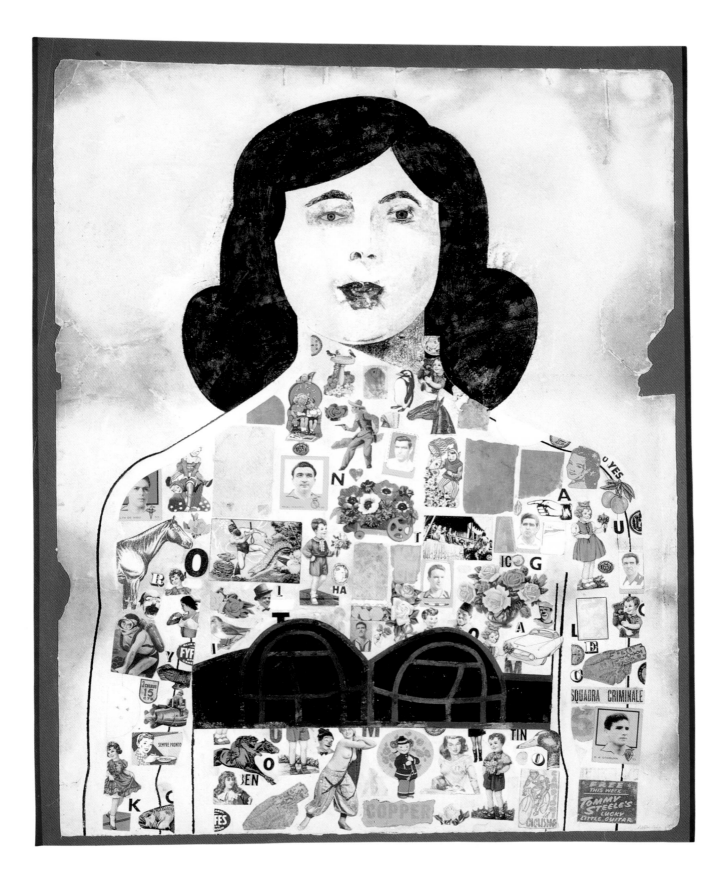

Paul Cézanne (1839-1906)
Study of trees, c.1887–9
Watercolour and pencil,
49.6 x 32cm
Purchased, 1966
P.6-1966
Cézanne observed, 'Drawing
and colour are not separate
at all; in so far as you paint,
you draw.' This sketch amply
demonstrates the firm sense
of geometry which underlies
his work. The white of the
paper is an active element,
while the blocks of violet and
green wash allude to broken
patches of light filtering
down from the canopy of
foliage above.

express their aspirations for the art of the future.
With similar groups elsewhere, they essayed
critiques of the representational agenda of the
Impressionists.

Impressed by the ancient folk culture of
Brittany, and the proximity to nature of the
inhabitants of Tahiti and the Marquesas Islands,
Gauguin sought freedom from the spiritual decay
which he associated with European bourgeois
culture. Pablo Picasso's celebrated *Demoiselles
d'Avignon* of 1906-7 was inspired by ancient
Catalan sculpture and black African carvings seen
in the museums of Paris. A focal point in European
fascination for the primitive, its faceted forms
presage the more radical break with the Western
tradition, effected in 1908-9, when Picasso
and Georges Braque (1882-1963) rejected the
naturalism of artificial perspective in favour of
a flat picture plane.

The term 'Cubism' was initially coined as a
journalistic taunt to describe their simplification
of form into geometric shapes. Associated with
this milieu were the expatriate Russians Alexandra
Exter and Sonia Delaunay (née Terk). With her
husband Robert Delaunay (1885-1941), the latter
explored the effects on the senses of brilliant
colour juxtapositions, virtually devoid of
representational content. In 1909-10 a group of
Italian artists fascinated by modern technology,
led by the poet Filippo Tomasso Marinetti, and
the painter and sculptor Umberto Boccioni (1882-
1916), issued a series of 'Futurist Manifestos'. These
declared that 'all forms of imitation should be
held in contempt and that all forms of originality
should be glorified', called for rebellion 'against
the tyranny of the words harmony and good

to embrace the work of Paul Gauguin (1848-1903)
and Vincent Van Gogh (1853-90), as well as
Cézanne. Two years previously the German art
critic Julius Meier-Graefe had described the same
trio as 'Expressionists'. A group of younger French
painters influenced by Van Gogh, led by Henri
Matisse (1869-1954), had already been dubbed
'Fauves' ('wild beasts') in 1905. And the same
year, inspired by the formal structures of post-
impressionism and the emotional content of
late medieval art, a group of painters in Dresden
adopted the name '*Die Brücke*' ('The Bridge') to

Sonia Delaunay
(1885-1979)
Study of light (electric prisms),
1913
Gouache and conté crayon
on cardboard, 31.4 x 21.2cm
Purchased, 1962
P.96-1962
Acknowledging her spiritual
masters as Van Gogh and
Gauguin, Delaunay was
fascinated by brilliant colour
contrasts. She characterized
her principal objective as
representation of 'the purity
and exaltation of colour'. This
is a study for her early
masterpiece *Electric Prisms*
(1914), a seemingly two-
dimensional composition of
intersecting radiating bands
of colour, intended to evoke
the effect of artificial lighting
on a street in the evening.

Alexandra Exter
(1882-1949)
Still Life, **1914–5**
Gouache, 33 x 25cm
Purchased, 1976
P.22-1976
By 1911 Exter was familiar
with Picasso's latest work,
and showed photographs
of it to friends in Russia.
This cubist arrangement,
contrasting upwardly
thrusting flat planes with
modelled and faceted forms,
came between the abstracted
townscapes and still lifes
which she painted until
1915, and the dynamic,
entirely non-representational
compositions which followed.
Here, coloured planes
comprise a still life, while
grey elements evoke the
encompassing space.

taste', and argued that 'universal dynamism must
be rendered in painting as a dynamic sensation'.[5]

One of the first British artists with direct
experience of these heady new Continental
departures was the painter and writer Percy
Wyndham Lewis, who espoused a semi-abstract
style of machine-like forms which he dubbed
'Vorticisim'. Lewis's iconoclastic stance, and that of
his fellow signatories of the 'Vorticist Manifesto',
including the poet Ezra Pound (1885-1972), as well
as the painters William Roberts and Edward

Wadsworth, is apparent from the polemical tone
of their magazine *Blast*, which first appeared in
June 1914:

BLAST First (from politeness) ENGLAND
Curse its climate for its sins and infections
Dismal symbol, set round our bodies,
of effeminate lout within.[6]

A few weeks after the publication of *Blast no. 1*,
the outbreak of war set in train the cataclysmic
chain of events which transformed the cultural

Left: Percy Wyndham Lewis
(1882-1957)
At the seaside, 1913
Pen and ink and watercolour,
46.5 x 31.5cm
Given by the family of Lionel
Guy Baker, in accordance with
his expressed wishes, 1919
E.3763-1919
This extraordinary group
demonstrates an impressive
range of avant-garde idiom. It
includes a superficially cubist
figure in a suit and bowler
hat, carrying a cane, a more
highly abstract machine-
figure, and an impassive
seated female, reminiscent of
African carvings. A
contemporary noted Lewis's
tendency to 'modify his forms
in the interest of drama ... to
the detriment of pure design'.

Opposite, left: William
Roberts (1895-1980)
*Soldiers erecting camouflage
at Roclincourt near Arras,* 1918
Pen, indian ink, watercolour
and red crayon, 41.2 x 35cm
Given by E. M. O'R. Dickey,
1962
P.94-1962
The artist served with the
Royal Artillery in France, and
helped erect camouflage
screens. This work portrays
the soldiers, their equipment
and the shattered landscape
around them as a network of
interlocking shapes. A review
of Roberts' first one-man
show, in 1923, acknowledged
such 'geometric distortion
and grim caricaturist humour
... based on powerful
draughtsmanship and
knowledge of form'.

and political landscape of Europe. Innumerable
artists served in this global contest of industrial
output and conscripted masses. Many were killed,
including the Germans August Macke (1887-1914)
and Franz Marc (1880-1916), or wounded, like the
Austrian Oskar Kokoschka. Some British painters,
including Wyndham Lewis, Roberts and Paul Nash,
served as official war artists, and depicted the
devastated landscape and startling light effects
of the Western Front. Kokoschka expressed the
bitter sense of alienation common to survivors:

For years I could not physically stand the people
who quietly conversed about their war
experiences, machine-gunning, throwing hand-
grenades into advancing phalanxes of living flesh,
or bayoneting, while they themselves having
returned to their normal routine, went on living
their sentimental lives. What shocked me was that
criminals, as a rule, behave like other people, while
eccentrics are an exception in their ranks as well.[7]

Perceptions of the world were rapidly changing.
First in neutral Switzerland, and later in New York,
Berlin and Paris, a group of mainly expatriate
artists devised the anti-rational programme of
events and displays known as *Dada* (French for
'rocking horse') which sought to lampoon the
values of bourgeois society. Although the German
Kurt Schwitters never officially belonged to this
provocative, short-lived movement, his cubist-
inspired assemblages of detritus seem to embody
Dadaism in its intention to create art from
discarded fragments of existence.

Left: Designed by Pablo Picasso (1881-1973)
Front stage curtain for the ballet, Le Train Bleu, 1924
Distemper on canvas, 1000 x 1100cm
Given by Richard Buckle, 1974
S.316-1978
This scene is based upon a small gouache painted while Picasso was on holiday in Brittany in 1922. Its monumentality recalls classical sculpture. The composition was vastly enlarged to decorate the curtain for *Le Train Bleu* – a ballet with a story about games on the beach by Jean Cocteau, and costumes by Coco Chanel – which was first performed by Diaghilev's *Ballets Russes* at Paris in 1924.

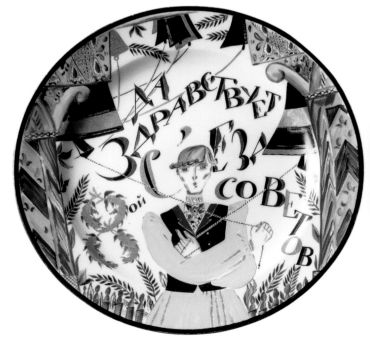

Between 1909 and 1929 the *Ballets Russes* of Sergey Diaghilev (1872-1929) provided a focus for the expatriate Russian avante-garde in Paris. After the Bolshevik Revolution, the Communist regime initially proved receptive to the non-objective styles of such artists as Wassily Kandinsky (1866-1944) and Alexandra Exter. However, conservative taste prevailed, and representational painting became the norm, culminating in the official imposition of Soviet Realism. Exter and Natalia Gontcharova both abandoned easel painting in favour of theatrical and industrial design, and illustration. Picasso also produced designs for Diaghilev and married Olga Koklova, a dancer in the *Ballets Russes*. Picasso was friendly with the poet André Breton (1896-1966), and featured in the first issue of the latter's *La Révolution Surréaliste* in 1924. Although based principally in Paris, surrealism was an international artistic and literary movement, and the painters most closely

aligned with its aims and ideals were a Belgian, René Magritte (1898-1967), and a German, Max Ernst (1891-1976). Breton outlined its aims in dictionary style:

Surrealism, n. Pure psychic automatism, by which it is intended to express, whether verbally or in writing, or in any other way, the real process of thought. Thought's dictation, free from any control of the reason, independent of any aesthetic or moral preoccupation.

Edward Wadsworth
(1889-1945)
Enigma, 1937
Tempera on panel,
53.9 x 38.1cm
Purchased, 1960
Circ. 213-1960
During the First
World War the artist
served with the Royal
Navy, and worked on
dazzle camouflage
for ships. Remaining
fascinated by the
sea, he composed
dramatic and
meticulous still lifes
of maritime subjects,
with a marked
anthropomorphic
quality. A
contemporary
observed, 'These
objects exchange
words. They act like
actors in a drama.
Talking objects ...
the spectator ... is
subjected to their
strange spell.'

ENCYCL. *Philos.* Surrealism rests on a belief in the superior reality of certain forms of association hitherto neglected, in the omnipotence of the dream, in the disinterested play of thought. It tends definitely to destroy all other psychic mechanisms and to substitute itself for them in the solution of the principal problems of life.[8]

Perhaps because British cultural life had survived the war comparatively intact, surrealism was not formally launched in London until the International Surrealist Exhibition of 1936. At its opening, the young Dylan Thomas distributed cups of boiled string to visitors. Another contributor was Edward Burra, who had previously been associated with Ben Nicholson, Nash and Wadsworth in the short-lived 'Unit One' (1933-35). This group of architects and artists had sought a 'sympathetic alliance between architect, painter, sculptor and decorator' under the inspiration of the *Bauhaus*, the seminal German school of modernist architecture and design in Dessau, which sought

to unite art and industry. Nicholson exhibited his first 'White Relief' in 1934, and rapidly emerged as the most exacting British abstractionist. The rise of Fascism forced the closure of the *Bauhaus* and scattered the Continental avant-garde. Paul Klee abandoned Germany for his native Switzerland while Nicholson's hero, the Dutch painter Piet Mondrian (1872-1944), and Kurt Schwitters, sought refuge in England. However, the atmosphere of mounting crisis preceding the Second World War was not conducive to the transplantation of International Modernism.

The British art movement most closely associated with the war was named 'Neo-Romanticism' by the painter and curator Robin Ironside in 1942, and fostered a backward-looking and elegiac figuration closely attuned to the patriotic spirit encouraged by the Ministry of Information. A programme was launched 'to make drawings, paintings and prints at the war fronts ... and on the land, and of the changed life of the towns and villages, thus making a permanent record of life during the war which would be a memorial to the national effort.'[9] The Neo-Romantics' fascination with their native landscape mirrored that of a previous generation of British painters, when the Napoleonic Wars had similarly dislocated contact with Continental Europe. Leading participants in the Official War Artists Scheme included John Piper (1903-92) and Graham Sutherland (1903-80), as well as Nash and Eric Ravilious, who was killed while on attachment to the Royal Air Force. Influenced by the experience of surrealism, the Neo-Romantics emphasized the strangeness of everyday experience, setting their vision of a tremulous present against the backdrop of a timeless past.

The devastation of the war cast a pervasive shadow long after its end. According to the existentialist philosophy of Jean-Paul Sartre (1905-80), human nature arose from conscious choice rather than innate essence, and the significance of a work of art lay not in itself, but the absent world which it evokes. While confessing some

**Edward Burra
(1905-76)**
*Surrealist
Composition, c.*1934
Watercolour on
paper, 77.7 x 35.2cm
Purchased, 1960
P.6-1960
The juxtaposition of
seemingly unrelated
and superimposed
forms reflects Burra's
earlier experiments
with collage to
intensify the impact
of images. This
composition pays
homage to surrealist
art seen in Paris
and illustrated
magazines; the
central figure recalls
those of Max Ernst,
while the arcaded
building, to the right,
is reminiscent of
works by Giorgio de
Chirico (1888-1978).

Paul Nash (1899-1946)
The eclipse of the sunflower, 1945
Watercolour on paper, 42 x 57.3cm
Bequeathed by the artist's widow, Margaret
Nash, 1962
P.19-1962
This is one of a series of paintings inspired
by William Blake's poem which begins, 'Ah,

Sunflower! Weary of Time/That countest
the steps of the Sun'. This explores the
relationship between the summer sun
and the flowers which turn towards it.
Nash alludes to their mystical association
by representing the sun's eclipse with the
flower's black centre.

**Paul Klee
(1879-1940)**
*Voice from the ether:
'and you will eat your
fill!',* 1939
Tempera and oil on
brown wrapping
paper, 50 x 38cm
Purchased, 1965
P.4-1965
The title inscribed
by the artist on this
startling image
indicates that this
salivating figure is
listening to a radio
broadcast. The
quotation is adapted
from the Old
Testament; Leviticus,
25:19. The painting's
sub-title, 'Head
listening to
propaganda',
indicates that Klee
was portraying a
member of the
German public,
duped by Nazi
promises of plenty.

puzzlement at Sartre's *Nausea*, Jean Dubuffet
nevertheless declared himself 'warmly
existentialist' as he began to paint purposefully
rough and seemingly infantile figurative works
expressing the 'instinct, passion, caprice, violence,
madness' which contemporary culture fastidiously
ignored.[10] The powerful *Three studies for figures
at the base of a crucifixion*, painted in 1945 by
Francis Bacon (1909-92), offers an even bleaker
commentary on the human condition.

In 1951 the Festival of Britain, held in London
on the centenary of the Great Exhibition,
sought rather self-consciously to celebrate the
achievements and hopes of a country theoretically
at peace but actually embroiled in a Cold War in
Europe, and a shooting war in Korea. The USA, as
the only major power to emerge from the Second
World War materially unscathed, now enjoyed
global economic and political influence. Cultural
supremacy followed in terms of language, popular
music, advertising, film and fashion, as well as
traditional forms of 'high art'. Mondrian and
other refugees, such as Josef Albers (1888-1976),
introduced geometric abstraction to the USA,
and from the late 1940s energetic new forms of
abstract painting were created by the immigrant
Russian Mark Rothko (1903-70) and the American-
born Jackson Pollock (1912-56).

In a radio interview titled 'The Future of
Painting', broadcast in 1959, the French
anthropologist Claude Lévi-Strauss (b.1908)
foresaw the possible demise of pictorial art:

... painting is not an inevitable feature of culture: a
society can perfectly well exist without any form
of pictorial art. So, it is not inconceivable that after
abstract art [there may be no painting] ... there
may be a kind of disruption or disintegration of
pictorial art before it finally disappears, or a new
beginning which is being prepared for in the sort
of Middle Ages through which we are now living ...
I seem to see a resemblance between certain
aspects of the researches and speculations of
abstract painters and certain modes of medieval

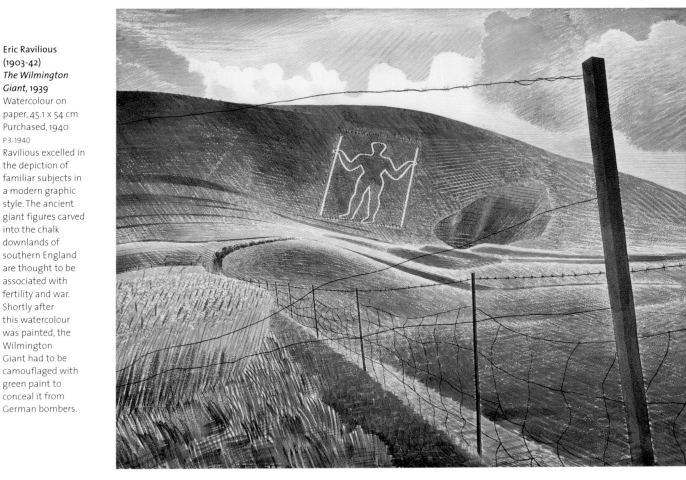

thought: notably the striving towards gnosis, i.e. towards a form of knowledge which might transcend science or towards a language which would be a para-language.[11]

Lévi-Strauss had been associated with Sartre and the surrealists in his youth. As a principal advocate of structuralism he interpreted cultures as systems of communication, which expressed the unconscious order of thought.

Confronted with the hegemony of an abstraction which seemed to threaten the very existence of painting, young figurative artists responded with irony. In the USA, Jasper Johns (b.1930) and Robert Rauschenberg (b.1925) combined familiar everyday images, including the American flag, targets, rubber tyres and Coca-Cola bottles, in startling juxtapositions which intially acquired the label 'Neo-Dada'. Inspired by New York street life, Claes Oldenburg made plaster replicas of domestic objects, and giant soft sculptures of foodstuffs and mechanical appliances. From 1962 Andy Warhol (1928-87), who had previously been a successful commercial illustrator, produced consciously impersonal screen prints of celebrities and banal subjects which became fashionable icons of consumer culture. Seminal exhibitions of contemporary American art were held at the Tate Gallery in 1956 and 1959, but their impact was dwarfed by the role of films, magazines and the expansion of television ownership which was increasingly evident by the early 1960s. The British artist Richard Hamilton (b.1922) defined the term 'Pop Art' in 1957:

Popular (designed for a mass audience)/Transient (short term solution)/Expendable (easily forgotten)/Low cost/Mass produced/Young (aimed at youth)/Witty/Sexy/Gimmicky/Glamorous/Big business.[12]

**Kurt Schwitters
(1887-1948)**
Big Fight, 1947
Collage on panel,
17.8 x 11.5cm
Purchased, 1978
P.7-1978
In 1919 Schwitters
coined the
meaningless word
'Merz' (from
kommerz, German
for 'commerce') to
describe his mixed
media collages.
He observed, 'The
metamorphosis
of materials can
be reinforced by
dividing, deforming,
overlapping or
painting over … the
box-top, playing card
and newspaper
clipping [which]
become surfaces'. In
this late work, paper
fragments are set
ironically within a
neoclassical frame.

**Jean Dubuffet
(1901-85)**
*Emblazoned with
ears,* 1961
Wash on paper,
42.7 x 33.3cm
Purchased, 1964
P.9-1964
Dubuffet was freed
by financial
independence from
the need to sell
his work. He was
fascinated by
graffiti, and argued
that the work of
professionally trained
artists was inferior
to the emotionally
spontaneous work of
children or imbeciles.
Dubuffet sought to
establish the validity
of an 'individual
creation without
precedent' which was
raw and compulsive,
which he
characterized as *Art
Brut* ('Rough Art').

Other leading figures in the formative years of pop art in England were the sculptor Edouardo Paolozzi (b.1924) and the painter Peter Blake, both fascinated by American comics and pulp literature. David Hockney, Allen Jones, Patrick Caulfield (b.1936) and the American R. B. Kitaj (b.1932) met as students at the Royal College of Art, and first exhibited together in 1961. Their brash re-interpretation of popular imagery fed the self-congratulatory media phenomenon known as the 'Swinging Sixties'.

Also closely linked to popular art, as well as such traditional artistic concerns as decoration and *trompe l'oeil* illusionism, was the movement a *Time* magazine article of 1964 dubbed 'optical art', rapidly abbreviated to 'Op Art'. Pioneered in the USA by Josef Albers and in France by Victor Vasarely (1908-94), its output utilized patterns to induce sensations of movement and vibration. Its principal British practitioner, Bridget Riley, became

well-known in the early 1960s for her literally dazzling black and white works, before moving on to more soothing and harmonic coloured compositions. 'Op Art' induced psychophysiological effects by harnessing the potential of geometric abstraction.

Exponents of Minimalism utilized an analogous repertory of forms to efface every trace of artistic personality, with the objective of making the work of art an apparently self-referential entity. A commentator observed, 'Minimalist painting is purely realistic – the subject being the painting itself.' The Americans Robert Ryman (b.1930) and Frank Stella (b.1936) are leading painters in this idiom, but its most characteristic productions are the three-dimensional constructions of Donald Judd (1928-94). The English artist Richard Smith similarly explored the relationship of surface, colour and shape in folded constructions, ranging in scale from prints and paintings on canvas, to large-scale architectural decorations.

Under the aegis of postmodernism – an exhilarating and highly eclectic, primarily architectural movement – the late 1970s

Claes Oldenburg
(b.1929)
Store Goods, 1961
Pencil and
watercolour on paper,
49.5 x 64.8cm
Purchased, 1963?
Circ.499-1963
In 1961 Oldenburg
staged a
performance, *The
Store*, in a real shop
front in Manhattan
where he sold crude,
painted plaster
sculptures of
everyday objects and
basic foodstuffs.
This drawing is the
graphic equivalent
of those plaster
commodities, and
has an energy and
abundance which
threaten to spill out
of the frame.

witnessed a resurgence in painterly figuration, particularly in Britain and Germany. Veterans of an earlier generation, including Francis Bacon, Balthus (1908-2001) and Lucian Freud (b.1922) appeared alongside such recent arrivals as Anselm Kiefer (b.1945), A. R. Penck and Bruce McLean (b.1944), their works embodying a portentous *New Spirit in Painting*.[13] Simultaneously, over the past three decades, a gradual erosion has occurred between the boundaries separating previously distinct art forms, from such traditional media as painting and sculpture to new areas including film and photography, and the manipulation of found and ephemeral materials, such as snow or twigs, chocolate or blood.

A figure of towering significance through the 1970s and '80s was the politically engaged German sculptor Joseph Beuys (1921-86), whose activities encompassed print-making and drawing, installation and performance art. Concern about environmental issues fostered the development of Land Art, utilizing natural

materials, including rocks and soil, and represented in Britain by Richard Long, David Nash (both b.1945) and Hamish Fulton (b.1946). While linked to a venerable tradition, descended from the paintings of Constable and Turner, their principal activities take place in the landscape, though some works are displayed in galleries. Such work is associated with Conceptual Art which, since the 1960s, has prioritized the role of artistic intention over the making of individual objects. Conceptual artists have questioned the institutional context of art, and explored its relationship to language and logic.

These concerns approach those of the French philosopher Jacques Derrida (1930-2004), whose theories of deconstruction influence academics, architects and artists. Proposing that discourse lacks a fixed structure, Derrida encouraged the imaginative and open-ended interpretation of its meanings. His writings on the visual arts include an extended analysis of a single phrase from one of Cézanne's letters to Bernard, mentioned above:

Above: David Hockney (b.1937)
Untitled study for a painting,
1967
Watercolour on paper,
45.7 x 61cm
Purchased, 1972
Circ. 195-1972
Hockney first visited Los
Angeles in 1963, and was
captivated by its blue skies
and luxurious living, so unlike
his life in Bradford and
London. This is one of a series
of pictures depicting the
effects of light and water
on swimming pools, dating
from 1966-7, which
culminated in the acrylic
painting *A Bigger Splash*.

The Truth in Painting is signed Cézanne ... He is
writing, in a language which shows nothing. He
causes nothing to be seen, describes nothing,
and represents even less ... the idiom "of the truth
in painting" ... can already be understood in a
multitude of ways ... the word by word, the word
for word, or the trait for trait in which it contracts:
as many words, signs, letters ... As for the meaning
... There are at least four of them ...

1. That which pertains to *the thing itself* ... truth
of truth ...

2. That which pertains, therefore, to adequate
representation ... truth faithfully represented ...
opens up the abyss ...

3. That which pertains to the *picturality*, in
the "proper" sense, of the presentation or of the
representation ...

4. That which pertains to truth in the order of
painting, then, and *on the subject of* painting ...
perhaps what is at stake in painting is truth, and
in truth what is at stake ... is the abyss[14]

In a telling instance of the mutability of
meaning which so fascinated Derrida, the sense
of the English translation of this quotation varies
markedly between the standard editions of his
essays on art and Cézanne's letters.[15]

Since the Renaissance, writers have praised the
intellectual dimension of painting, its capacity to
out-do nature, and to represent that which exists
only in the imagination. As early as 1863,

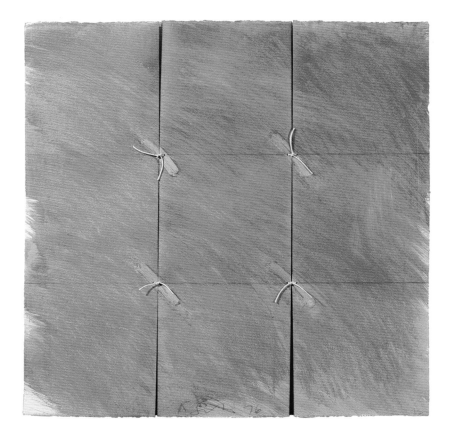

Baudelaire characterized 'modernity' as 'the transient, the fleeting, the contingent; it is one half of art, the other being the eternal and the immovable'.[16] The search for such timeless values motivated the painters from traditional art academies during the nineteenth century. In the years after 1900, Picasso and others called into question the pursuit of representational values which had underpinned European painting for five centuries. Notions of progress and fashion were central to the concept of a cultural avant-garde, a term which surfaced in its current English meaning as a journalistic tag in 1910. The same year Roger Fry's exhibition *Manet and the Post-Impressionists* sought to place the achievements of what a contemporary deemed 'The Great French Modern Art', in its historical context.

The opposition of totalitarian regimes to Modernism between the 1930s and 1950s, succeeded by its triumphant vindication under the aegis of American political power, guaranteed its credentials as the definitive artistic movement of the twentieth century. The paintings of Jackson Pollock, perhaps the pre-eminent Modernist, reveal a sense of pathos and exploration of pictorial space, in continuity with the values of Renaissance art; traces of a classical tradition to which Bridget Riley firmly subscribes.[17]

Recently, attention has concentrated on the failings of Modernism, namely its general inability to engage on terms of equality with non-Western culture, or the concerns of women, and its implicit links with industrialization and international capitalism. Discontent has motivated a range of critiques. Furthermore, new media, most recently computer and internet-based work, pose a fundamental challenge to the pre-eminence of painting. Advocates of postmodernism recommend a return to figuration and the sensuous values of oil paint. It remains to be seen whether painting will retain its long-established place at the acme of the visual arts.

Paula Rego (b.1935)
Untitled, 1981
Black ink and oil on paper, 69 x 101.5cm
Purchased, 1984
P.1-1984
Rego has often used the vivid immediacy of drawing to tell stories with a dark and violent sub-text. Her works of the 1980s, with animals acting out human emotions, drew inspiration from her childhood in Portugal, as well as 'caricature ... sights in the street, proverbs, nursery-rhymes, children's games and songs, desires, terror'.

Gulam Mohammed Sheikh (b.1937)
City for Sale, 1981/4
Oil on canvas, 204.5 x 306cm
Purchased, 1986
IS.15-1986
Sheikh studied at the Royal College of Art and the Faculty of Fine Arts in Baroda, India, where he taught. This work is a response to the 1981 film *Silsila* and the communal riots which occurred in Baroda. Sheikh contrasts images of street life and the riots with a cinema screen showing the climactic moment in this romantic movie, where the wronged wife encounters her husband and his mistress.

Above: Jean Tinguely (1925-91)
Metapandemonium (Flou), 1982
Indian ink, gouache, crayon and
collage, 23 x 29cm
Purchased, 1982
P.54-1982
Tinguely's sculptures are anarchic,
self-destructive constructions of
miscellaneous, unrelated materials,
and are often metaphors for
contemporary culture. His drawings
share this sense of an uncontrolled
kinetic energy. Here a chaotic
accumulation of motor parts, overlaid
with collaged papers and feathers,
explodes like a multi-coloured firework.

Above, left: Andy Goldsworthy (b.1956)
Source of Scaur, 1991/2
Watercolour on paper, 235 x 121cm
Purchased, 1993
E.705-1993
Goldsworthy uses only natural materials, such as leaves and stones, to make artworks, and usually these are ephemeral marks or structures in the landscape. This drawing was made with a snowball incorporating crushed red stone from the River Scaur. He placed this at the top edge of a tilted sheet of paper, allowing the coloured pigment from the melting snow to stain it like a watercolour wash.

Above, right: Vik Muniz (b.1961)
Action Photo I (after Hans Namuth) from the Pictures of Chocolate series, 1997
Dye destruction print, 152.4 x 121cm
Purchased, 1998
E.493-1998
This photograph records an ephemeral picture made by Muniz using chocolate syrup. It reproduces a famous 1950s' photograph showing the painter Jackson Pollock dripping paint on a canvas laid on the floor. Complex, subtle, and witty, Muniz suggests that works of art are fragile, mutable records of fleeting moments and actions.

Notes

CHAPTER 1

1. Belting, Hans, *Likeness and Presence – A History of the Image before the Era of Art* (Chicago and London, 1994) pp.55, 68
2. Martindale, Andrew, *Heroes, ancestors, relatives and the birth of the Portrait* (The Hague, 1988) pp.30-5
3. Haskell, Francis, *History and its images: art and the interpretation of the past* (New Haven and London, 1993) pp.26-36
4. Haskell, Francis and Penny, Nicholas, *Taste and the antique: the lure of classical sculpture 1500-1900* (New Haven and London, 1981) pp.8, 308-10, 335-7
5. ibid., pp.8-11, 148-51, 243-7
6. Haskell, 1993, pp.43-51
7. Rubin, Patricia Lee, *Giorgio Vasari: Art and History* (New Haven and London, 1995) p.1
8. Haskell and Penny, 1981, pp.53-6
9. Muller, Jeffrey M., 'Rubens's Collection in History', in Kristin Lohse Belkin and Fiona Healy, *A House of Art: Rubens as Collector* (Rubenshuis & Rubenianum, exhib. cat., Antwerp, 2004) pp.10-85
10. Haskell, Francis, 'Charles I's Collection of Pictures' in Arthur MacGregor (ed.), *The Late King's Goods: Collections, Possessions and Patronage of Charles I in the Light of the Commonwealth Sale Inventories* (London and Oxford, 1989) pp.203-31
11. Bassegonda, Bonaventura, 'Pictorial Decoration of the Escorial During the Reign of Philip IV', in Jonathan Brown and John Elliott (eds.) *The Sale of the Century: Artistic Relations between Spain and Great Britain, 1604-1655* (Museo Nacional del Prado, Madrid, exhib. cat., New Haven and London, 2002) pp.107-40
12. Holt, Elizabeth Gilmore, *A Documentary History of Art*, vol. 2, (New York, 1958) pp.183-7
13. Quoted in Fermor, Sharon, *The Raphael Tapestry Cartoons* (V&A, London, 1996) p.24
14. Meyer, Arline, *Apostles in England: Sir James Thornhill & the Legacy of Raphael's Tapestry Cartoons* (Miriam & Ida D. Wallach Art Gallery, Columbia University, exhib. cat., New York, 1996) pp.22-67
15. Fermor, 1996, pp.25-7
16. Moore, Andrew (ed.), *Houghton Hall. The Prime Minister, The Empress and the Heritage* (Norfolk Museums Service and English Heritage, exhib. cat., London, 1996) pp.48-73
17. Reynolds, Joshua (ed. Robert R. Wark), *Discourses on Art* (New Haven and London, 1975) pp.45, 269
18. Newman, John, 'Reynolds and Hone; "The Conjuror" Unmasked', in Nicholas Penny (ed.) *Reynolds* (Royal Academy, exhib. cat., London, 1986) pp.343-54
19. Reynolds (ed. Wark), 1975, pp.248-9
20. Taylor, Brandon, *Art for the Nation: Exhibitions and the London Public 1747-2001* (Manchester, 1999) pp.33-66
21. Leslie, Charles Robert, *Memoirs of the Life of John Constable* (Oxford, 1951) pp.274-5
22. ibid., p.276
23. ibid., p.299
24. ibid., p.318
25. ibid., p.312
26. ibid., p.299
27. Wilton, Andrew, *Constable's 'English Landscape Scenery'* (London, 1979) p.24

28. This classical topos, derived from Xenophon, was popular with Neoclassical artists. Benjamin West's painting of the subject, dated 1764, is in the V&A (40-1886)
29. Heleniak, Kathryn Moore, 'Victorian collections and British nationalism: Vernon, Sheepshanks and the National Gallery of British Art', *Journal of the History of Collections* (2000), vol. 12, no. 1, p.92
30. ibid., pp.93-4
31. ibid., pp.94-8
32. *Department of Science and Art* (Minute, Deed of Gift, 6 February 1857) p.3
33. ibid., p.3-4
34. Quoted in Heleniak, 2000, p.100
35. Redgrave, Samuel, *A Descriptive Catalogue of the Historical Collection of Water-Colour Paintings in the South Kensington Museum* (London, 1876) p.10
36. Quoted in Coombs, Katherine, *The Portrait Miniature in England* (V&A, London, 1998) p.12
37. Redgrave, Samuel, *Special Exhibition of Portrait Miniatures on Loan at the South Kensington Museum*, London 1865
38. Nochlin, Linda, *Realism and Tradition in Art: Sources and Documents*, (Englewood Cliffs, 1966) pp.110-1, excerpt from a letter of 30 August 1848
39. Caygill, Marjorie and Cherry, John (eds.), *A. W. Franks: nineteenth-century collecting and the British Museum* (London, 1997)
40. Stevens, Timothy and Trippi, Peter, 'An Encyclopedia of Treasures: The Idea of the Great Collection', in Malcolm Baker and Brenda Richardson (eds.), *A Grand Design: The Art of the Victoria and Albert Museum* (Baltimore Museum of Art, and V&A, exhib. cat., New York, 1997) pp.149-219
41. Lloyd, Christopher, 'Britain and the Impressionists', in Ann Dumas and Michael F. Schapiro (eds.) *Impressionism: Paintings Collected by European Museums* (High Museum of Art, Atlanta, etc., exhib. cat., 1999) pp.65-76 and House, John, 'Modern French Art for the Nation: Samuel Courtauld's collection and patronage in context', in John House (ed.), *Impressionism for England. Samuel Courtauld as patron and collector* (Courtauld Institute Galleries, exhib. cat., London, 1994) pp.9-33
42. Holmes, Charles J., 'The Constantine Ionides Bequest', *The Burlington Magazine* (April-September, 1904), vol. 5, pp.455-6, Long, Basil S., *Catalogue of the Constantine Alexander Ionides Collection, 1, Paintings in Oil, Tempera and Water-Colour together with certain of the Drawings* (V&A, London, 1925) and Watson, Andrew, 'Constantine Ionides and his Collection of 19th-Century French Art', *Journal of the Scottish Society for Art History* (1998), vol. 3, pp.25-31
43. Quoted in Cooper, Douglas, *The Courtauld Collection: A Catalogue and Introduction* (London, 1954) p.67
44. Evans, Mark, 'The Davies Sisters of Llandinam and Impressionism for Wales, 1908-1923', *Journal of the History of Collections* (2004), vol. 16, no. 2, pp.219-33
45. Taylor, 1999, pp.141-55
46. Quoted in Cowling, Elizabeth and Mundy, Jennifer, *On Classic Ground: Picasso, Léger, de Chirico and the New Classicism 1910-1930* (Tate Gallery, exhib. cat., London, 1990) p.201
47. Taylor, 1999, pp.176-94

CHAPTER 2

1. See especially Belting, 1994, pp.xxi, 1-16
2. Mango, Cyril, *The Art of the Byzantine Empire 312-1453: Sources and Documents* (Englewood Cliffs, 1972) p.17
3. Quoted in Dodwell, Charles R., *The Pictorial Arts of the West 800-1200* (New Haven and London, 1993) p.32
4. Holt, Elizabeth Gilmore, *A Documentary History of Art*, vol. 1, (New York, 1957) p.20
5. Panofsky, Erwin and Panofsky-Soergel, Gerda (trans. and eds.), *Abbot Suger – On the Abbey Church of St. Denis and its Art Treasures* (Princeton, 1979, second edition) pp.5, 47-9
6. ibid., p.67
7. Dodwell, Charles R. (trans. and ed.), *Theophilus – The Various Arts* (London, 1961) pp.1, 63-4
8. ibid., p.4
9. For the portrait of Jean II, see Martindale, 1988, pp.9, 31-2
10. Franco Brunello (trans. and ed.), *De arte illuminandi: e altri trattati sulla tecnica della miniatura medievale*, (Vicenza, 1975) pp.37-143
11. Thompson, Daniel V. (trans. and ed.), *The Craftsman's Handbook: the Italian 'Il libro dell' arte'* (New York, 1960) pp.1-2, 91
12. ibid., p.57
13. Stechow, Wolfgang, *Northern Renaissance Art 1400-1600: Sources and Documents* (Englewood Cliffs, 1966) pp.4-5
14. ibid., p.86
15. Sobré, Judith Berg, *Behind the Altar Table: The Development of the Painted Retable in Spain, 1350-1500* (Columbia, 1989) pp.325, 328
16. Stechow, 1966, p.4

CHAPTER 3

1. See especially Goldthwaite, Richard A., *Wealth and the Demand for Art in Italy 1300-1600* (Baltimore and London, 1993) pp.243-50
2. Gombrich, E. H., 'The Early Medici as Patrons of Art', in *Norm & Form, Studies in the Art of the Renaissance* (London & New York, 1966), p.51
3. Fraser Jenkins, A. D., 'Cosimo de' Medici's Patronage of Architecture and the Theory of Magnificence', *Journal of the Warburg and Courtauld Institutes* (1970), vol. 33, p.166
4. Baxandall, Michael, *Giotto and the Orators: Humanist observers of painting in Italy and the discovery of pictorial composition 1350-1450* (Oxford, 1971) p.51
5. ibid., p.99
6. Gombrich, E. H., 'Apollonio di Giovanni: A Florentine cassone workshop seen through the eyes of a humanist poet', in *Norm & Form: Studies in the Art of the Renaissance* (London & New York, 1966), p.21
7. Alberti, Leon Battista (trans. and ed. by John R. Spencer), *On Painting* (New Haven, 1971) pp.43, 98
8. ibid., pp.43, 45, 49, 50, 55, 57, 59
9. ibid., p.64
10. ibid., pp.89-90
11. Rogers, Mary, 'Sonnets on female portraits from Renaissance North Italy', *Word & Image* (October-December, 1986), vol. 2, no. 4, pp.291-2, 300-1
12. Gombrich, E. H., 'Apollonio di Giovanni' p.12

13. Campbell, Thomas P., *et al, Tapestry in the Renaissance: Art and Magnificence*, (Metropolitan Museum of Art, exhib. cat., New York, New Haven and London, 2002) pp.198-9
14. Klein, Robert and Zerner, Henri, *Italian Art 1500-1600: Sources and Documents* (Englewood Cliffs, 1966) pp.6-7
15. ibid., p.14
16. ibid., pp.34-5
17. Vasari, Giorgio (trans. Gaston du C. de Vere Cole, intro. and notes by D. Ekserdjian), *Lives of the Painters, Sculptors and Architects*, vol. 2, (London, 1996) pp.75, 77
18. Erasmus, Desiderius (ed. J. K. Sowards), *Collected Works of Erasmus, Literary and Educational Writings*, vol. 4 (Toronto, Buffalo and London, 1985) p.399
19. Hilliard, Nicholas (eds. R. K. R. Thornton and T. G. S. Cain), *A Treatise Concerning the Arte of Limning* (Mid Northumberland Arts Group, 1981) p.18
20. ibid., p.63
21. ibid., p.69
22. ibid., pp.71, 73
23. ibid., p.73
24. Stronge, Susan, *Painting for the Mughal Emperor: The Art of the Book 1560-1660* (V&A, London, 2002) pp.100-6, 110-4, 136-9

CHAPTER 4

1. Klein, Robert and Zerner, Henri, *Italian Art 1500-1600: Sources and Documents* (Englewood Cliffs, 1966) pp.120-1
2. Norgate, Edward (eds. Jeffrey M. Muller and Jim Murrell), *Miniatura or the Art of Limning* (New Haven and London, 1997) pp.82-3
3. Magurn, Ruth Saunders (trans. & ed.), *The Letters of Peter Paul Rubens* (Cambridge, Massachusetts, 1955), p.407
4. Holt, Elizabeth Gilmore, *A Documentary History of Art*, vol. 2, (New York, 1958) pp.142-5
5. Puttfarken, Thomas, *Roger de Piles' Theory of Art* (New Haven and London, 1985) p.34
6. ibid., p.43
7. Murdoch, John, *Seventeenth-century English Miniatures in the Collection of the Victoria and Albert Museum* (London, 1997) p.206
8. Piles, Roger de (trans. John Savage), *The Art of Painting and the Lives of the Painters*, with an 'Essay towards an English School' by Bainbrigge Buckeridge (London, 1706) pp.viii-ix

CHAPTER 5

1. See Weyl, Martin, *Passion for Reason and Reason for Passion: Seventeenth Century Art and Theory in France, 1648-1683* (New York, 1989)
2. Nichols, John Bowyer, *Anecdotes of Hogarth, written by himself* (London, 1839) pp.25-31
3. Brown's comments, originally communicated in a letter to Lord Lyttelton, were first published in 1766; Bicknell, Peter, *Beauty, Horror and Immensity: Picturesque Landscape in Britain, 1750-1850* (Cambridge, 1981) pp.x, 1-2
4. From Walpole's *Anecdotes of Painting in England* (1762-5), quoted in Barrell, John, *The Dark Side of the Landscape* (Cambridge, 1980) p.7

5. Diderot, Denis (trans. and ed. John Goodman, intro. Thomas Crow), *Diderot on Art*, vol. 1, *The Salon of 1765 and Notes on Painting*, (New Haven and London, 1995) pp.22-4

6. ibid., pp.116-7

7. Azara, José Nicolás de, *The Works of Anthony Raphael Mengs*, vol. 1 (London, 1796) pp.135-7

8. Reynolds, Joshua (ed. Robert R. Wark), *Discourses on Art* (New Haven and London, 1975) pp.252-61

9. For the relative status of British miniaturists and watercolourists at the end of the eighteenth century, see Coombs, Katherine, *The Portrait Miniature in England* (V&A, London, 1998) pp.92-102, and Smith, Greg, 'Watercolourists and Watercolours at the Royal Academy', in David H. Solkin (ed.), *Art on the Line: The Royal Academy Exhibitions in Somerset House 1780-1836* (Courtauld Institute Galleries, exhib. cat., New Haven and London, 2001) pp.189-200

CHAPTER 6

1. Reynolds, Joshua (ed. Robert R. Wark), *Discourses on Art* (New Haven and London, 1975) pp.78-9; quoted in William Vaughan, *Romantic Art* (London, 1978) p.13

2. Reynolds (ed. Wark, 1975) pp.xxvi-xxxi, 284-319

3. Leslie, Charles Robert, *Memoirs of the Life of John Constable* (Oxford, 1951) p.82

4. Reynolds, (ed. Wark, 1975) pp.284-5, 290

5. Bindman, David, *The Complete Graphic Works of William Blake* (London, 1978) p.468

6. Leslie, 1951, p.279

7. Wordsworth, Jaye and Woof, *William Wordsworth and the Age of English Romanticism* (New Brunswick and London, 1988) pp.61-8

8. Constable, John (ed. R. B. Beckett), *John Constable's Correspondence*, vol. 6 (Ipswich, 1968) pp.77-8

9. Quoted in Lister, Raymond, *Samuel Palmer and 'The Ancients'* (Fitzwilliam Museum, exhib. cat., Cambridge, 1984) p.6

CHAPTER 7

1. Baudelaire, Charles-Pierre (trans. by P. E. Charvet), *Selected Writings on Art and Artists* (Harmondsworth, 1972) pp.37-8

2. ibid., pp.35, 53, 403

3. ibid., pp.104-7

4. Nochlin, Linda, *Realism and Tradition in Art: Sources and Documents* (Englewood Cliffs, 1966) pp.33-4, 48

5. ibid., pp.57, 59

6. Kendall, Richard (ed.), *Degas by himself: drawings, prints, paintings, writings* (London, 1987) pp.104

7. Taichiro Kobayashi, quoted in Gabriel P. Weisberg, (ed.), *Japonisme: Japanese Influence on French Art 1854-1910* (Cleveland, exhib. cat., 1975) p.13

8. Noon, Patrick (ed.), *Constable to Delacroix: British Art and the French Romantics* (Tate Britain, exhib. cat., London, 2003)

9. Baudelaire (1972) p.53

10. Excerpts from letters of 9 and 26 May 1851; Nochlin (1966) pp.119-23

11. Quoted in Premble, John, *The Mediterranean Passion: Victorians and Edwardians in the South* (Oxford, 1988) pp.46-7

12. Quoted in Calloway, Stephen, *Aubrey Beardsley* (V&A, exhib. cat., London, 1998) p.63

CHAPTER 8

1. Danto, Arthur C., 'A Century of Self-Analysis: Philosophy in Search of an Identity', in Christos M. Joachimides and Norman Rosenthal (eds.), *The Age of Modernism. Art in the 20th Century* (Martin-Gropius-Bau, exhib. cat., Berlin, 1997) pp.16-20

2. Undated letters of 1905 and 12 May 1904 in John Rewald (ed.), *Paul Cézanne. Letters* (London, 1941) pp.250, 236

3. Letter of 23 October 1905; ibid., pp.251-2

4. Letter of 15 April 1904, ibid., p.234

5. Quoted in Herbert Read, *A Concise History of Modern Painting* (London, 1959) p.110

6. Quoted in Richard Cork, 'What was Vorticism?', in Jane Farrington, *Wyndham Lewis* (Manchester City Art Galleries, exhib. cat., London, 1980) p.23

7. Quoted in Edith Hoffmann, *Kokoschka: Life and Work* (London, 1947) p.144

8. Read, 1959, pp.132-3

9. T.E. Fennemore in 1939, quoted in Mellor, Saunders and Wright, *Recording Britain: a Pictorial Domesday of Pre-war Britain* (V&A, exhib. cat., London, 1990) p.7

10. Quoted in Frances Morris, *Paris Post War: Art and Existentialism 1945-55* (Tate Gallery, exhib. cat., London, 1993) p.79

11. Quoted in Georges Charbonnier (ed.), *Conversations with Claude Lévi-Strauss* (London, 1969) pp.132-3

12. Quoted in Marco Livingstone (ed.), *Pop Art* (Royal Academy of Arts, exhib. cat., London, 1991) p.157

13. Joachimides, Rosenthal and Serota (eds.), *A New Spirit in Painting* (Royal Academy of Arts, exhib. cat., London, 1981)

14. Derrida, Jacques (trans. Geoff Bennington and Ian McLeod), *The Truth in Painting* (Chicago, 1987) pp.2-7

15. John Rewald (ed.), *Paul Cézanne. Correspondance* (Paris, 1937) pp.276-7; '*Je vous dois la vérité en peinture et je vous la dirai*'. Derrida, 1987; 'I owe you the truth in painting and I will tell it to you'; Rewald (ed.) 1941, 'I owe you the truth and shall tell it to you in painting'.

16. From 'The Painter of Modern Life', quoted in Charles-Pierre Baudelaire (trans. P. E. Charvet), *Selected Writings on Art and Artists* (Harmondsworth, 1972) p. 403

17. Varnedoe, Kirk with Karmel, Pepe, *Jackson Pollock* (The Museum of Modern Art, exhib. cat., New York, 1998) p.131; Bridget Riley and Neil MacGregor, 'The Art of the Past', in Robert Kudielka (ed.), *Bridget Riley: Dialogues on Art* (London, 1995) pp.19-24

Bibliography

Alberti, Leon Battista (trans. and ed. by John R. Spencer), *On Painting* (New Haven, 1971)

Azara, José Nicolás de, *The Works of Anthony Raphael Mengs*, vol. 1 (London, 1796)

Barrell, John, *The Dark Side of the Landscape* (Cambridge, 1980)

Bassegonda, Bonaventura, 'Pictorial Decoration of the Escorial During the Reign of Philip IV', in Jonathan Brown and John Elliott (eds.) *The Sale of the Century: Artistic Relations between Spain and Great Britain, 1604-1655* (Museo Nacional del Prado, Madrid, exhib. cat., New Haven and London, 2002) pp.107-40

Baudelaire, Charles-Pierre (trans. by P. E. Charvet), *Selected Writings on Art and Artists* (Harmondsworth, 1972)

Baxandall, Michael, *Giotto and the Orators: Humanist observers of painting in Italy and the discovery of pictorial composition 1350-1450* (Oxford, 1971)

Belting, Hans, *Likeness and Presence – A History of the Image Before the Era of Art* (Chicago and London, 1994)

Bicknell, Peter, *Beauty, Horror and Immensity: Picturesque Landscape in Britain, 1750-1850* (Cambridge, 1981)

Bindman, David, *The Complete Graphic Works of William Blake* (London, 1978)

Brunello, Franco (trans. and ed.), *De arte illuminandi: e altri trattati sulla tecnica della miniatura medievale*, (Vicenza, 1975)

Buckberrough, Sherry A, *Sonia Delaunay*, (Albright-Knox Art Gallery, exhib. cat., Buffalo, 1980)

Burton, Anthony, *Vision & Accident: The Story of the Victoria and Albert Museum* (V&A, London, 1999)

Calloway, Stephen, *Aubrey Beardsley* (V&A, exhib. cat., London, 1998)

Campbell, Thomas P., *et al, Tapestry in the Renaissance: Art and Magnificence*, (Metropolitan Museum of Art, exhib. cat., New York, New Haven and London, 2002)

Caygill, Marjorie and Cherry, John (eds.), *A. W. Franks: Nineteenth Century Collecting and the British Museum* (London, 1997)

Charbonnier, Georges (ed.), *Conversations with Claude Lévi-Strauss* (London, 1969)

Constable, John (ed. R. B. Beckett), *John Constable's Correspondence*, vol. 6 (Ipswich, 1968)

Coombs, Katherine, *The Portrait Miniature in England* (V&A, London, 1998)

Cooper, Douglas, *The Courtauld Collection: A Catalogue and Introduction* (London, 1954)

Cowling, Elizabeth and Mundy, Jennifer, *On Classic Ground: Picasso, Léger, de Chirico and the New Classicism 1910-1930* (Tate Gallery, exhib. cat., London, 1990)

Craske, Matthew, *Art in Europe 1700-1830* (Oxford, 1997)

Derrida, Jacques (trans. Geoff Bennington and Ian McLeod), *The Truth in Painting* (Chicago, 1987)

Dibar, Lalya S. and Ekhtiar, Maryam (eds.), *Royal Persian Paintings: The Qajar Epoch 1785-1925* (Brooklyn Museum of Art, exhib. cat., New York, 1998)

Diderot, Denis (trans. and ed. John Goodman, intro. Thomas Crow), *Diderot on Art*, vol. 1, *The Salon of 1765 and Notes on Painting*, (New Haven and London, 1995)

Dodwell, Charles R. (trans. and ed.), *Theophilus – The Various Arts* (London, 1961)

Dodwell, Charles R., *The Pictorial Arts of the West 800-1200* (New Haven and London, 1993)

Erasmus, Desiderius (ed. J. K. Sowards), *Collected Works of Erasmus, Literary and Educational Writings*, vol. 4 (Toronto, Buffalo and London, 1985)

Evans, Mark, 'The Davies Sisters of Llandinam and Impressionism for Wales, 1908-1923', *Journal of the History of Collections* (2004), vol. 16, no. 2, pp.219-33

Farrington, Jane, *Wyndham Lewis* (Manchester City Art Galleries, exhib. cat., London, 1980)

Fermor, Sharon, *The Raphael Tapestry Cartoons* (V&A, London, 1996)

Filarete (trans. and ed. John R. Spencer), *Filarete's Treatise on Architecture* (New Haven and London, 1965)

Fraser Jenkins, A. D., 'Cosimo de' Medici's Patronage of Architecture and the Theory of Magnificence', *Journal of the Warburg and Courtauld Institutes* (1970), vol. 33, pp.162-170

Goldthwaite, Richard A., *Wealth and the Demand for Art in Italy 1300-1600* (Baltimore and London, 1993)

Gombrich, E. H., 'Apollonio di Giovanni: A Florentine cassone workshop seen through the eyes of a humanist poet', in *Norm & Form: Studies in the Art of the Renaissance* (London & New York, 1966) pp.11-28

Gombrich, E. H., 'The Early Medici as Patrons of Art', in *Norm & Form, Studies in the Art of the Renaissance* (London & New York, 1966) pp.35-57

Haskell, Francis, 'Charles I's Collection of Pictures' in Arthur MacGregor (ed.), *The Late King's Goods: Collections, Possessions and Patronage of Charles I in the Light of the Commonwealth Sale Inventories* (London and Oxford, 1989) pp.203-31

Haskell, Francis, *History and its Images: Art and the Interpretation of the Past* (New Haven and London, 1993)

Haskell, Francis and Penny, Nicholas, *Taste and the Antique: The lure of classical sculpture 1500-1900* (New Haven and London, 1981)

Heleniak, Kathryn Moore, 'Victorian Collections and British Nationalism: Vernon, Sheepshanks and the National Gallery of British Art', *Journal of the History of Collections* (2000), vol. 12, no. 1, pp.91-107

Hilliard, Nicholas (eds. R. K. R. Thornton and T. G. S. Cain), *A Treatise Concerning the Arte of Limning* (Mid Northumberland Arts Group, 1981)

Hoffmann, Edith, *Kokoschka: Life and Work* (London, 1947)

Holmes, Charles J., 'The Constantine Ionides Bequest', *The Burlington Magazine* (April-September, 1904), vol. 5, pp.455-6

Holt, Elizabeth Gilmore, *A Documentary History of Art*, vol. 1, (New York, 1957)

Holt, Elizabeth Gilmore, *A Documentary History of Art*, vol. 2, (New York, 1958)

House, John, 'Modern French Art for the Nation: Samuel Courtauld's collection and patronage in context', in John House (ed.), *Impressionism for England. Samuel Courtauld as patron and collector* (Courtauld Institute Galleries, exhib. cat., London, 1994) pp.9-33

Joachimides, Rosenthal and Serota (eds.), *A New Spirit in Painting* (Royal Academy of Arts, exhib. cat., London, 1981)

Joachimides, Christos M. and Rosenthal, Norman (eds.), *The Age of Modernism. Art in the 20th Century* (Martin-Gropius-Bau, exhib. cat., Berlin, 1997)

Kauffmann C. M., *Catalogue of Foreign Paintings* (V&A, London, 1973)

Kendall, Richard (ed.), *Degas by himself: drawings, prints, paintings, writings* (London, 1987)

Klein, Robert and Zerner, Henri, *Italian Art 1500-1600: Sources and Documents* (Englewood Cliffs, 1966)

Kudielka, Robert (ed.), *Bridget Riley: Dialogues on Art* (London, 1995)

Leslie, Charles Robert, *Memoirs of the Life of John Constable* (Oxford, 1951)

Lister, Raymond, *Samuel Palmer and 'The Ancients'* (Fitzwilliam Museum, exhib. cat., Cambridge, 1984)

Livingstone, Marco (ed.), *Pop Art* (Royal Academy of Arts, exhib. cat., London, 1991)

Lloyd, Christopher, 'Britain and the Impressionists', in Ann Dumas and Michael F. Schapiro (eds.) *Impressionism: Paintings Collected by European Museums* (High Museum of Art, Atlanta, etc., exhib. cat., 1999) pp.65-76

Long, Basil S. *Catalogue of the Constantine Alexander Ionides Collection, 1, Paintings in Oil, Tempera and Water-Colour together with certain of the Drawings* (V&A, London, 1925)

Magurn, Ruth Saunders (trans. & ed.), *The Letters of Peter Paul Rubens* (Cambridge, Massachusetts, 1955)

Mango, Cyril, *The Art of the Byzantine Empire 312-1453: Sources and Documents* (Englewood Cliffs, 1972)

Martindale, Andrew, *Heroes, ancestors, relatives and the birth of the portrait* (The Hague, 1988)

Mellor, Saunders and Wright, *Recording Britain: a Pictorial Domesday of Pre-war Britain* (V&A, exhib. cat., London, 1990)

Meyer, Arline, *Apostles in England: Sir James Thornhill & the Legacy of Raphael's Tapestry Cartoons* (Miriam & Ida D. Wallach Art Gallery, Columbia University, exhib. cat., New York, 1996)

Moore, Andrew (ed.), *Houghton Hall. The Prime Minister, The Empress and the Heritage* (Norfolk Museums Service and English Heritage, exhib. cat., London, 1996)

Morris, Frances, *Paris Post War: Art and Existentialism 1945-55* (Tate Gallery, exhib. cat., London, 1993)

Muller, Jeffrey M., 'Rubens's Collection in History', in Kristin Lohse Belkin and Fiona Healy, *A House of Art: Rubens as Collector* (Rubenshuis & Rubenianum, exhib. cat., Antwerp, 2004) pp.10-85

Murdoch, John, *Seventeenth-century English Miniatures in the Collection of the Victoria and Albert Museum* (London, 1997)

Newman, John, 'Reynolds and Hone; "The Conjuror" Unmasked', in Nicholas Penny (ed.) *Reynolds* (Royal Academy, exhib. cat., London, 1986) pp.343-54

Nichols, John Bowyer, *Anecdotes of Hogarth, written by himself* (London, 1839)

Nochlin, Linda, *Realism and Tradition in Art: Sources and Documents* (Englewood Cliffs, 1966)

Noon, Patrick (ed.), *Constable to Delacroix: British Art and the French Romantics* (Tate Britain, exhib. cat., London, 2003)

Norgate, Edward (eds. Jeffrey M. Muller and Jim Murrell), *Miniatura or the Art of Limning* (New Haven and London, 1997)

Pace, Claire, *Félibien's Life of Poussin* (London, 1981)

Panofsky, Erwin and Panofsky-Soergel, Gerda (trans. and eds.), *Abbot Suger – On the Abbey Church of St. Denis and its Art Treasures* (Princeton, 1979, second edition)

Parkinson, Ronald, *Catalogue of British Oil Paintings 1820-1860* (V&A, London, 1990)

Pears, Iain, *The Discovery of Painting: The Growth of Interest in the Arts in England, 1680-1768* (New Haven and London, 1988)

Piles, Roger de (trans. John Savage), *The Art of Painting and the Lives of the Painters*, with an 'Essay towards an English School' by Bainbrigge Buckeridge (London, 1706)

Pope-Hennessy, John and Lightbown, Ronald, *Catalogue of Italian Sculpture in the Victoria and Albert Museum* (London, 1964)

Premble, John, *The Mediterranean Passion: Victorians and Edwardians in the South* (Oxford, 1988)

Puttfarken, Thomas, *Roger de Piles' Theory of Art* (New Haven and London, 1985)

Rackham, Arthur, *Catalogue of Italian Maiolica* (V&A, London, 1977)

Ray, Anthony, *Spanish Pottery 1248-1898* (V&A, London, 2000)

Read, Herbert, *A Concise History of Modern Painting* (London, 1959)

Redgrave, Samuel, *A Descriptive Catalogue of the Historical Collection of Water-Colour Paintings in the South Kensington Museum* (London, 1876)

Redgrave, Samuel, *Special Exhibition of Portrait Miniatures on Loan at the South Kensington Museum* (London, 1865)

Rewald, John (ed.), *Paul Cézanne. Correspondance* (Paris, 1937)

Rewald, John (ed.), *Paul Cézanne. Letters* (London, 1941)

Reynolds, Graham, *Catalogue of the Constable Collection* (V&A, London, 1973)

Reynolds, Joshua (ed. Robert R. Wark), *Discourses on Art* (New Haven and London, 1975)

Rogers, Mary, 'Sonnets on female portraits from Renaissance North Italy', *Word & Image* (October-December, 1986), vol. 2, no. 4, pp.291-304

Rubin, Patricia Lee, *Giorgio Vasari: Art and History* (New Haven and London, 1995)

Shearman, John, *Raphael's Cartoons in the Collection of Her Majesty the Queen and the Tapestries for the Sistine Chapel* (London, 1972)

Smith, Greg, 'Watercolourists and Watercolours at the Royal Academy', in David H. Solkin (ed.), *Art on the Line: The Royal Academy Exhibitions in Somerset House 1780-1836* (Courtauld Institute Galleries, exhib. cat., New Haven and London, 2001)

Sobré, Judith Berg, *Behind the Altar Table: The Development of the Painted Retable in Spain, 1350-1500* (Columbia, 1989)

Stechow, Wolfgang, *Northern Renaissance Art 1400-1600: Sources and Documents* (Englewood Cliffs, 1966)

Stevens, Timothy and Trippi, Peter, 'An Encyclopedia of Treasures: The Idea of the Great Collection', in Malcolm Baker and Brenda Richardson (eds), *A Grand Design: The Art of the Victoria and Albert Museum* (Baltimore Museum of Art, and V&A, exhib. cat., New York, 1997) pp.149-219

Stronge, Susan, *Painting for the Mughal Emperor: The Art of the Book 1560-1660* (V&A, London, 2002)

Taylor, Brandon, *Art for the Nation: Exhibitions and the London Public 1747-2001* (Manchester, 1999)

Thompson, Daniel V. (trans. and ed.), *The Craftsman's Handbook: the Italian 'Il libro dell' arte'* (New York, 1960)

Treuherz, Julian (ed.), *Dante Gabriel Rossetti* (Van Gogh Museum, exhib. cat., Amsterdam and the Walker, Liverpool, Zwolle, 2003)

Varnedoe, Kirk with Karmel, Pepe, *Jackson Pollock* (The Museum of Modern Art, exhib. cat., New York, 1998)

Vasari, Giorgio (trans. Gaston du C. de Vere Cole, intro. and notes by D. Ekserdjian), *Lives of the Painters, Sculptors and Architects*, 2 vols. (London, 1996)

Picture Credits

Vaughan, William, *Romantic Art* (London, 1978)

Vecht, A., *Frederik van Frytom 1632-1702* (Amsterdam, 1968)

Watson, Andrew, 'Constantine Ionides and his Collection of 19th-Century French Art', *Journal of the Scottish Society for Art History* (1998), vol. 3, pp.25-31

Watson, Rowan, *Illuminated Manuscripts and their Makers* (V&A, London, 2003)

Watson, William (ed.), *The Great Japan Exhibition: Art of the Edo Period 1600-1868* (Royal Academy, exhib. cat., London, 1981)

Weisberg, Gabriel P. (ed.), *Japonisme: Japanese Influence on French Art 1854-1910* (Cleveland, exhib. cat., 1975)

Weyl, Martin, *Passion for Reason and Reason for Passion: Seventeenth Century Art and Theory in France, 1648-1683* (New York, 1989)

Whalley, Joyce Irene, *Pliny the Elder: Historia Naturalis* (V&A, London, 1982)

Williamson, Paul, *Medieval and Renaissance Stained Glass in the Victoria and Albert Museum* (V&A, London, 2003)

Wilton, Andrew, *Constable's 'English Landscape Scenery'* (London, 1979)

Wordsworth, Jaye and Woof, *William Wordsworth and the Age of English Romanticism* (New Brunswick and London, 1988)

Index